Make Your Small Business Website Work

ROCKPORT

Make Your Small Business
Website Work

Easy Answers to Content,
Navigation, and Design

John Heartfield

GLOUCESTER MASSACHUSETTS

ROCKPORT PUBLISHERS

First published in the United States of America by
Rockport Publishers, Inc.
33 Commercial Street
Gloucester, Massachusetts 01930-5089
Telephone: (978) 282-9590
Fax: (978) 283-2742
www.rockpub.com

Library of Congress
Cataloging-in-Publication Data
Heartfiled, John.
 Make your small business website work : easy answers
to content, navigation, and design / John Heartfield.
 p. cm.
 ISBN 1-59253-053-2
 1. Web sites–Design. 2. Computer graphics. 3.
Business enterprises. I. Title.
TK5105.888H42 2004
658.8'72'0285572–dc22 2003025870
 CIP

10 9 8 7 6 5 4 3 2 1

Interior Design & Layout: Collaborated Inc.
Cover Design: Tim Nihoff Studios

Printed in China

 To friends and loved ones with the hope that I always show you who you are.

» CONTENTS

Introduction

In a very real sense, any business on the Web is a small business. No matter how famous your brand or how varied your selection, people won't tolerate bad service when they can quickly leave your site and find what they want at another that is more accommodating.

Creating great website navigation for small business should be an easy task—that is, the website has to be easy to use. However, when you set out to accomplish this goal, you may find that the path to organizing and presenting your content is scattered with pitfalls.

You can avoid these pitfalls by learning some simple rules, keeping in mind a few clear principles, and following the advice in this book. Here, by example, you'll learn the basics of solid Web navigation design.

This book doesn't contain a lot of complicated terms or systems. It doesn't discuss Web software in depth or outline how to program navigation. It also doesn't offer specific places on the Web dedicated to the actual construction of websites. Those topics are covered adequately in other books, and it's easy enough to find that information through Web search engines such as Google or Yahoo. Instead, this book offers real websites and straightforward advice on how to construct the type of clear, simple, and consistent website that's good for business.

Although the focus of this book is websites for small business, the tips offered here will help anyone who wants to build a website that is functional—not frustrating—for visitors.

Why You Should Read This Book

Every day, an untold amount of money is lost because of mistakes that should have, and could have, been easily caught and corrected. Here's an example (the story is true, but the product has been changed to protect the innocent): A Web shopper hears about a website that sells a revolutionary new type of garden tool. The shopper types in the URL and arrives at a homepage touting the new tool, displaying a photo, and offering a special discount for buying direct from the website. The site boasts a prominent "buy now" button.

The shopper is impressed, gets out a credit card, and clicks "buy now." A form appears requesting the usual information including a phone number field. The shopper types in all the information except phone number (people are hesitant to give their phone number to ecommerce sites) and clicks the submit button. Instead of verification that the order has been received or a "thank-you!" message, the shopper is taken to the same homepage with everything, including the prominent "buy now" message, as it was before.

The shopper assumes it's some kind of glitch but feels the tool would really make gardening easier. The "buy now" button is clicked again and, once again, the same form appears. All of the shopper's information is still in the fields of the form. The shopper doesn't see any errors in their credit card info and, once again, tries to submit the information. Once again, the shopper is sent to the homepage.

Forget it, the shopper thinks, *I'll live without it.*

The problem? The form was located below the fold, the nonvisible area of a long vertical page in a browser open to normal size. When the shopper clicked "buy now," instead of going to a new page, the navigation used an anchor (a marker inside the page) to jump to the form at the bottom of the page.

When the shopper submitted the personal information, the website detected an error. The phone number field was empty. The page was loaded again. But since the form was below the fold, the homepage appeared normal. The only difference in the newly reloaded homepage was that a small line was added above the buy form noting that the phone number field could not be left blank. When the shopper clicked "buy now" again, the "you must complete the phone number field" message was, in essence, invisible to the shopper. Of course, the shopper could have put any phone number into that field.

If the person who designed the navigation above had read this book, that company would be shipping many more orders.

Who Should Read This Book

To get the most from this book, you should have a basic familiarity with the Web and a general understanding of the way browsers work. None of the information contained in this book is specific to any one browser. Furthermore, it is not necessary to have any background in interface or graphic design to understand the concepts this book presents.

In short, this book is for anyone who would like to ensure that a website meets the needs of its visitors.

A Note about the Websites Featured in This Book

The examples featured in this book were chosen because they represent the principles of excellent website design. No site is perfect and, in some cases, suggestions regarding minor areas where they might be improved are included. In all cases, the example sites are superior models for small business websites.

» **"The guest is a jewel resting on the cushion of hospitality." –Nero Wolfe**

» NAVIGATION DESIGN TOOLS

The right tools make any construction project easier. "User testing" and "quality assurance" are indispensable. If you take a little time to learn about the other tools described in this section, you'll find the task of building a coherent website is considerably easier.

One tool that is not mentioned but that is absolutely vital is your commitment to frequently back up any work you perform on computers. Computers are not reliable machines. At all times, you should be thinking, *If my system failed this minute how many hours of work would I have lost between now and the last time I did an external backup?*

Make at least three current backups that are not connected to your system (CD, DVD, Zip drives, etc.). Rotate one of them into another environment—a safety deposit box is ideal.

Hopefully you'll never have to reap the benefits of the time you spend backing up your work, but backups are insurance you can't afford to be without.

User Testing

The motto of a competent website developer is: "Test early, test often."

You will never know how well your navigation functions until you watch an objective audience interact with it. The question is: Do you want that moment to be after you go live on the Web or after you've developed the first prototype of your interface?

Begin testing as soon as you have something viable, even if it's just some sketches on paper. You don't need a large group to test your navigation. Try to find people who fit the description of your target audience and *who are unfamiliar with your navigation*. This is key: You don't want to use people from inside your development team who have seen the navigation before.

Decide what you want to learn from a test. Prepare tasks for the test users to complete, such as buying pieces of merchandise within three clicks or finding out your store hours.

Make testers comfortable in a quiet place. Get someone else to record their reactions so you're free to watch them. Don't lead them through the navigation. Ask them to perform the tasks you've prepared. You'll often be amazed by what they do and what you'll learn as they wend their way through what you believed to be a completely self-explanatory navigation.

Here's an example of a disaster that could have been avoided with simple testing. A company once posted articles on international sales issues on the Internet, which displayed visitor comments. In other areas of the site, visitors were invited to post comments on the articles, but when they went to the article page, there was no mechanism available to post comments. The problem was that the option to post comments only became visible after visitors became registered members of the site and logged in. There was no notice or instruction to that effect in the navigation, and angry and frustrated visitors felt as if they had wasted their time while at the site.

Before beginning testing, you should also make sure that all your labels are clear. Each label should be as unambiguous as possible so that visitors will know where labels will take them.

As you conduct user testing, make sure testers understand you have no emotional investment in the site and they won't hurt your feelings if they're critical or frustrated. People in user tests may try as hard as they can to succeed at the tasks you set for them. Let them know it's okay to fail. Remember, visitors on the Web won't be trying so hard, instead, they'll be off to your competitor's site as soon as they encounter problems.

Don't instruct or disagree with a tester who complains or expresses confusion. In addition, don't tell them how to get back. Later, you can figure out a better way of showing them how to get back, but for now, allow the users' reactions to lead you to solutions. Except for providing users with tasks, be as quiet as possible. In site testing, the tester is always right.

Keep in mind that testing is not just to find flaws. Listen to your testers as they make suggestions such as:

- ▶ "I didn't see it. It should have been grouped with those other buttons."

- ▶ "Those choices would be clearer if they weren't in a pull-down menu."

- ▶ "I wish there was a reset option here."

If you find that you need help before or while conducting user testing, you can seek support from companies that do nothing but usability testing. A quick Web search for "usability" or "user testing" will reveal volumes of useful information on this invaluable tool.

User testing is an ongoing process, and you should test several times during the development cycle. Test your wireframe sketches, your digital model, and several times before the site is posted on the Web for everyone to see. And you can continue to test after your site has gone live. In fact, it's possible to get statistics on what paths your visitors followed and what choices they made. Web statistics are a gold mine of information about what's popular on your website and what's not.

Testing your navigation is like honing your sales technique. It pays off.

Sketching

Even if you're surrounded by an array of technology, a pencil with a good eraser can be one of the most useful tools you own when constructing a website. It can be used to help you determine what to place on your site, how to group it, how to label it, and what a rough layout of the site might look like.

With your pencil in hand, start by thinking about your target visitor. Draw an oval in the center of a piece of paper. What are the things that visitors could possibly want? Draw arrows from the center oval to surrounding ovals and write visitor goals in them (see below left). The surrounding ovals are not labels but just loose descriptions, and at this point they don't have to be organized or grouped. Simply

include every visitor objective you can. Of course, also include things you want to present but put it in the form of a visitor request. For example, a restaurant owner wants to offer a complete menu, so the owner draws a "read the menu" oval.

When your group of circles is as complete as possible, try to identify what goals naturally go together. For example, in the sketch shown below left, when visitors view products they should be able to buy them, so "buy products" naturally goes with "view products."

Often, certain elements will jump out as choices that should be on every page of your site—for example, the option to "view items in the shopping cart."

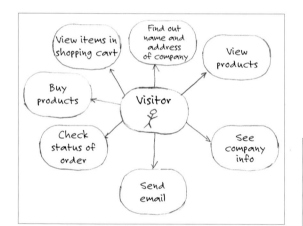

≫

Think of as many visitor goals as possible, and add one oval to the circle for each goal. The ovals in this sketch are just a start. When the circle of goals is as complete as possible, choose the most important ones as your first description of main navigation, and then look for goals that can be grouped under your main navigation as sub-navigation.

≫

Sketch all the tasks visitors have to do or might want to do when purchasing a product. These are just a few examples of the steps a customer might take; customize the sketch to the needs of your own customers.

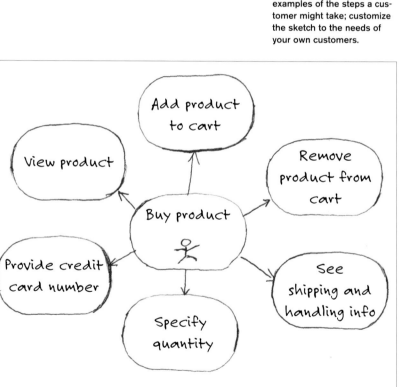

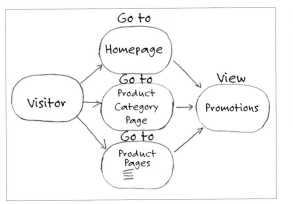

«

A sketch can help you map out paths to website elements. In this sketch, you can see that "promotions" can be reached when visitors "go to" the homepage, the "product category" pages, and selected product pages.

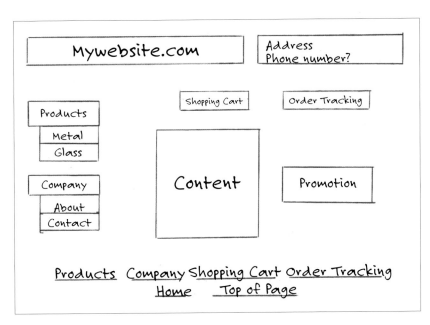

«

Sketch out a simple version of your navigation to see how elements might go together and to test early versions. This is not a plan for the graphic design of your site—that comes later. This type of sketch helps you form an initial concept of how your website might be structured.

Once you've sketched out some goals, you can use the same process to identify individual visitor goals. Examine the sketch on the previous page that has "Buy product" in the center. Keep in mind that at this point, you're still just brainstorming and you're not establishing any structure or order. This process of sketching is like figuring out how many bedrooms a house will contain before the architect draws a floor plan.

In addition to helping you identify goals, sketches like this can be used to begin to describe the flow of your site. For example, you may have a "promotions" page, which is available from the homepage, the "product category page," and some individual product pages. A sketch, such as the one at the top of the page, could easily be used to show the relationship between these pages.

Once you have a general idea of the elements and groupings of your navigation, sketch some sample pages (above right). Here's where you can try out your initial choices for labels and menu groupings. These are not designs for the site pages, so avoid getting locked into any navigation or design too quickly. Remember that these sketches are just diagrams to help you determine if you've included the right choices and chosen the correct labels.

As mentioned, you can actually use these sketches to get feedback from visitors. Do they understand where the labels will take them? Can they perform simple tasks moving from one piece of paper to the next?

Why is this initial planning stage so important? As soon as you go through the process of radically modifying an HTML file, you'll begin to appreciate why you want to make all your initial corrections and adjustments with paper and pencil.

Site Maps

There are two kinds of site maps. The first type of site map discussed below is used primarily by website visitors; the second type of site map is utilized by the site designers to describe the website's overall architecture.

Some designers provide a page that is an online site map for visitors as part of their navigation; other sites include a simple list of links to pages on the site. In the following example, each one of the underlined options is a link to a page on the site.

Our Products
 Metal
 Wood
 Glass

Find Out More About We Do
 Meet Our People
 Experience
 Jobs & Opportunities

Online site maps can also be represented with very simple graphics. Whatever the structure and complexity of a site map, it should be limited to one webpage. In general, a site map is a simple tool to let the visitor find a link to the topic of choice, but because these maps are for visitors, simpler is better. Online site map labels can be slightly longer and more descriptive than normal labels. For example, a short navigation label such as "People" can be expanded to "Meet Our People" in the map.

An online site map complements a website's navigation but it is not a substitute for a site's overall navigation. Although some visitors find it convenient to scan a site map for a particular topic, it would be very difficult to jump from page to page using only an online site map. When planning your website, do not consider using an online site map as a substitute for any accepted form of navigation.

The other type of site map is a representation of the structure (or architecture) of your site and is a tool to help you understand the connections between your Web pages. A site map allows you to describe such procedures as login and to see where pages are located in the site's hierarchy. It also allows you to ensure that all necessary pages have been included and that each page is accessible. But unlike the online site map designed to help visitors access the site, this type of site map is for the development team only and serves as an excellent way to communicate ideas between team members.

Before creating your website, you should keep in mind that the site should be created from the site map and not the other way around. If you use a site map, build it before you build the site. Your site will probably be more organized and, in any case, it's much easier to change a map than it is a site.

In addition to providing useful navigation for your readers and development team, site maps have other benefits. After the site is launched on the Web, site maps can be historic records of its structure, and as the site evolves, each map and its update will become extremely useful references.

Several possible features of a site map are shown in the "Site Map Elements" (opposite page). It's important to note that this illustration is *not* a representation of a good website structure, but simply a demonstration of how you can use the features of a site map to document a site.

Each rectangular box represents a page. For more complicated sites, you might also want to label each page with information such as section location, its page number, and whether that page is a template for other page. Pages that are built from template pages are similar in all respects except content.

The pages that look as if they're layered on each other are template pages.

Don't be too concerned with how you get from page to page in a site map. This map notes that there are four options on the homepage and all of them are global: "products," "shopping cart," "company," and "order tracking." "Glass products" is not directly available from the homepage in this structure. You must be on the "products" page to access it.

The "tracking" section of the site requires a password to access it. The blue diamond shapes are conditionals. The right exit line is "yes" and the left exit line is "no." When visitors want to access "tracking," the system checks if they're logged in. If the visitor is logged in, it takes them directly to tracking. If the visitor is not logged in, the system asks if they're a member. If the visitor responds positively, the system asks for his or her password and then takes the visitor directly to tracking. That's just part of the explanation. Diagramming it in the site map makes the entire process much easier to build and understand.

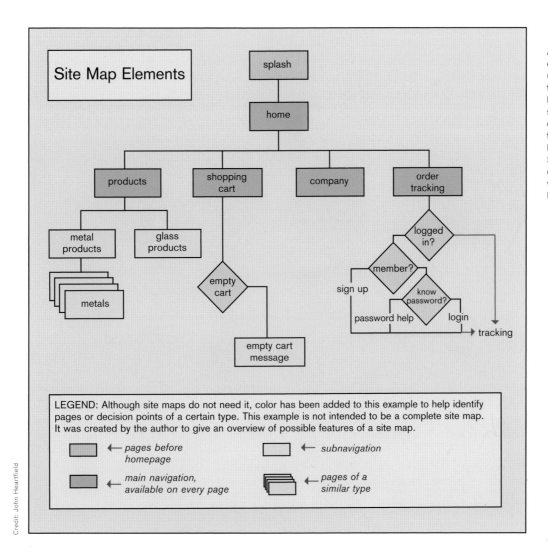

Site Map Elements

splash

home

products | shopping cart | company | order tracking

metal products | glass products

metals

empty cart

logged in?

member?

sign up | know password?

password help | login

empty cart message

tracking

LEGEND: Although site maps do not need it, color has been added to this example to help identify pages or decision points of a certain type. This example is not intended to be a complete site map. It was created by the author to give an overview of possible features of a site map.

← *pages before homepage* ← *subnavigation*

← *main navigation, available on every page* ← *pages of a similar type*

《

A site map is used by the development team to quickly understand the structure of the website. Each rectangular box represents a page in the site. The blue diamonds are decision points. A branch to the right means "yes" and a branch to the left means "no." Site maps are also useful for documenting the site and visually explaining processes like login.

Wireframes (Storyboards)

Wireframes are often referred to as "storyboards" and show the elements of a website page without graphic design. They can be as simple or complex as the site designer wishes.

Wireframes are extremely useful for constructing and documenting sites, checking the navigation elements on a page, and understanding how one page relates to another. It's not necessary to make a wireframe for every page on the site, but it's useful to have a wireframe for each page that's a template. Like site maps, wireframes are a great way of documenting a site's history and facilitating communication between members of the development team.

Graphic designers build pages from wireframes. If the person who builds the wireframe is not the person who is designing the graphics, make sure those people agree on the look of the wireframes. Of course, they'll want to agree on what notations to use in the wireframe (notations such as "CN" for content or "BN" for bottom navigation) but, in addition, graphic designers often feel a less-is-more philosophy is appropriate regarding the description of elements on the page.

The wireframe on the next page contains information regarding several aspects of the elements on the page. It isn't a design for the page or a layout of the elements. It simply describes what types of elements are found on the page. Elements such as navigation buttons are labeled as they would be on the website.

There is no right way of building a wireframe. The way you describe elements and the information you provide regarding those elements depends entirely on the size of your team and the nature of the information you want to document and share. For example, some developers like to document fonts in the elements of the wireframe. Even though the graphic designer generally chooses the fonts, sometimes it's convenient to be easily reminded what font parameters go with what element. If two months after launch, the designer has moved to Brazil, the developer can change a label or two knowing exactly which font (and its parameters such as size, leading, spacing, and color values) was originally used.

Instead of using specific notations, some developers like to use different shapes for global navigation elements, subnavigation elements, text content, or options. On the wireframe shown, the developer has used a simple convention to denote that the "choose language" option is a pull-down menu.

Although a wireframe is not a page layout, the grouping of page elements should be illustrated. The wireframe example shown here indicates that "shopping cart" and "order tracking" are part of the same logical group and should be located in the same prominent area of the page.

Don't overlook the creation of a wireframe when you're building your website. The site map is a map of your entire site, but wireframes are maps of your most important Web pages.

》

A wireframe, or storyboard, shows the content, functional, and navigational elements offered on Web pages, especially ones whose form will be repeated over and over. Wireframes don't describe the layout or the design of the page. They show what elements are grouped together. Although font ID notes are shown for elements on this page, it's not wise to use too many fonts or font colors on Web pages.

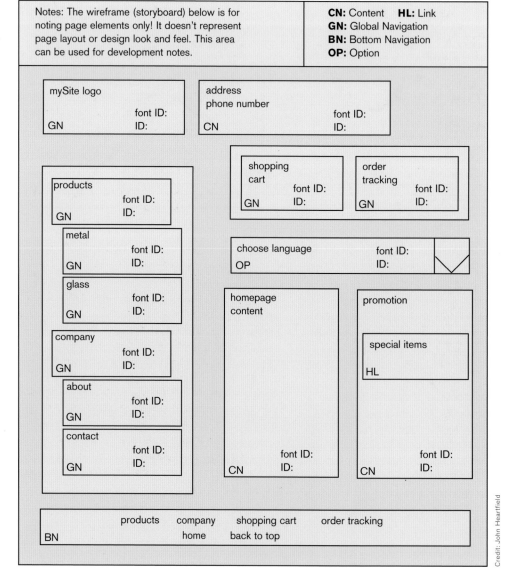

Credit: John Heartfield

Quality Assurance

The process of quality assurance includes all the steps you must take to ensure that your website functions in an optimal manner. Think of all the things that could go wrong on a website. Your visitors could choose navigation elements and get a "URL not found" error. Prices on your product (which can be updated quickly) might be entered incorrectly and you could be on the hook for some extreme bargains.

These examples represent noticeable problems, but less obvious factors could be costing you money as well. One of the biggest problems with small international websites that offer multiple languages is that they attempt to offer text and labels without the help of a native speaker. Even when you're posting text on your site in your own language, you must use a spell checker and have a proofreader other than yourself review it. If the text contains spelling errors or obvious grammatical mistakes, your site—and your business practices—appear sloppy.

Here's a real-life example of how errors in text can affect a company's image. One international leather goods site repeatedly confuses the English word "produce," which specifically describes fruits and vegetables, with "products," which can be any type of merchandise. In addition, the company actually compounds the error by using produce in the company's URL.

Fortunately, you can greatly increase the chances that your visitors will experience quality when they visit your site. When you build a site using software such as Microsoft FrontPage, Macromedia Dreamweaver, or Adobe GoLive, you can check for broken links. Check for broken or redirected links often and especially whenever you make changes. In addition, before your site is ready to be posted on the Web, get someone who is unfamiliar with the website to manually check every link and every piece of content. Wireframes are invaluable to help with this process.

Remember that quality assurance is not just testing if everything works at the end of the development process. It's a continuing process that begins on day one. Here are some pitfalls to avoid:

▶ Poor definition of goals

If your objectives are incomplete, confusing, or too general, your website project is headed for trouble.

▶ An unrealistic production schedule

Sometimes it's difficult to estimate how much time is required. Too much time and your team might become unfocused. Too little and the work will suffer. Try to give yourself a reasonable estimate and then add a quarter to a third more time.

▶ Inadequate testing

This is covered in the previous section on user testing.

▶ Too many features

An extremely common compunction after development is under way is to pile on new features that usually slow down production, require much more testing, and are often extraneous to the website visitor's goals.

▶ Miscommunication

If developers don't take the time to find out what customers need, a successful website would be a miracle.

As with visitor testing or user testing, there are many companies that will test your site and/or perform quality assurance. A quick Web search on the phrases "quality assurance" or "user testing" will reveal a number of companies. If you can afford it, you should hire one with good credentials.

A good quality-assurance firm will ensure your site is tested on computers running at least the most popular operating systems and browsers. Your site should be tested on slower connections to be certain your media loads within a reasonable period of time. The QA company should provide you with written reports on its findings and statistics. Quality assurance is an exacting discipline. Look for companies that have a proven track record; if possible, talk with former clients.

» PLANNING

When beginning a project such as a website, the impulse is to produce something tangible as soon as possible. Web developers must learn to resist that impulse. Instead, the planning phase of website development must be done patiently and thoroughly, with the understanding that revisions will have to be made throughout the process. Solving problems during the planning phase is easier and much less time consuming than at any other time.

If you're working as a team, the planning stage is the time to be sure you get everyone's input. Make sure all decision makers sign off on the plan before you begin construction.

The majority of the decisions that make websites work are made during planning. It's nearly impossible to create a cohesive site without first knowing your goals, knowing your audience, and having a carefully thought-out plan.

20

26

34

40

48

54

LILY'S JEWELRY

ack Pearls Hawaiian Heirloom 🛍 Shopping Bag

Dreamweaver ColdFusion Flash Fireworks

Exceptional Computer

Your Instructors...

Noble Desktop, LLC
594 Broadway, Suite 1208, New York, NY 10012

York St. Petersburg London Silicon Valley

GO Contacts Submit RFP

.NET Service Provide

RUI CAMILO

SPEKTRUM
STUDIO
E-POSTCARD

PORTFOLIO

STILLS
PORTRAIT
REPORTS
FASHION
PEOPLE
ENVIRONMENT

June 1st... It's our ONE YEAR ANNIVERSARY blow out. And
you know we throw a good party at the Kula. (check workshops)
July-Oct... Schuyler and Alison are leading 4 long weekend
getaways. It's better to get sweaty in the woods. (check retreats)

04.25.2003

TODAY'S CLASSES Thursday, May 8, 2003

10:00 AM 2:00 PM 4:30 PM 6:30 PM

KULA FLOW $14 drop-in
vigorous and uptempo asana party 5 class card $65 ($13/class)
 10 class card $115 ($11.50/class)
INSTRUCTOR

» KNOW YOUR GOALS

Do you ever wonder why there are so many bad websites? It's difficult to imagine constructing an effective website without determining and understanding its goals. If you don't know what you're trying to accomplish, how can you convey a coherent message?

Often, businesses decide to slap up a website because "everyone seems to have one." If they do take the time to identify goals, they may consist of, "Goals? I want to get up there and sell."

These are some basic questions to answer while planning your site's design:

► What is the mission or nature of my business?

► What is my most important goal?

Attempting to accomplish too many goals at once weakens the impact of your site.

► Why will visitors come to the site?

What does my site need to do to be an effective sales tool?

How can I convey the quality of my services in a compelling and convincing manner?

Why will people originally come to the site?

Why will they come back?

► What should this site do for my business in the short term? In the long run?

► Who is my target audience?

It's fine to have more than one audience, but try to determine the most important.

► What message do I need to impart to my target audience?

Write down the answers to these questions. It's unlikely that only one person is involved in creating the website, but even if that's the case, that person needs to be clear about why the site is being built. If several people are building the site, they all have to agree on the answers. One person should be responsible for ensuring the site fulfills the stated goals.

Your number-one goal should be to avoid unintentionally tricking or frustrating visitors. Give visitors constant, clear cues as to their location in your site, present choices in logical groups, provide relevant information regarding purchases, and make sure it all works with as much objective user testing as possible. You don't know if you've achieved your goals until you've seen a visitor making their way around your site.

Your Neighborhood Virtual Grocer

Client: FreshDirect **Web Link: www.freshdirect.com**
Design Firm: FreshDirect's in-house design department
Site Builders: Alvin Kwok, Neal Bayless

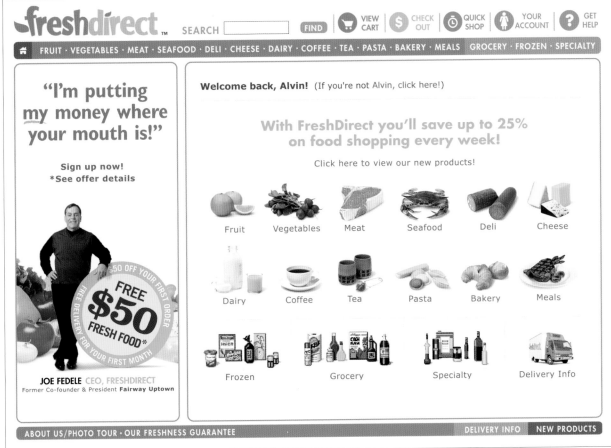

FreshDirect is a growing business, and one of the main reasons for this growth is its colorful, well-organized website interface. The company's mission is to deliver high-quality foods at a better price, but customers cannot physically walk into a FreshDirect location and see those delicious foods. The FreshDirect market exists only on the Web. Its order-preparation and delivery system promptly responds to orders placed by customers on their website.

FreshDirect went live in Manhattan in September 2002, after extensive user testing and test marketing. Alvin Kwok, chief creative officer and editor in chief, and Neal Bayless, executive producer, were there from the beginning and headed the team that built FreshDirect.

Home: The FreshDirect homepage gives visitors the impression that they have entered a bright, well-organized, and friendly supermarket. The owner is there to greet them with a great offer and they can begin shopping right away.

>>
Partial Site Map: It's essential for the design team to have a map to keep on top of a site as complex as FreshDirect. This partial map shows the main navigation and its relation to other pages, pages contained in the help section, and one example of the pages in a department.

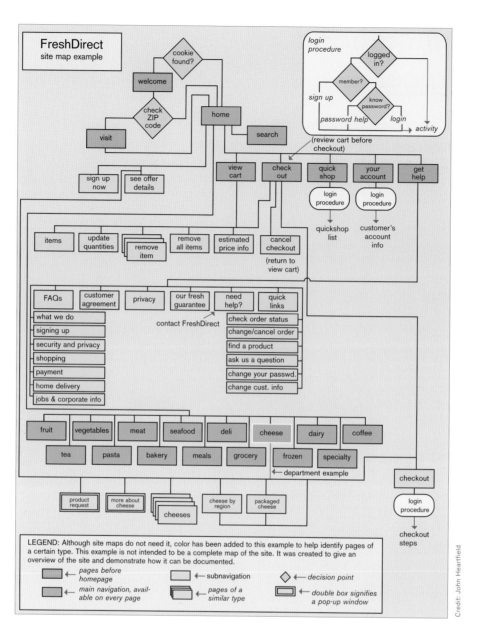

An Exercise in Problem Solving

"How could we get our customers to trust buying perishables such as fresh fruit, meats, and vegetables on the Web?" Kwok says. "That was our number-one priority. If you go to a butcher you've known for twenty years, you'll trust that person to choose a cut of meat for your family. How could we make an experience so educational, easy to use, and useful that they'd feel that same sense of trust about us?"

It was a problem that required a unique solution, given the product and service they had to offer.

"We did a lot of research in terms of hierarchy, product representation, and presentation," Kwok says. "At every step of the way, we tried to expand our own knowledge of the product and become advocates for

the consumer as well as the people who work here. The first thing you must understand is what you're trying to communicate," he continues. "Have a clear set of goals and understand the product as well as you can."

Much of that understanding had to do with accessing and presenting the food experts who work at FreshDirect. It was essential for the design team to become very familiar with the products and to learn how people interact with those products in the real world so they could incorporate those feelings into the site. They relied on their experts, who have spent many hours with consumers, to let them know what to communicate to their audience on the website.

It's All About the Food

It is immediately clear from the FreshDirect interface that the homepage navigation is true to the website's slogan, "It's all about the food." FreshDirect is very careful not to put its corporate content in the way of ecommerce.

The site is divided into two distinct areas, each easily accessible from the other, but each with a different goal. The first area the visitor encounters is the FreshDirect store, a carefully organized shopping experience that offers various food departments in logical groupings. These department hyperlinks appear both in the consistent top navigation section and as the major content of the homepage. Two less prominent links lead visitors to a guided corporate tour of FreshDirect.

In the virtual store, the visitor is shown five intuitive icons that are also identified by text in the top of the global navigation section. This is a good way to use icons, and it's important that when icons are presented in this manner, the icon and the text that identifies it are both active.

These icons were determined to be the five most valuable choices for visitors to FreshDirect. Two are especially noteworthy: "QuickShop" lets a visitor reorder a previously filled shopping cart with a minimum of clicks (see below right). "Get Help" leads to an orderly help section that offers frequently asked questions (FAQs), Quick Links, and, finally, a direct contact number for FreshDirect.

Keeping Visitors Informed

One of the most thoughtful components of FreshDirect's interface is a gray message that stands out at the top of every page and reads, "Home Delivery Is Not Currently Available In Your Area." This message appears if your residence is not currently in the FreshDirect delivery zone and clearly illustrates how much the company cares about its visitors.

"Displaying information regarding access to services on a regional site is critical," Bayless notes. "You must be clear about setting expectations about what visitors can and cannot get from the site. Otherwise, the risk is too great that you'll end up frustrating them."

Directly below the five main navigation icons are fifteen choices for the different FreshDirect departments. Although many interface designers believe that generally, navigation menu choices should be limited to no more than seven per section, FreshDirect did extensive user testing in this case and made a winning decision to bend the rule.

For example, rather than make "Cheese" a subnavigation choice of "Dairy" to limit the main navigation choices, FreshDirect decided that enough people would want to go directly to the cheese section. Therefore, they offered "Cheese" as a main navigation option and placed it next to "Dairy" in the main navigation menu.

⩔

QuickShop: Some interface design problems appear simple until navigation designers try to solve them. How does QuickShop simplify the process of reordering groceries? Their solution is that all the items a customer has ever ordered are already in QuickShop. Straightforward instructions inform the customer how to remove items from QuickShop and add what remains to the check out cart. Because the customer doesn't add items to the QuickShop list but only to the shopping cart, confusion is avoided.

≪

Seafood: FreshDirect knew it was important to make their website engaging as well as functional. Their seafood expert holds a giant claw. A chef offers guidelines on seafood preparation. These features, highlighted in the navigation, are designed to reinforce the belief that FreshDirect is passionate about food.

Making It Real

If visitors want apples, they can quickly see all the apples FreshDirect offers as well as those they do not. All of the food on FreshDirect is photographed with the goal of whetting the visitor's appetite. Rolling the mouse over an apple (below) playfully slices it in half for a view of the interior. Visitors can make a selection, click on a type of apple, choose the quantity desired, and make the addition to their shopping cart.

In specialty sections, such as seafood and meat, visitors are guided though a longer ecommerce process, but each step of that process is designed to reinforce the message that FreshDirect is committed to giving the customer the same types of choices they'd experience in a real market.

At first glance, there seems to be a fair amount of duplication in the hyperlinks on each FreshDirect page. For example, after choosing "Whole Fish" in the "Seafood" department, two hyperlinks for "Seafood" appear practically next to each other (opposite page, left).

FreshDirect can pull this off because the navigation groupings are logical, consistent, and laid out extremely well. Once you start shopping at FreshDirect, you quickly begin to appreciate the colorful food photos on the right and the useful lists on the top and the left that duplicate those choices.

"We want the user to have as many options as possible without confusing them." Kwok says. "Visual display of each product is important. You might want a brown pear but you don't know what's it's called. At the same time, if you know the name of that pear, you can just choose it from the alphabetized list."

»

Fruit: Customers may not remember how a Golden Delicious apple differs from a Granny Smith. So FreshDirect provides them with a visual selection. There's also a playful aspect to this screen. Rolling the mouse over an apple slices it and displays a cross section.

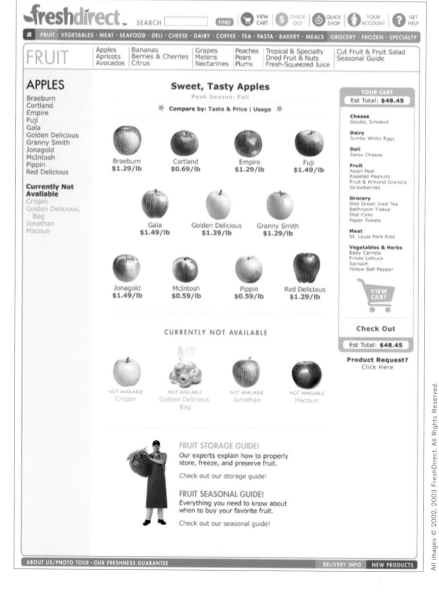

PLANNING ORGANIZING PRESENTING

«

Whole Fish: In a website with so many sections, it's essential to let the visitor know their exact location and give them options to quickly move to other areas. Deeper in the navigation, FreshDirect offers consistent choices in a dependable layout.

Defining Website Elements That Work

Another interesting aspect of the FreshDirect interface is the absence of visual cues on the rollover of many key navigation elements.

"Once again, this had to do with balance," Kwok says. "Don't misunderstand me, I'm a strong believer in established practices, but the download time for the amount of images we'd need for these rollovers was a bad trade-off. In our design, we decided the browser's hyperlink hand was sufficient feedback for visitors."

"Of course, we made sure to prove that with testing," Bayless adds. We did extensive formal and informal user testing. We watched users interact with our design and often we could tell what had to be adjusted even before they made their comments."

When asked if they had studied other sites during the design of FreshDirect, Kwok replied, "We did and we still do. In fact, we didn't just study sites in our industry but also sites that related to shopping where users made a great deal of choices, such as companies that sold office supplies. Seeing how other professionals handle similar interface problems is invaluable."

By allowing the visitor to own the online shopping process, and by highlighting FreshDirect's experience in all aspects of their product—from how an apple tastes to how a fish fillet might be prepared—the FreshDirect interface informs the consumer, "We know food. Trust us to choose the same quality you would for your family."

» SELLING MERCHANDISE

During business hours, someone is always available to serve the customer at your company's physical location. On the Web, your navigation is your sales team. Consistently selling merchandise on the Internet is mainly about avoiding sales disasters in your navigation.

A sales disaster is an error or oversight that prevents visitors from making a purchase or causes them to get something they don't want. Sales disasters cause consumers to leave a site and not return. Almost half of all sales disasters occur because visitors cannot easily find an item or sufficient information about it.

Ecommerce sites lose a significant percentage of their customers because of mistakes in the navigation design of the checkout area. That's approximately the same percentage they lose because of pricing and delivery issues. Here's a list of common sales disasters in order of importance:

- ▶ Customers can't find an item.

- ▶ Customers can't get desired merchandise information.

- ▶ Customers are frustrated by poorly designed checkout.

- ▶ Navigation demands that consumers register before they can make a purchase.

- ▶ Navigation fails to display shipping and tax information.

- ▶ Navigation fails to display accurate information about availability.

- ▶ Navigation fails to provide clear options for adding and removing items from a cart.

- ▶ Navigation fails to clearly display prices.

- ▶ Navigation fails to provide delivery information.

- ▶ Navigation requires customers to provide too much personal information.

Strangely enough, visitors are more willing to give their home addresses than their email addresses because they don't want their in-boxes flooded with spam. If you want to send promotional material through email, make sure the option to refuse it is clearly shown. In addition, people do not like to provide their telephone number, and they especially don't want to provide personal information such as age, number of children, and income.

Although there are other ways to gather that kind of information about your Web audience, don't require them to provide it when they're about to make a purchase. Always require only the minimum amount of information you need in order to complete their purchase.

You Can Be What You Want

Client: Lily's Jewelry Web Link: www.lilysjewelry.com
Design Firm: Henry Kuo Site Builder: Henry Kuo

Welcome to Lily's Jewelry.

LILY'S JEWELRY

Rings Pendants Necklaces Bracelets Earrings Black Pearls Hawaiian Heirloom Shopping Bag

About Us Contact Us Delivery Return Policy

Lily's Jewelry, located in Honolulu, Hawaii, is a small, family-owned retailer that has been in business for twenty years. When the owners decided to expand to the Web, in addition to a new, relatively inexpensive way to increase sales, they wanted a striking Internet presence. They asked designer Henry Kuo to give visitors the impression that they had stepped into a luxurious jewelry store.

Kuo is a self-taught Web developer with a natural sense of navigation and space. "I've worked at three Web companies, all of them with extremely different takes on design," he says. "At one, usability was a key issue. Eventually I learned how to lay out navigations that made more sense. I wanted Lily's Jewelry to be trustworthy and easy to use. And, of course, the content had to be accessible."

Home: The homepage of Lily's Jewelry is a direct reflection of its designer's philosophy: "Simple. Easy to understand. I design with the user in mind."

Focus on the Merchandise

There are only two pieces of text above the main navigation area—a small "Welcome to Lily's Jewelry" in the upper right and the company logo in the center of the page (see previous page). As a subtle animation shifts on the homepage background, ample images of jewelry slide in and out of view.

It seems natural to click on the images when they pause for a moment, especially because the cursor changes to a hyperlink hand upon rollover. Even so, it might have been helpful to provide some visual feedback that more information is available on the items on the "Merchandise Info" page (opposite).

That screen is an outstanding example of product information and display in a small area. A large close-up of the item dominates the screen territory. This type of emphasis on product display is one of the best ways to prevent a sales disaster on your site.

To the right of the item is a short description with essential information including price, material, design, item number, and size availability. Providing key information is important but don't overdo it. Visitors are likely to be annoyed by paragraphs of specifications about a particular item.

»

Partial Site Map: This map shows the main navigation screens and the screens available from the merchandise Item # 07001 screen, one of the Hawaiian heirlooms. Because it is part of the main navigation, the Hawaiian heirlooms category page is, by definition, available from the Item # 07001 page, but the site builder also included an additional link to it. It is not necessary to note this in a site map, which is an overview of the structure of the site.

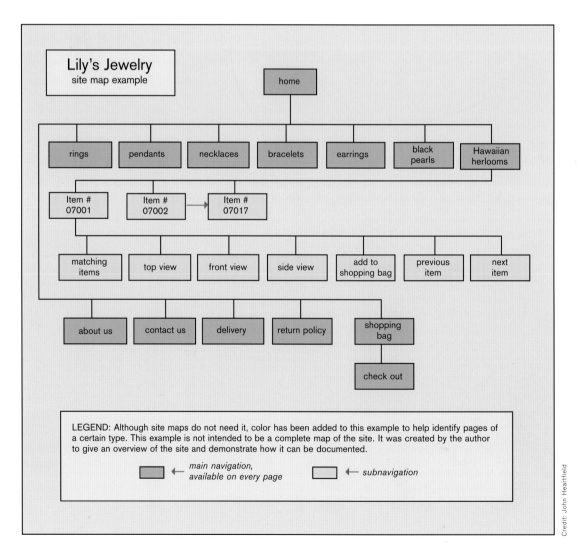

Credit: John Heartfield

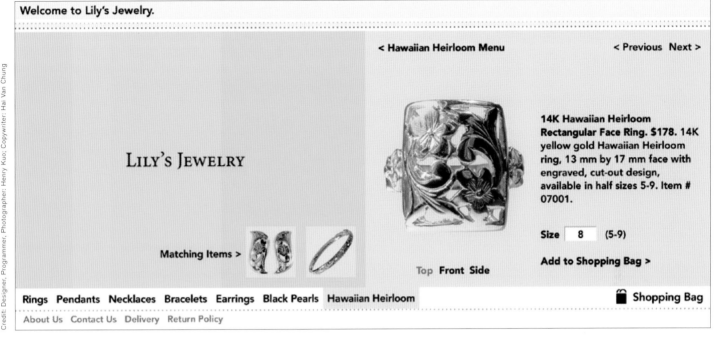

Credit: Designer, Programmer, Photographer: Henry Kuo; Copywriter: Hai Van Chung

The site immediately allows visitors to add items to the shopping bag and, where applicable, a text box is provided to enter the size. Next to that box is a range of integers that represents the smallest and largest sizes. If visitors enter an integer outside of the available sizes, the navigation will adjust it to the largest or smallest size. However, if the visitor enters a real number such as "5.6" or text such as "med" for "medium" the navigation doesn't handle it well. Always remember that visitors can't be expected to do what you think they'll do, especially with elements such as text boxes.

"I could have programmed it so the input box wouldn't accept anything other than integers," says Kuo. "But I decided that anyone buying an expensive ring on the Internet would know about something as basic as ring sizes. Plus there's a system in place to inform the buyer about missing or erroneous information in an order."

For many items, the visitor may choose a top, front, or side view by rolling over those choices. This is a great feature that is easy and intuitive to use. The "previous" and "next" options cause the items in a category to fade into view. Fade in and fade out are commonly used Flash features, but they slow down the appearance of the items. Website builders should generally assume that visitors want content as quickly as it can be delivered.

On the left, the "Hawaiian Heirloom Menu" takes the user back to the category page, grouping merchandise of the same type. Therefore, "Hawaiian Heirloom Menu" has the same functionality as the "Hawaiian Heirloom" choice in the main navigation.

Kuo added "Hawaiian Heirloom Menu" to the "Merchandise Info" page (above) because "it's an inconvenience to move the mouse all the way back to the bottom left to view the category page again." Providing duplicated options in a screen area where the user is currently focused can work as a design choice. Confirm your design choices with user testing and don't overdo any particular idea.

A "Return to Hawaiian Heirloom" option might have been a better label since "Hawaiian Heirloom Menu" implies a different destination than "Hawaiian Heirloom."

The owners decided to add "Matching Options" after the design for the screen was complete. One benefit of Kuo's economical use of space was that it allowed him to find a convenient and logical space to place these thumbnails.

≪

Merchandise Info: There's a wealth of options and information on this screen, yet the element that stands out the most is the jewelry. On the Web, when you display your merchandise in the best way possible, you'll increase your chances of selling it.

Don't Reinvent the Navigation Wheel

Kuo found the inspiration for his main navigation after browsing competitors' sites. "We checked out several sites, especially ones that specialized in Hawaiian jewelry. We studied how they laid out their navigation, what kind of functionality they offered, and how they photographed their products. Most organized their sites by jewelry type. That made sense to me. We thought about also organizing the jewelry by price, metal type, or gems, but that would have added a lot of complexity to the navigation."

Kuo placed the company information option ("About Us," "Contact Us," "Delivery," and "Return Policy") at the bottom of the screen so that when they were chosen, information could be displayed underneath and not intrude on precious screen territory.

To access content on the Web, visitors can click, drag, or roll over elements, pull down menus, type into text fields, and more. Although there are valid reasons for offering every type of input element,

you must be careful to choose the correct ones for your navigation scheme.

Clicking offers stability since the information usually remains visible ("on") until visitors choose another option. Rollovers are convenient because information can be turned on and off automatically. For the company information options, Kuo chose rollovers.

"I tried it with mouse clicks, but rollovers felt better. The content is fairly minimal, so I felt it wouldn't be too disturbing if a user errantly rolled over a label. With rollovers I didn't have to be concerned about the best way to make the content invisible again after it was displayed."

Above the company information options, a category option such as "Rings" takes the visitor to the "Category" page (below). When the visitor rolls over a particular ring, the navigation displays its name and price. A mouse click on an item takes the user to the merchandise info page discussed earlier.

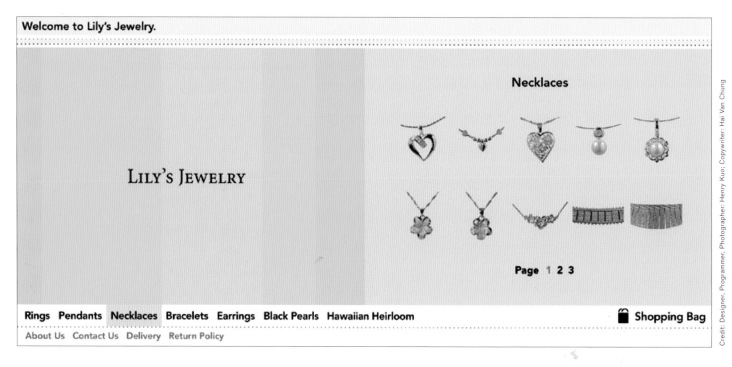

Credit: Designer, Programmer, Photographer: Henry Kuo; Copywriter: Hai Van Chung

Category: The "Category" page of Lily's Jewelry classifies merchandise by type of jewelry— probably the most important grouping to the consumer. Product hierarchy and cross referencing are often appropriate in category pages, but in this instance it's unnecessary and the "Category" page is beautifully simple.

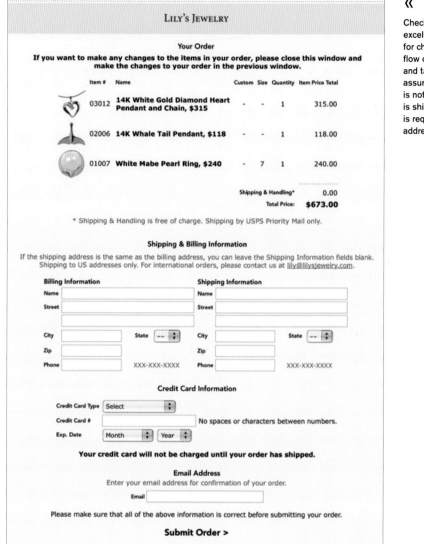

Credit: Designer, Programmer, Photographer: Henry Kuo; Copywriter: Hai Van Chung

《

Check Out: This screen is an excellent single-page layout for check out. Examine the flow of information given and taken; the customer is assured that the credit card is not charged until the order is shipped and no registration is required except an email address to confirm the order.

Checking Out Purchases or Checking Out of the Site Forever?

There are problems to solve in any navigation. For example, how do visitors know their choice of item has been successfully recorded? Many ecommerce sites update that information on the same page. However, part of the charm and elegance of Lily's Jewelry is its minimalist design. Kuo decided that a simple solution would be to move visitors to the "Shopping Bag" page every time an item was added. Because the target audience for Lily's Jewelry was unlikely to make a great number of purchases per visit (as opposed to a record store or a food market), Kuo's solution works.

Another challenge Kuo faced was how to handle the final check out. "I coded the check out process in CGI because customers enter sensitive data, like credit card numbers. I could have easily coded it in Flash,

but I wasn't sure if people would be comfortable offering their information through the Flash medium, so I used CGI programming to make check out secure."

When visitors check out, the navigation launches a new browser window (above). Kuo clearly informs customers they have to close the check out window and return to the "shopping bag" page to make changes in their order. By gathering only essential information and displaying important facts regarding orders, the undemanding check out window avoids the most common sales disasters at the check out counter.

Visitors who come to lilysjewelry.com can browse through exquisite pieces and make purchases when they find jewelry that's made for them. The site is a stylish, useful display case for the beautiful merchandise it offers.

»

This is not a page layout but an illustration of the type of elements that make sense on a business homepage.

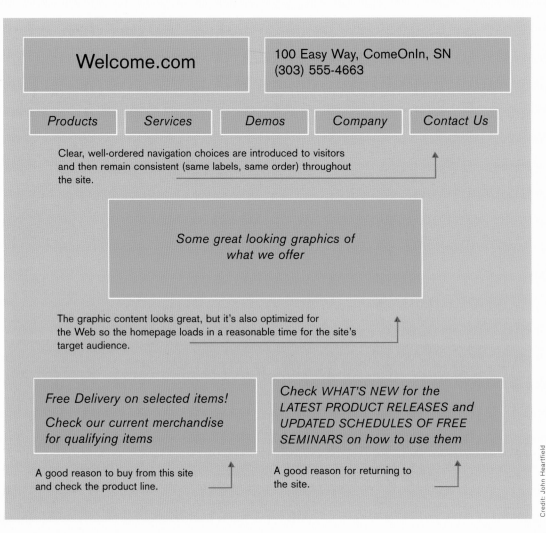

Welcome.com

100 Easy Way, ComeOnIn, SN
(303) 555-4663

| Products | Services | Demos | Company | Contact Us |

Clear, well-ordered navigation choices are introduced to visitors and then remain consistent (same labels, same order) throughout the site.

Some great looking graphics of what we offer

The graphic content looks great, but it's also optimized for the Web so the homepage loads in a reasonable time for the site's target audience.

Free Delivery on selected items!

Check our current merchandise for qualifying items

Check WHAT'S NEW for the LATEST PRODUCT RELEASES and UPDATED SCHEDULES OF FREE SEMINARS on how to use them

A good reason to buy from this site and check the product line.

A good reason for returning to the site.

Credit: John Heartfield

First Impressions–Elements of an Effective Homepage

Your homepage introduces visitors to your site and becomes the central location they return to as they explore. It's your storefront on the Web–the place where you welcome visitors and expose the major themes of your site.

When you offer that critical first impression, will your homepage greet visitors appropriately?

Appropriate

▶ The company's name, address, phone number, and type of merchandise or service offered

▶ Logical groups of navigation options that remain consistent throughout the site

▶ Navigation labels that acclimate visitors to your site and remain consistent throughout the site

▶ A picture, testimonial, or sample that shows why your company is outstanding

A small hotel in the Caribbean shows guests swimming with dolphins.

▶ Special offers currently available, especially ones for Web customers

▶ Data about your business that changes frequently and is of interest to your target audience

If your homepage is a resource for your customers, you'll dramatically increase the amount it's accessed (hits).

▶ A search text box, if possible

Use a text box identified as "Search" and not a search option button or label since text boxes are more likely to be used. Use an expert to ensure your search handles misspellings and returns useful results.

Inappropriate

▸ Any sound that cannot be completely controlled by visitors

A general rule: Don't play sound without visitors' consent. Sound is risky because unwanted or unpleasing sound drives visitors away.

▸ Large graphics or animation files that make visitors wait for the page to load

▸ Long, unbroken text about your company

If your homepage requires text, offer small, clearly delineated sections regarding important information about your product or showing why your service is valuable.

▸ Too many navigation options caused by not layering the choices appropriately

Too many choices confuse and frustrate visitors looking for a specific option.

▸ Extraneous data that doesn't relate directly to why your visitors need your site

Don't overload visitors with information they don't need to know.

MoveAlong.com

Hope you're enjoying our company jingle that began playing when you arrived, and is looped for your listening pleasure

Don't play sound without visitors' consent and always make sure they can easily control sound. Always provide a clear no-sound (mute) option.

MoveAlong.com is the BEST store on the web. We are NEVER undersold!

Web consumers are generally too savvy for this kind of hyperbole and it's likely to make them distrust you.

Products	Services	Demos	Company	Contact Us
News	Offers	Refurbished	Location	Games
Bill's Corner	Services	Screensaver	Mailing List	Online Store

Too many options in no logical order frustrate visitors looking for a particular choice.

Some great looking graphics or animation that takes a long time to load on a fast connection

Avoid paragraphs and paragraphs of text. Limit text on your site to the minimum necessary to inform visitors. In general, the Web is a visual medium.

Photos of Bill's latest vacation!

Bills attempt to "personalize" his website and provide "graphic" content distracts visitors from the site's goals.

Credit: John Heartfield

≫

Even though this is not a page layout, notice how the number of navigation options included in this illustration makes it appear cluttered. Every practice noted in this illustration is highly discouraged.

Mistakes

▸ Not providing a clear link to your homepage on every page of your site

If visitors get lost, your homepage is a reliable starting point for the navigation. Visitors should always be able to return home by clicking on a hyperlinked company logo or a main navigation option labelled "Home." Bottom navigation should include a link labeled "Home."

▸ Filling every inch of the screen with content or navigation

Many business owners make the mistake of thinking it's necessary to put every fact on the homepage. People who surf the Web are used to hyperlinked material. Expose your content appropriately.

▸ Changing the order of main navigation options between the homepage and subsequent pages

▸ Describing your business with any of these words: unique, best, always, never, most, only, first, biggest, smallest

▸ Making your URL an animation splash page that can't be easily skipped by the user

When a splash page is included, a clearly visible "skip intro" option must be included. Don't force visitors to watch any animation

When building your homepage, imagine a customer is strolling past your business. What do you want them to see? Let them know who you are and what you offer in the quickest, clearest, and most attractive way possible.

» SELLING SERVICES

A basic principle of selling products on the Web applies to selling services as well—the first service they'll encounter is the service provided by your website navigation.

In the minds of visitors, an organized, friendly website translates into a business that provides professional service in its own field. If the navigation hasn't been well planned in advance, it would be miraculous for the final result to be organized.

Naturally, you want to advertise your business. But, more importantly, your site should be a resource for potential customers and should include some great examples of your service. If your company runs a dance studio, have a clear navigation option to a short dance lesson. If your service is a language school, offer a page of translations for common phrases and idioms.

Demonstrate expertise in your field by providing links relevant to your services. For example, a scientific equipment store might provide a link to an educational site that specializes in microscopes. When you do provide links to other sites, don't forget to have them open in a new browser window so your site window is still open and available.

If your business has a physical location, or more than one location, make sure visitors can always access all of your addresses and phone numbers.

In addition, a visible and convenient email address is mandatory. Another helpful feature is providing a clear map to your service and/or a link to a map site such as Expedia or MapQuest. Once again, whenever you link to another site, launch the site in another window.

Let visitors know your hours of operation. If your services are offered on a schedule, it's important to include a clear, easy-to-locate schedule. Clicking on items in a schedule for more details is very common, and when navigation practices become common, it makes sense to adopt them.

If your business involves a great deal of interaction with the public, include the best picture you can of yourself and/or your employees. When your store is attractive, show it. Pair those photos with professional data but avoid revealing personal information.

In general, strive to provide the information that visitors want, not what you think you should tell them. You should also give your visitors a reason to return to your site again and again. As with any website, keep the navigation clear, and make your service the focus of the website, not your navigation.

A Lesson in Selling Services

Client: **Noble Desktop** Web Link: **www.nobledesktop.com**
Design Firm: **Noble Desktop** Site Builders: **Scott Carson, Moneta Ho**

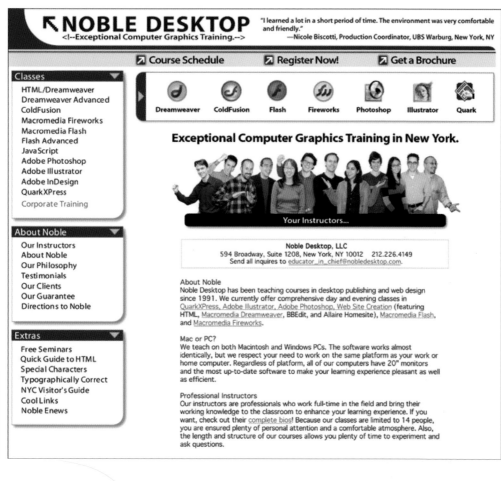

《

Home: Noble's homepage is an excellent example of how to offer a great deal of options and still keep the navigation from appearing cluttered. Each logically grouped set of choices is encapsulated in a distinct area of the page. The groups on the left under the headings "Classes," "About Noble," and "Extras" are more available and usable than if they were contained in a pull-down menu.

Noble Desktop has been offering on-site training in popular multimedia tools since 1991. In the mid-1990s, Noble stopped advertising in local newspapers, but the company kept growing.

"We get the majority of our new business from the site," says Scott Carson. "Since its debut, we've seen a steady increase in business. When people sign up for our classes, they often cite our site design as the deciding factor in their decision. There are a lot of computer training companies out there, but very few well-designed sites. If a training company can't present its content clearly and effectively, how is it going to teach difficult concepts?"

"The navigation is very specific to the type of website and its goals," says Moneta Ho. "Our site has to be quick and effective. It's vital for users to be able to tell where they are in the navigation and be able to rapidly get to other places in the site."

Noble's target audience was potential students and because that covers a large demographic, the site builders felt that the best way to accomplish the site's goals was to create a simple design that would load quickly and could be printed easily.

A Sum of Parts

There's a great deal of information on the homepage, but it's separated into well-defined areas. On the top left is an animated gif next to the Noble Desktop logo. On the top right, animated text offers endorsements from former students.

The decision to animate text must be made carefully. Many visitors find moving text to be distracting or unreadable. Noble Desktop presents the animated text both as an accent and as a way to draw the visitor's eye to endorsements. In addition, potential students may want to see some zing on a training company's homepage, and the animation is a way of demonstrating a simple technique.

Three options stand out at the top: "Course Schedule," "Register Now," and "Get a Brochure." Usage stats from Noble's previous site indicated that "Course Schedule" was the most frequently chosen option; "Register Now!" and "Get a Brochure" were logical complements for it. The labels for these choices are the largest on the page and a distinctive group icon emphasizes them further.

Directly below them are labeled icons for the most popular classes. Noble wisely uses the same icon for the software as the companies that manufacture the software. Remember that any time material protected by trademark or copyright is used, the owner's permission must be granted.

»

Partial Site Map: Noble Desktop offers a great deal of main navigation options, but they are so well categorized that visitors should have no problem finding the information they want.

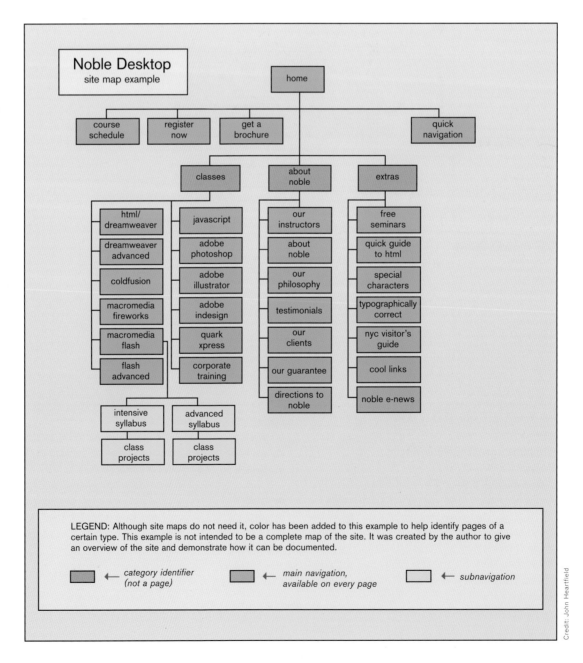

Noble Desktop
site map example

home

course schedule · register now · get a brochure · quick navigation

classes · about noble · extras

classes		about noble	extras
html/ dreamweaver	javascript	our instructors	free seminars
dreamweaver advanced	adobe photoshop	about noble	quick guide to html
coldfusion	adobe illustrator	our philosophy	special characters
macromedia fireworks	adobe indesign	testimonials	typographically correct
macromedia flash	quark xpress	our clients	nyc visitor's guide
flash advanced	corporate training	our guarantee	cool links
		directions to noble	noble e-news

intensive syllabus · advanced syllabus

class projects · class projects

LEGEND: Although site maps do not need it, color has been added to this example to help identify pages of a certain type. This example is not intended to be a complete map of the site. It was created by the author to give an overview of the site and demonstrate how it can be documented.

■ ← category identifier (not a page) ■ ← main navigation, available on every page □ ← subnavigation

Credit: John Heartfield

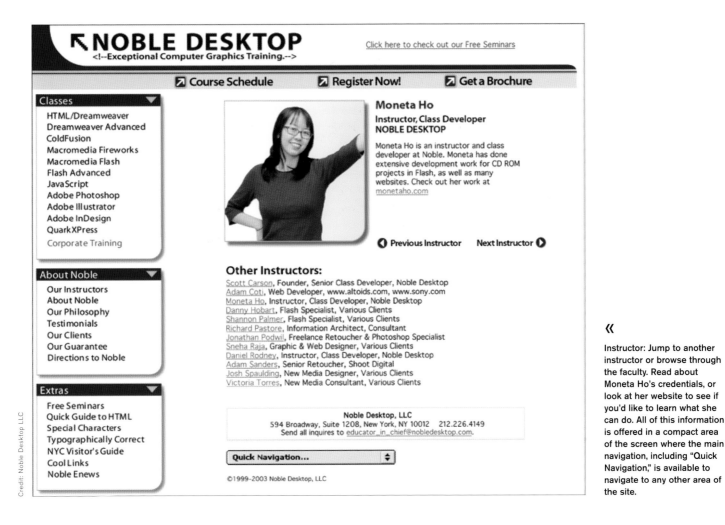

《

Instructor: Jump to another instructor or browse through the faculty. Read about Moneta Ho's credentials, or look at her website to see if you'd like to learn what she can do. All of this information is offered in a compact area of the screen where the main navigation, including "Quick Navigation," is available to navigate to any other area of the site.

Face Forward

In addition to a professional look, the homepage gives the impression of a fun, inviting place to learn. Centered on the page is a group photo of the course instructors. "New students tell me the reason they chose us was because the instructors looked so amiable," Carson says.

When the mouse rolls over an instructor, a line about the person is displayed directly below. Clicking on any instructor takes visitors to a page that is very similar to the "Our Instructors" page but contains a larger photo of the instructor and some additional information (see above).

"If you check all of the computer training companies out there, very few say who their teachers are," Carson says. "Instructor information builds trust in the students because they know the qualifications of the people who will be teaching them."

Because Noble Desktop is an on-site service, the company's address, phone number, and contact information are prominently displayed under the instructors.

To the left are three boxes that divide options into three logical groups. The first group, "Classes," offers hyperlinks to all the available classes. The second group, "About Noble," provides information about the company. The third group, "Extras," identifies value-added options that relate directly to the company.

How to Get Bookmarked

Some of the options in the "Extras" box include a "Schedule of Free Seminars," "A Quick Guide to HTML," "Special Characters," and "Typographically Correct."

Any of these options might cause visitors to bookmark Noble as a resource. Site builders should strive to offer resources that are directly associated with the company's services in order to encourage return visits.

The same concept is apparent on the "Directions to Noble" page where there's an excellent map with driving directions, a detailed subway route, and options for out-of-town visitors, such as "Where to Stay," "Places to Eat," "Sights to See," and "Evening Entertainment."

Designing with Change in Mind

The Noble website is designed to be updated as fast as changes in the industry occur. The navigation had to be easy to change and expand because the company often changes and expands. Noble built the menus in a modular format so options could be easily added or deleted. In other navigation systems that rely on multiple graphic elements, such as buttons, icons, or images, each update involves lengthy Photoshop work and HTML recoding.

The ability to update the navigation extends to the atypical bottom navigation. A pull-down menu labeled "Quick Navigation" (below right) allows visitors to jump to any major page in the site. Adding another Noble course offering to the course group or "Quick Navigation" is as simple as adding an item to a menu.

This type of expandable navigation is necessary because Noble wanted to make the process of finding info and signing up for a class as quick and easy as possible. All associated options had to appear on every page so prospective students could get the information they needed. Therefore, the navigation drove the design more than anything else.

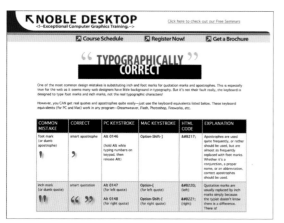

Credit: Noble Desktop LLC

≫

Typographically Correct: This is just one of several useful tips on the "Typographically Correct" page. It was a great decision to make this information fill the page to emphasize the typography; as a result, visitors will bookmark it for future reference. And when visitors return, they'll be on the Noble site with five key options available at the top of the page.

≫

Quick Navigation: Noble Desktop replaced the usual bottom navigation with "Quick Navigation," an easy way to jump to the many pages of the site, including the homepage. "Quick Navigation" functions as a site map on the bottom of every page and is a good complement to Noble's main navigation. However, this type of long list should never be used as the only navigation for any site.

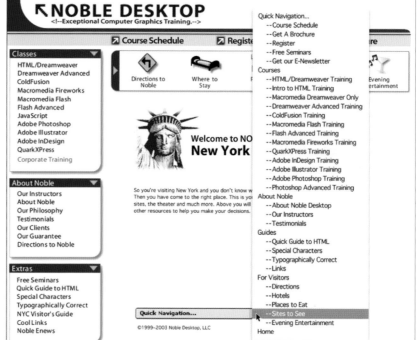

Credit: Noble Desktop LLC

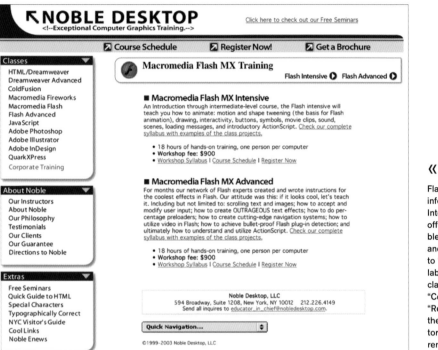

《

Flash Training: The complete information for two classes, Intensive and Advanced, is offered in the same accessible format. The placement and wording of the invitations to "Check our complete syllabus with examples of the class projects" are identical. "Course Schedule" and "Register Now!" are offered in the bullet points to give visitors those options without removing the focus from the class being outlined.

It's Simple for a Company That Teaches Flash

A company that teaches design and Web development cannot afford to frustrate visitors. Carson says, "Our ease of navigation and the clear presentation of our information draws the most comments from our visitors." Noble's direct and simple navigation is very successful in offering the shortest path to the content.

Simplicity is not limited to the navigation paths. Ho avoided metaphors because she finds most metaphoric navigation to be "unbearably hokey."

When Ho checked the competition, she also found that: "A lot of the other sites were much fancier—with Flash bells and whistles, for example—but we wanted to focus on reaching as broad an audience as possible. That meant keeping the navigation as straightforward as possible."

On the homepage, text should generally be kept to a minimum. On the Noble homepage, there are paragraphs of text that don't overwhelm the eye or make the page look cluttered because the majority of text appears below the fold and users can scroll to read what they like. Above the fold, it looks more like an integrated element of the design than a large text field.

"Aside from the obvious links to each class that we teach, I also included a long explanation of our business below the fold," Carson says. "If visitors scroll down on the page there's a complete sales pitch for our classes. Granted, it's very long and most people don't read it all. But for those truly interested in the company, it's the easiest way for them to get an overview without clicking to three or four different pages."

For example, clicking the "Macromedia Flash" option on the homepage takes the visitor to a page where details are provided about Flash training at Noble (see above). The price is clearly noted. After the visitor has decided, nearly every other option related to the Flash course, as well as all of the other courses, is only one more click away.

"Visitors are very impressed that we include examples of the work students do in class," Carson says. "These examples are key. They give potential students confidence that they'll learn what they need."

The best evidence that the site builders achieved their goal is that it doesn't seem necessary to have a search engine on a site that offers so much data. Visitors don't have to search for the content they need.

On the homepage, Noble Desktop claims that its instructors are "straight from the trenches of Web design." The company's wonderfully organized and easy-to-use website proves it.

» SELLING EXPERTISE

The Web audience is full of people looking for individuals and companies they can call upon for solutions to their problems. A small-business website should be a declaration of expertise. If your site helps to build your reputation as an expert in your area, then clients and customers will come to you—which is very different than approaching them as an unknown.

Your website should not just make claims about your expertise but also demonstrate your professional knowledge. To accomplish this, you must be willing to share at least part of that knowledge without a fee other than the potential benefit to your business. Your website may offer your knowledge in the form of free software (partial versions or products that expire after a reasonable time), evaluations, newsletters, articles you've written for industry websites, and so on. This advice is equally valid for websites that offer products. If a customer is attracted by your creativity and expertise, you are much less likely to encounter strong sales resistance.

The professionalism of your site speaks volumes about your experience and the way you do business. One quick tip to make your site more professional is to register the simplest, easiest-to-remember domain name you can. For example, if the name of your company is "vvv," and "vvv.com" is available, and you manufacture widgets, register "vvv" instead of "vvvwidgets." You'll still get people looking for widgets in search engines and people will be more likely to type in the correct address from your business cards.

Website builders may also diminish their site's professionalism by overlooking typographical errors and grammar problems. Be sure to spell check text and have a proofreader check it because very often, a writer won't catch obvious errors. Don't let your work appear sloppy.

In addition to offering your knowledge and ensuring your professionalism, consider other ways to demonstrate your expertise. Have you been in business an impressive number of years? Has your business been run by your family for generations? Do you have brand-name clients? Are you an officer of an organization related to your industry? Can you demonstrate how your business has grown?

When you've made a list, incorporate these points into the navigation of your website. You'll discover that every site is a story—except that rather than being told in a linear fashion from beginning to end, it is offered in small packets that visitors can pick and choose. It's your job to make those packets convincing and compelling.

To help you add knowledge and expertise to your site, there are some excellent Internet PR resources. Type "B. L. Ochman" or "Ilise Benum" into any Web search engine, and you'll find an array of resources to help you enhance your website.

If you don't sell yourself, you competitors will be doing the selling.

A Persuasive Website

Client: DataArt Web Link: www.dataart.com
Design Firm: DataArtStudio
Designer: Andrei Balashov, The DataArtStudio team

《

Home: The theme of time and how DataArt can help you manage it begins on the homepage. The bulleted text is an effective way to provide key information to visitors.

.NET is Microsoft's vision for an ideal online world that involves countless PCs, servers, smart devices, and Internet-based services operating together seamlessly. In this technologically cohesive environment, businesses exchange data, integrate their systems, and come together for comprehensive, customized solutions. Data speeds across devices, platforms, and applications whenever it's needed.

DataArt's website seeks to demonstrate the company's expertise helping businesses take advantage of the type of benefits .NET offers: better systems integration, cross-platform compatibility, and lower information technology costs.

»

Partial Site Map: It's impor-
tant to emphasize that the
site maps created for this
book show only parts of the
whole structure of the site.
Site maps can be individual-
ized for your specific needs.
For example, page number,
section, and/or template
number can identify each
page in the map. If color is
not use, some other visual
method can be employed to
group the elements. For
example, rectangles can be
main navigation and ovals
can be subnavigation.
Diamonds are usually used
for decision points. The
system evaluates whether
the answer to the question
in the diamond is "yes" or
"no" and directs the visitors
accordingly.

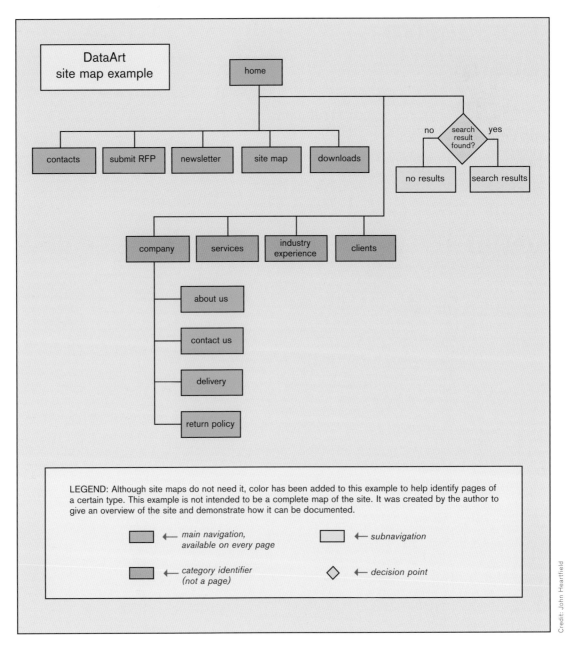

Time Is of the Essence

This mission begins on the homepage where a digital clock shows the number of hours of experience DataArt as a company has racked up since it was founded by Eugene Goland.

Time is a factor in almost all programming tasks, and time is also a thread running through the DataArt site. To the left of the digital clock are four analog clocks showing the time in DataArt's offices in New York, St. Petersburg, London, and Silicon Valley. The addresses and contact numbers for all offices are conveniently located at the bottom of the page.

The site's graphics, while not striking, are orderly, well spaced on a white background, and have a solid,

technological feel. In addition, because of the small file sizes of the graphic elements, the pages load quickly.

"We built this site to look modern, professional, and to deliver our message clearly. Our previous site failed to do any of that," says Eugene Goland. "We needed a site that clearly demonstrates that our services offer a competitive advantage. Our secondary goal was to offer visitors many reasons and methods to contact us."

In the center of the homepage is a persuasive list of reasons to choose DataArt. Each heading, such as "Technology," draws visitors to convincing bullet points.

Function and Content

DataArt arranged the navigation so that functional navigation ("Contacts," "Submit RFP," etc.) was on top and content navigation ("Team," "Technology Focus," etc.) was on the left. These options are global and remain properly consistent throughout the site.

The color choices for the content navigation menu might be improved. The slightly varied pastel colors of "Company," "Services," "Industry Expertise," and "Clients" don't seem to differentiate those headings.

Under three of those headings, the options are pale blue. Under "Industry Expertise," the subheading options are clearly a different color. Perhaps the intention was to make the options of "Industry Expertise" stand out, but because the subheading options are all at the same level, it might have been better to make them all the same color. If it was necessary for "Industry Expertise" to stand out, that could have been accomplished by making all the headings the same color and deepening the hue on that option. No matter how it's accomplished, some graphic redesign might be appropriate.

The "What We Do" page (below left) has cartoon graphics that draw the eye to important information. In areas such as "Development" there's a hyperlink to "Learn More." This is a good way of not overloading the page in places where all the information cannot be delivered in an appropriate space. It's better to offer a "Learn More" option than to continue with a great deal of text that would throw the cartoons out of balance and increase the horizontal size of the page.

The cartoons strike a fine balance. They are not so out of place that they clash with the navigation of the site, yet they are distinctive enough to draw a visitor's attention to that particular space on the page.

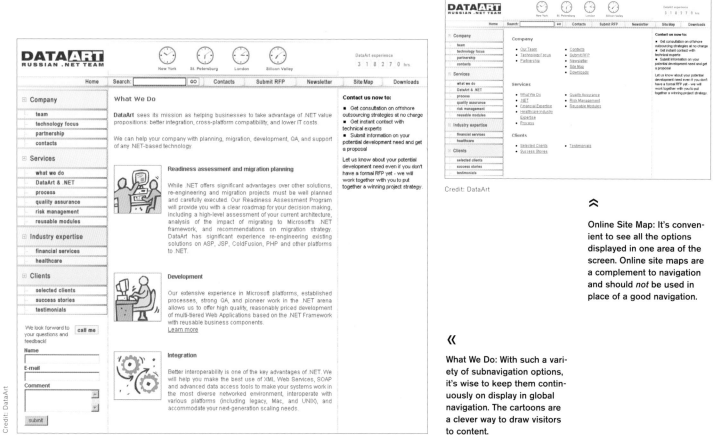

Credit: DataArt

Credit: DataArt

⌃

Online Site Map: It's conven-ient to see all the options displayed in one area of the screen. Online site maps are a complement to navigation and should *not* be used in place of a good navigation.

《

What We Do: With such a vari-ety of subnavigation options, it's wise to keep them contin-uously on display in global navigation. The cartoons are a clever way to draw visitors to content.

»

Quality Assurance: The "Price, Time, Functionality" triangle has been a standard in the software industry for quite some time. The key point to remember is that the three sides are interrelated. You cannot affect one side of the triangle without having some effect on another.

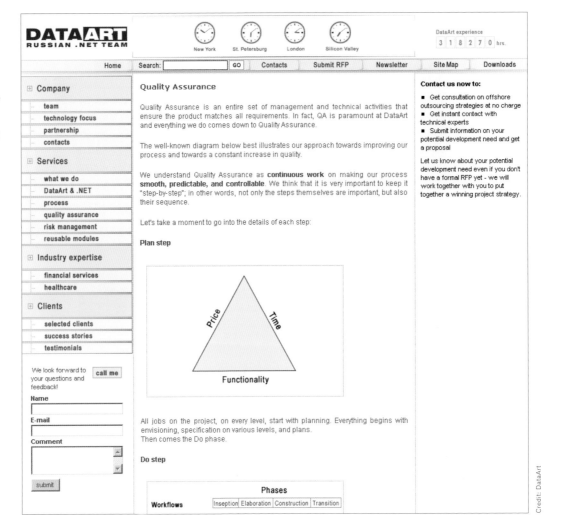

Credit: DataArt

Indexed Navigation

Goland believes that a great deal of DataArt's site is a balancing act. He says, "DataArt's main business is software outsourcing and consulting services. The problem is there are visitors familiar with certain concepts who want more concrete information and those who want just a basic overview. Uniting both approaches would appear awkward, so we mainly focused on the first group of 'prepared' visitors. That's our target audience because people usually find us in search engines or by referral and they know what they're looking for."

If they're looking for a way to get around the site, DataArt provides a top-level online site map (see previous page). Remember, site maps take two forms. One you build for yourself to help keep track of the general structure of the site, and the other is a tool for visitors. The online site map offered to visitors is simply an index of the hierarchy of the site.

The DataArt online site map is an indexed mirror of the functional and content navigation options. Because one of the design goals of the DataArt site was to give visitors the opportunity to view any page with one click without subnavigation menus that are hidden and revealed, there aren't many navigation options to reveal in this particular site map. Notice, however, that it is convenient to view all the options in one space.

Remember this rule: Do *not* make your main navigation look like an online site map because, although it allows visitors to visually search for a desired page in the map, it's a navigation that offers too many options for visitors to handle every time they want a new page.

Pushing All the Buttons

Quality assurance is well defined by DataArt as "an entire set of management and technical activities that ensure the (final) product matches all requirements." That means everything from making sure all the content is carefully spell checked and in the right place to clicking every option on the site to ensure it functions as it should.

On the "Quality Assurance" page opposite, DataArt displays the classic triangle diagram to describe the relationship between price, time, and functionality (or quality). Once again, DataArt recycles the theme of time, which is so important to those who produce software and those who purchase it. The simple, classic message that the three factors are totally interwoven and that increased quality demands either an increase in time or price just as increased time (to plan and design) can decrease price is one that should be memorized by anyone planning to build and launch a website. Displaying it helps solidify DataArt's claims of development experience.

What's Your Experience?

One of the first questions a visitor is likely to ask is: "Have you done this kind of thing before?"

The "Technology Focus" page below offers several breakdowns of DataArt's hours of experience and the precise type of intersection of "Industries" and "Technologies." For example, visitors can set "Industries" pull-down menu to "Government" and the "Technologies" pull-down menu to C/C++ and then generate a table. Visitors will note that DataArt has 2701 hours of experience doing C/C++ programming for the government.

"We knew this time we had to get it right," says Goland. "We had to make a great deal of complex information easy to access. We had to avoid terms that might scare visitors off. We didn't want to consume too much space in the working areas of the site."

DataArt did get it right. It's a website that's likely to convince visitors that DataArt has the experience and the expertise to deliver what it promises.

«

Technology Focus: On this page, visitors can find out how many hours of experience DataArt has in their type of project. It's an inventive way to answer the question, "How much do you know about what I need?"

DATAART
RUSSIAN .NET TEAM

New York St. Petersburg London Silicon Valley

DataArt experience
3 1 8 2 7 0 hrs.

| Home | Search: [____] GO | Contacts | Submit RFP | Newsletter | Site Map | Downloads |

Technology Focus

DataArt's Project Management System allows our clients to monitor project status in real-time. In the table below you can see the amount of effort (in person-hours) that DataArt has applied to a specific project aspect or intersection of tasks.

We have 3 1 8 2 7 0 hours of experience.

You can select a pair of dimensions from the pull-down lists below:

[Industries ▾] [Technologies ▾] [Generate table]

Industries vs Technologies

	Financial	Government	Internet (ISP/PSP/Portals)	Market Researching & Consulting	Non-profit	Printing	Publishing	Real Estate	Software Development	Trading/Commerce	Transportation
ASP (VBScript, JScript)		738	8658	641					602	704	756
C/C++		2701	21428	670	670				2701		
COM/DCOM/COM+		2685	3068	670	670				2685		
Delphi	1147	808	808						808		
DHTML	731	701	8813	660					5872	2798	1013
mySQL			2104						2487		
Postgress									2487		
Server Java (JSP, J2EE, CORBA)			1549								
SQL (TransactSQL, PL/SQL)		8450	27305						8450		
Thin Client Development (DHTML, JavaScript, Java, IE ActiveX/NN Plug-ins)		8450	18344	641					8450	641	908
VisualBasic		4288	4288						4288		
WAP			947								
XML/XSL	637	879	879	611	719				895	678	

Contact us now to:
- Get consultation on offshore outsourcing strategies at no charge
- Get instant contact with technical experts
- Submit information on your potential development need and get a proposal

Let us know about your potential development need even if you don't have a formal RFP yet - we will work together with you to put together a winning project strategy.

Company
- team
- technology focus
- partnership
- contacts

Services
- what we do
- DataArt & .NET
- process
- quality assurance
- risk management
- reusable modules

Industry expertise
- financial services
- healthcare

Clients
- selected clients
- success stories
- testimonials

We look forward to your questions and feedback! [call me]

Name
[____]
E-mail
[____]
Comment
[____]
[submit]

》

Strong Navigation.com is not a layout for a website but, rather, an illustration of some of the principles of good navigation. It shows a proper grouping of options, consistent labeling of options and icons, and an easy-to-use bottom navigation. The first and second group of main navigation choices should be available in a convenient spot on every page. Option labels are shown in italics.

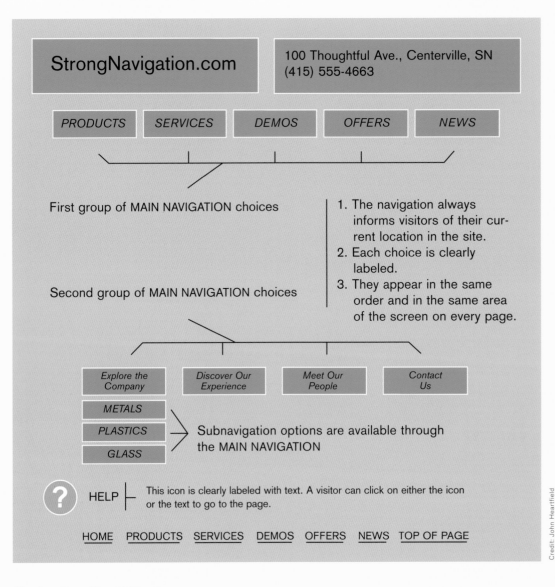

Navigation That Won't Frustrate Visitors

A great navigation system helps guide visitors to their goals with as little interference as possible. When building navigation, always keep your visitors in mind and remember to test your design with first-time visitors, modify it based on their feedback, and then test it again.

Some of the best interfaces are a balance of established principles and what works best for a particular site. Think of the numbered headings below as key guidelines and the text under them as valuable suggestions. Pay special attention to warnings about common mistakes. To avoid frustrating visitors, a Web interface should be:

1. Simple

Simplify your navigation as much as possible. Start with all the choices you plan to offer, and determine the few that encompass the others. These are the best candidates for navigation to the main sections of your site.

In general, don't offer more than seven navigation choices in the same visual style. If you need more than seven, divide them into logical categories and have more than one group of main navigation elements. Make the elements in a group visually consistent but distinct from those in other groups.

Don't overload visitors with too much information on your homepage.

2. Clear

Always let the visitor know where they're currently located in your website.

If you use icons, make sure they're clearly labeled. If the design calls for unlabeled icons, rollover labels are acceptable. I prefer constantly visible text along with the icons to inform me where I'm going.

Labels should be short and provide strong cues to the element's destination. If your site is built around a metaphor, make sure your navigation icons and labels fit into that metaphor.

Hyperlinks should be unique on your site. Don't have identical labels link to different pages.

3. Consistent

After carefully choosing your main navigation elements, place them in the same order in the same area of the screen on every page. Always allow the visitor to jump to any area of the main navigation.

Navigation elements that belong to the same group should be the same size and design and respond with similar visual feedback on input, such as rollovers.

4. Easy

When building a business site, don't make the user "learn" your navigation or absorb significant new ways of doing things in order to access your content.

Navigation choices should be available. Don't hide them until the visitor rolls over something to reveal them. Design is important, but functionality comes first.

Include bottom navigation on every page of any site with long horizontal content. Put top of page links at logical points in a long page and in the bottom navigation.

Count the number of pages it takes to purchase an item. If that number exceeds four, reconsider your design.

5. Available

Place the main navigation at the top or in the upper left of the page so the navigation remains visible if the visitor reduces the size of the browser over your content.

Include your address and phone number in the main navigation area if your business has a location in the real world. In addition, make sure the visitor can contact you by email.

WeakNavigation.com

$ What hyperlink does this icon represent? The visitor has to roll over it to find out.

This is confusing and has nothing to do with widgets. What's the metaphor? In addition, it plays an animation before it shows larger or smaller windows.

| Product | Services | People | News | Offers | Experience | DEMOS | Company | Contact |

BAD MAIN NAVIGATION

1. No strong feedback to inform visitors of their current location
2. Too many NAVIGATION options in no logical order
3. The options are displayed in mixed sizes and styles
4. Choices are poorly labeled

Credit: John Heartfield

When building an ecommerce site don't make the visitor hunt for key interface elements. Put the "Buy Item" or "Add to Cart" buttons close to the item for sale. "Shopping Cart" and "Check Out" choices must be readily available.

Display a price total for the items in a customer's shopping cart. A customer should always be able to instantly remove an item from their cart. If an "Update" button is necessary, make sure it's easy to see.

6. Responsive

Visual feedback, such as subtle rollovers, is often a good idea to inform the visitor that a hyperlink is available.

However, do not animate your navigation elements. Why put on a small, repetitive show before giving your visitors what they want? Some developers think these animations are cute or make their sites distinctive, but the charm is usually fleeting and such animations are a waste of the visitor's time.

≪

A companion to Strong Navigation.com, this illustration shows three bad navigation ideas: a vague icon, a confusing navigation animation, and a main navigation that contains too many choices and styles.

» KNOWING YOUR AUDIENCE

One of the most important decisions you make about your website is who your audience is. It's not enough to know what you want to say, it's essential to define the audience for your message. For example, a physics lecture to an eight-year-old is unlikely to succeed unless it's put in terms the child can understand.

Your site can't be everything to everyone. Although every website seeks to attract as large an audience as possible, to be effective you must focus on the audience that you really want to reach. Often that focus determines not only your content, but also how you present that content.

When you think about your target audience, consider some characteristics:

► Computer and connection equipment: Dial-up modem? Cable? DSL?

Example: If your primary target audience is corporate, they'll likely have faster Internet connections and your navigation can be more graphic intensive. If you're aiming at the general public, limit the size of both your graphics and pages so they'll load quickly on slower connections.

► Age

Example: A younger audience is more likely to be familiar with computer conventions than an older crowd. In general, the older the audience, the more straightforward the navigation should be.

► Gender

Example: Icons and labels should be androgynous unless you're specifically designing for a male or female audience.

► Socio-Economic Status

Example: A target audience with greater resources probably enjoys more bandwidth and faster computers.

► Jargon or buzzwords that your visitors will (or will not) know

Example: A site that sells camping equipment could use hiking terms in its navigation.

► Geographic locations

Example: If your business is located near landmarks, you could provide directions from some of those locations to your business.

► Interests and hobbies

Example: A company that sells sailboat equipment might use some nautical terms (while providing clear explanations for novice sailors).

The most important characteristic of a target audience is their reason for coming to a site. People who own small businesses often know what their customers want, and their salespeople also have valuable opinions. Another excellent way to find out what your audience wants is to talk to your customers, or people you want to be customers, and ask them what they want from your website.

Once you know what they need, make sure they can easily get it.

Targeting
Navigation

Client: Rui Camilo Photography Web Link: www.rui-camilo.de
Design Firm: Scholz & Volkmer Intermediales Design
Site Builders: Melanie Lenz (screen designer), Michael Schaab (flasher/programming/project manager), Heike Brockmann (art director/project manager), Michael Volkmer (creative director)

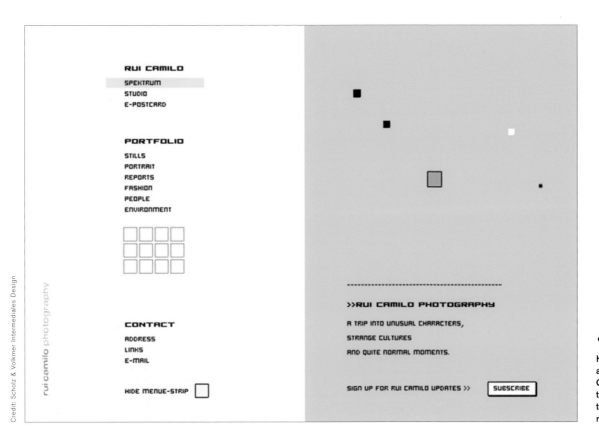

《

Home: Information is offered as an interactive game. Rui-Camilo relies on its audience to understand that touching the mouse to the squares reveals content.

The goal of rui-camilo.de is to provide "the clearest visualization of the far-reaching facets of Rui Camilo's photography portfolio," according to Heike Brockmann.

Michael Volkmer of Scholz & Volkmer adds, "The full-size photographs are optimally staged as central stylistic elements. Visitors are not distracted from them by copy or frame design. Clear navigation is integrated with the photographs. The user can even make it invisible. The central criterion for selecting a photographer is the photographs. Therefore, our intention is to keep the navigation elements restrained."

Restrained does not mean conventional or uninteresting. The Rui Camilo site has won more than thirty awards, including Gold at the NYF New Media Competition in New York and Gold at the London International Advertising Awards. Since its launch, Camilo's business has increased dramatically. He receives email from all over the world commenting on both his photos and the site's design.

Melanie Lenz and Michael Schaab had only been working professionally with Scholz & Volkmer for less than two years when they began working on Camilo's site. The team had a tight three-month schedule and a low budget. They worked together in one room to keep each other updated and share their innovative ideas.

Partial Site Map: On this site map, pages are grouped under the three main category labels ("rui camilo," "portfolio," "contact") on the menu-strip. One portfolio category ("stills") is noted. The option "send an e-postcard" will be noted on the wireframes. "Subscribe" is noted because it's wise to document it on the "spektrum" page.

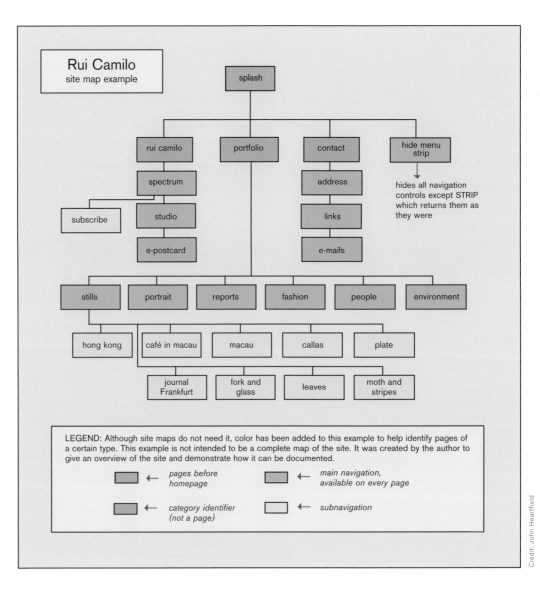

Credit: John Heartfield

Rui Camilo Does Not Do Weddings

The splash page informs the user that the site is 24-bit display optimized. That impressive-sounding phrase simply means the site looks best if visitors set their monitors to millions of colors. The fact that visitors aren't told what that phrase means reveals volumes about the site.

Camilo's target audience was art directors and art buyers at advertising agencies. This demographic is familiar with computer displays and open to an inventive integration of navigation and image. Naturally, Camilo wanted every visitor to enjoy the site but because it was aimed at a specific audience, he gave the designers more freedom to be imaginative.

It's unusual for a photographer's site not to display a photograph on the homepage. As visitors navigate the site, they soon become aware that there really is no homepage. The navigation is not divided into layers but is one seamless tool for accessing content.

The navigation menu-strip contains controls divided into three groups: "rui camilo," "portfolio," and "contact." The largest column houses "spektrum," a short paragraph, and an invitation to subscribe for email updates.

It's worth noting that although Camilo is based in Germany, the site is entirely in English. There's no option to change the language to German. In fact, except for the address option, visitors might wonder where Camilo's studio is located.

Once again, this is possible because of the target audience. Any art director or buyer at a German agency would have more than enough English to understand the site's minimal text. For the rest of the audience, Lenz and Schaab feel the navigation speaks for itself.

A Truly Transparent Navigation

The divisions of the homepage produce a modern sense of balance and although they're separate from one another, they complement each other. The central placement of "portfolio" communicates to visitors that it is the centerpiece of the site. After choosing a category group of "portfolio," the integration of content and navigation deepens.

The menu-strip remains intact but becomes semi-transparent. A high-quality photograph fills the entire screen (see below left). Simultaneously, if visitors are observant, they'll see that some of the white boxes under the categories are colored. A colored box indicates that a photograph has been preloaded by Flash and is ready to view full screen.

Preloading means photos are streamed while visitors are doing something else so larger file sizes can later be displayed very quickly, which translates into larger images with better quality. The great looking photographs and the navigation feed off each other and both have the same modern feel. Although there's no instruction, it's apparent that clicking on any colored box displays a photograph in the high-lighted category while a short photo identifier appears underneath the group of boxes.

Some photos are portrait format so the menu-strip does not cover them at all. Others are full-screen and contain principal subjects that appear on the right. And some photographs have portions of content that are actually covered by the transparent menu-strip. The design team decided to solve this problem by fading out the navigation altogether.

At the bottom of the menu-strip is a box labeled "hide menu-strip." When visitors click it, the menu-strip disappears and the box becomes slightly larger and playfully follows the mouse around the screen (bottom right). This box can be nearly dragged off the screen to get an unobstructed view of the current photograph on display. Clicking the box again causes the menu-strip to reappear.

The advantage of this rare type of navigation is that the photographs are pages not just the main focus of the pages. A disadvantage is that there is no category identification when the menu-strip is hidden and visitors cannot navigate through the bare photographs of a category without constantly hiding and recovering the menu-strip.

Credit: Scholz & Volkmer Intermediales Design

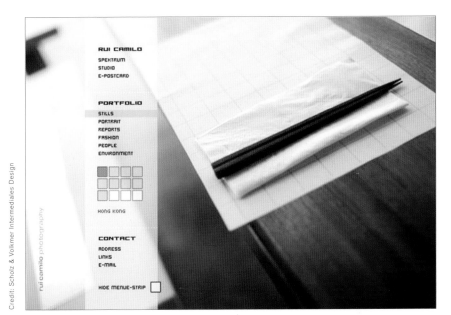

Credit: Scholz & Volkmer Intermediales Design

《

Photograph with Menu-strip: Some photography purists would argue that navigation elements should not be integrated into a photographer's work. By concentrating the composition of the photo on the right and keeping the navigation in tune with the photographer's vision, a rare assimilation of content and navigation is achieved.

《

Photograph without Menu-strip: After visitors choose "hide menu-strip," a high-quality photo fills the screen without the need for a new browser window. The "rui camilo photography" horizontal logo and an option to bring back the menu-strip comprise the absolutely minimum navigation. Brockmann believes, "The main navigation elements should consist of the fewest elements needed to assure complete orientation."

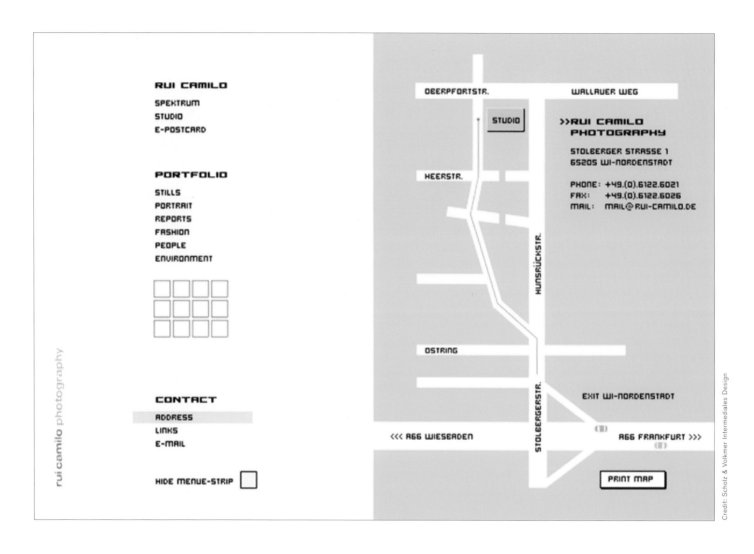

Content Presentation As an Activity

**Address: Rather than offer
Camilo's address and phone
number on every screen,
the site builders created this
useful map and added zoom-
ing cars, an entertaining
touch, at the bottom.**

When the user does return to the menu-strip, the
site has additional information to present in the "rui
camilo" grouping. The team decided that playful
activities were a great way to differentiate this section
from the content section "portfolio."

The option "spektrum" (see homepage, p. 49) is
the type of navigation element that can be offered
when site builders target their site to a sophisticated
audience. On the homepage, squares bounced back
and forth like a game of Pong. Unless visitors touch a
moving square accidentally with the mouse, or vice

versa, no information is revealed. Since no instruction
such as "catch a square" is offered, some visitors
may miss that content entirely and simply enjoy the
random movement.

More computer-literate visitors will search for a way
to interact with the squares. Some link to categories
in "portfolio," one is a link to Scholz & Volkmer, and
the largest one is facts about Camilo.

Below "spektrum" is "studio." It brings up a 360-
degree view of Camilo's studio. Visitors can enjoy
the view or play with the simple zoom and navigation
controls.

A Bit Too Much Simplicity

At first glance, "epostcard" appears to be an attractive option for visitors (below). The ability to easily send a beautiful greeting card to a friend is the type of feature that could be an additional reason for visitors to return to the site. When the recipient views the card, it is a small, rectangular Web page with a minimum of text. All of the images that flowed by on the Rui Camilo site do exactly the same on the recipient's greeting card.

Although this book often advises to keep the navigation simple, the problem with the greeting card screen is that it's too simple. It's not at all clear that all of the pictures will be sent as a presentation. On the contrary, it might be intuitive for visitors to assume that the photograph currently displayed is the one that will be sent when they click "send." So they'll watch the photos go by, perhaps expecting new ones or waiting to choose the one they like best. In addition, the epostcard screen does not offer a preview of the card being sent. Many people will not send an epostcard unless they can preview it. This possible confusion is not on the order of a sales disaster, but it is a potential waste of the visitor's time—something to be avoided at all costs.

Finding Rui Camilo

Though the epostcard screen may have some weaknesses, the "address" screen is a great example of how to present information in a spare, charming manner. A red line showing the best route from the AGG, the nearest large thoroughfare, augments the clean, printable map. Small red cars passing by in a random pattern help identify the AGG.

Finding the right tone for rui-camilo.de began with looking at competitor's sites. "We always research the competition before starting a project," Brockmann says. "Frankly, the competition was not very moving. Most photographer's sites looked the same: Small pictures with decorative design elements."

The design team could see Camilo's photographs were modern and distinctive. They knew the sensibilities of the target audience and created a functional and stylish portfolio book for them to enjoy.

Credit: Scholz & Volkmer Intermediales Design

rui camilo photography

RUI CAMILO

SPEKTRUM
STUDIO
E-POSTCARD

PORTFOLIO

STILLS
PORTRAIT
REPORTS
FASHION
PEOPLE
ENVIRONMENT

CONTACT

ADDRESS
LINKS
E-MAIL

HIDE MENUE-STRIP

>>SEND A GREETING CARD TO A FRIEND

FROM:
E-MAIL:
TO:
E-MAIL:
COMMENT:

NOTIFY ME WHEN CARD IS RECEIVED SEND

《

Epostcard: Different images are loaded as the visitor prepares to send out a postcard. The visitor may think that it's necessary to choose one image to send. Actually, the entire gallery of photos is sent to the recipient. To avoid confusion, it would be good to note that in the navigation.

» BUILDING AN AUDIENCE

In the vast ocean of the Web, it's difficult enough to get surfers to find your island. As a small business, you'll do everything you can to get visitors to your site, but how can you increase the chances that they'll bookmark your website and come back again and again?

Naturally, you want your website to be a reflection of your business. But as you build your navigation, think of the site as a resource not only for you but also for your customers.

Here are some navigation features that encourage repeat site traffic:

▶ Up-to-date information about your business

Think about what people ask you when they call your business, then incorporate that information into the site.

Visitors appreciate information regarding cancellations and discontinued items.

▶ An up-to-date library of Web links (URLs) that complements but doesn't compete with your business

Be sure those links open the other sites in new browser windows.

▶ Value-added features

Every two weeks, a restaurant might offer a simple new recipe from their head chef.

An interior designer's website offers a series of short tutorials.

▶ Special deals

With their permission, let visitors know about these offers by email.

▶ A great customer-support system

Great customer support might include email support, FAQs, and even live chat support.

▶ A monitored Web forum that allows both your company and customers to exchange information about your products.

When it comes to encouraging repeat site traffic, the key is to place something valuable regarding your business at the visitors' fingertips (or mouse click). Ideally, that something would be relevant and new each time visitors access the site.

Don't think of your site as simply an advertising tool or marketplace. Some of the best sites use great design and navigation to prove their commitment to the consumer rather than paragraphs full of empty words. Useful navigation goes much further on the Web than tacky animations or pages of self-serving copy.

Remember that losing an audience is much easier than building one. Offer bad navigation and they'll be gone in no time.

Presenting Dynamic Content Elegantly

Client: Kula Yoga Project Web Link: www.kulayoga.com
Design Firm: Apt5a Design Group
Site Builders: Jason Fried, Richard Bloom, Andy Schaaf

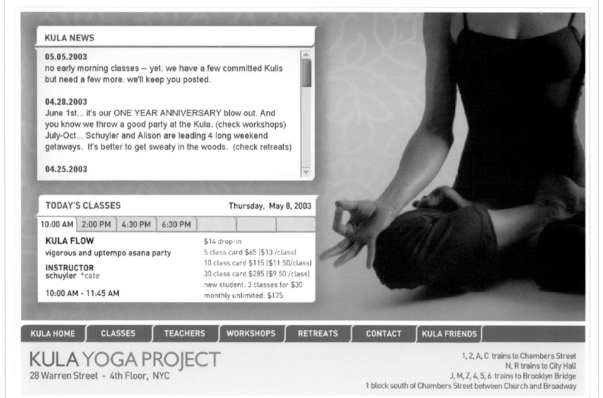

The Kula Yoga Project website offers a consistent navigation, built with Macromedia Flash and supported by PHP. The design creates a useful community, complete with daily updates that keep visitors coming back.

The homepage is uncluttered so that important information elements immediately catch the visitor's eye. Two bold windows rest on top of a calm, welcoming background and display current news and up-to-the-minute information about the day's classes. The site owners can change this data at any time through an easy PHP backend built by Apt5a.

Home: The Kula Yoga Project homepage manages to appear calm and organized while offering a great deal of substance. Kula News is available in an attractive scrolling field; tabs, labeled with the class time, show the daily class listings; and the main navigation, which remains identical on every page of the site, is a solid foundation on which the content rests.

»

Partial Site Map: This partial site map of the Kula Yoga site is almost complete. It shows how a great site can have a simple structure.

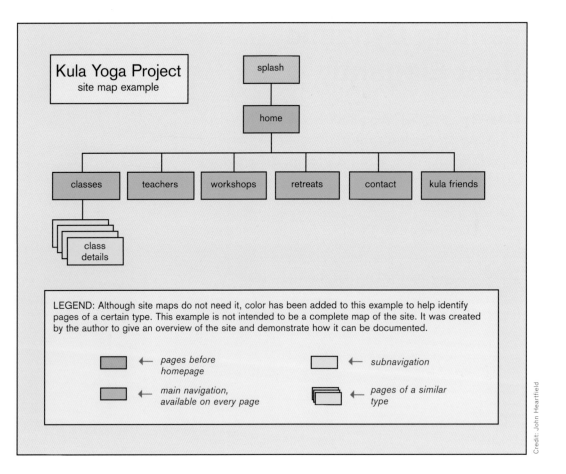

Kula Means Community

"We consider the daily schedule updates on the homepage to be a necessity," says designer Jason Fried. "A first-time visitor learns that they can find out which classes are going on that day or if there are substitute teachers. This has definitely proved to be a feature that brings people back to the site. One day the site was down for a short time due to a server problem and the phone in the studio was ringing off the hook. Everyone was calling to ask when the site would be up again."

Because the Kula site interface was created with Macromedia Flash, designers Fried and Richard Bloom believe they have avoided many of the display issues that can arise in HTML code when audiences use different browsers. Additionally, Flash made it easy to create and control the interface elements. For example, the tabs and scroll bars were designed to perfectly fit the various amounts of content in each window. Fried notes, "All our scroll bars are sized to the data you're accessing. That is something people are used to on their computers. Since we were using Flash, we could make sure the experience was as natural as possible."

Simplicity Is Key to Any Website

A clear and consistent message is a vital part of any successful design, especially for websites. Fried notes, "Consistency is our main goal. If you don't have consistency, it just feels like a mishmash. The alignment, navigation, color, and design all have to be consistent." Bloom adds, "We always try to make the interface as easy to use as possible."

When asked about their vision for the Kula Yoga site, the designers chimed in together, "Form and function, functionality and beauty. We wanted to build a soft and gentle site with a clean, modern interface."

All the screens on the Kula website are divided into two areas: content and main navigation. Bloom says, "In general, it makes sense to separate the main navigation module from the content." Fried explains, "We made sure that no matter where you go, you can always see the identical navigation area. I've been to so many sites where the navigation changes from page to page and I just don't understand it."

Placement of the main navigation systems was also a carefully thought-out decision. Because of the weight of the information in the navigation module, the designers decided to place it at the bottom, rather than the top, because they felt it was a strong anchor for the content above. The navigation area also provides the address and subway directions—a consistent reminder that this on-site service business is located in New York City.

Developing the Core Navigation

Main navigation should never be thrown together. How did Apt5a determine the optimum main navigation? Fried explains, "I think with a small business website, the main navigation is usually pretty obvious. Where's your business? What's important?" Bloom notes, "Clients come to us and give us everything they want; it's like a puzzle on the table and we put it together. We decide what should be grouped together and what isn't needed. We break the client's needs down to what's really necessary and then group buttons that belong in the same category, such as *classes* and *teachers*. Deciding what shouldn't be displayed on the screen is often as important as deciding what should be displayed."

Apt5a uses soft fade ins to introduce new content, but they never fall into the trap of using animation for navigation. Although Flash began as an animation program, Fried believes that Flash is best used as a tool to build direct navigation systems. "If you look at any functional user interface—for example, a Palm Pilot—and the way you interact with it, a site should perform the same way. If you build an interface with Flash, adding in all these little navigation animations defeats the purpose of what you're doing."

© 2002 Apt5A Design Group

CLASSES	MONDAY	TUESDAY	WEDNESDAY	THURSDAY	FRIDAY	SATURDAY	SUNDAY
7:00 AM							
8:00 AM							
9:00 AM							
10:00 AM	OPEN FLOW 10:00 - 11:35 STEVEN	KULA FLOW 10:00 - 11:45 CATE	PRE-NATAL 10:30 - 11:45 REBECCA	KULA FLOW 10:00 - 11:45 SCHUYLER	OPEN FLOW 10:00 - 11:35 STEVEN	KULA FLOW 10:00 - 11:45 CHER	KULA FLOW 10:00 - 11:45 TAL
11:00 AM							
12:00 PM	KULA FLOW 12:00 - 1:35 ANNIE		KULA FLOW 12:00 - 1:35 ALISON		KULA FLOW 12:00 - 1:35 ANNIE		OPEN FLOW 12:00 - 1:45 LAURA
1:00 PM							
2:00 PM		OPEN FLOW 2:00 - 3:35 CHER		OPEN FLOW 2:00 - 3:35 CHER			
3:00 PM							
4:00 PM	KULA FLOW 4:30 - 6:15 ALISON	KULA FLOW 4:30 - 6:15 ERIN *TAL	KULA FLOW 4:30 - 6:15 TAL	KULA FLOW 4:30 - 6:15 ERIN *TAL	KULA FLOW 4:30 - 6:15 SCHUYLER	KULA FLOW 4:00 - 6:00 TAL	RESTORATIVE 4:00 - 5:45 CATE
5:00 PM							
6:00 PM	KULA FLOW 6:30 - 8:15 CATE	KULA FLOW 6:30 - 8:15 SCHUYLER	KULA FLOW 6:30 - 8:15 SCHUYLER	KULA FLOW 6:30 - 8:15 ALISON	KULA FLOW 6:30 - 8:15 CATE		KULA FLOW 6:00 - 8:00 ALISON
7:00 PM							
8:00 PM			OPEN FLOW 8:30 - 10:00 LAURA				
9:00 PM							
					* substitute teachers names are in red		

«

Classes: A schedule is mandatory for any business website that offers services at a particular time. It's a smart idea to have it resemble the type of schedules visitors have probably seen before in personal calendar programs. When visitors roll over key information about classes, including up-to-date visual feedback regarding substitute teachers, the cursor indicates links to more information.

Keeping Clicks to a Minimum

The navigation Apt5a has designed allows changing parts of the screen to be well integrated into the whole, which eliminates the need to jump around from page to page for information. Elements relate seamlessly to one another and all of the choices available to the user are only a click or two away.

As the visitors navigate to different content areas, each area is clearly and consistently labeled in the upper left-hand corner of the screen. The "Classes" section (previous page) offers a schedule in a form that may appear familiar to many computer users. An excellent feature places a substitute teacher's name in bold red type. The "Classes" feature could bring visitors back to the site each time they intended to take a class and it may help bind them to the services offered by the Kula Yoga community. Although there's little visual feedback, other than the appearance of the usual hyperlink hand on rollover, it's reasonably apparent a visitor can choose any particular class for more information.

After clicking on a class, the visitor is taken to a subsection of the main schedule (opposite, top), which is a good example of displaying a great deal of information in a small space. Visitors have the option of choosing the day of the week and the class times on that day. On the left side, more information about the class is displayed, whereas on the right side, information about Vinyasa yoga and class prices is provided. In addition, there's a convenient sign-up for their mailing list.

Teachers: The presentation of content on the teachers' page is tightly controlled. The use of meticulously sized scrolling fields and the clean photos of the teachers in graceful yoga postures demonstrate what Apt5a wanted to accomplish—a meld of functionality and beauty.

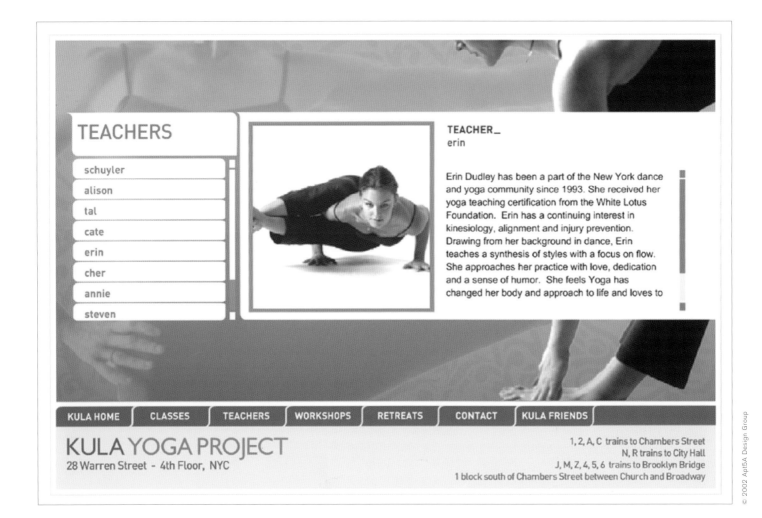

CLASSES	MONDAY	TUESDAY	WEDNESDAY	THURSDAY	FRIDAY	SATURDAY	SUNDAY
10:30 AM - 11:45 AM							
12:00 PM -1:35 PM							
4:30 PM - 6:15 PM							
6:30 PM - 8:15 PM							
8:30 PM - 10:00 PM							

Wednesday
6:30 - 8:15

KULA FLOW
vigorous and uptempo asana party

INSTRUCTOR_SCHUYLER *TAL

Intended for students with a regular yoga practice.
Kula Flow classes will include a number of advanced
postures with variations. All students are welcome to
attend, but if you are new to vinyasa, we recommend
starting with Open Flow.

PRICES

$14 drop-in
5 class card $65 ($13 /class)
10 class card $115 ($11.50/class)
30 class card $285 ($9.50 /class)

new student special: 3 classes for $30
monthly unlimited: $175
6-mo unlimited: $160/mo
12-mo unlimited: $140/mo

student & unemployment discount: 15% (with proper ID)

CLASS PRICES WHAT IS VINYASA? BACK TO MAIN SCHEDULE

SIGN UP FOR THE MAILING LIST TO FOR UP TO DATE INFORMATION ON KULA YOGA RETREATS, WORKSHOPS, AND OTHER HAPPENINGS

NAME EMAIL SUBMIT

«

Classes Detail: The structure of this page remains familiar even though it is three levels away from the homepage (homepage->classes->particular class). The day and time structure of the main class page remains in the same style so it's simple to access details about any class. Options are available to toggle one area of the screen to display either class prices or a description of Vinyasa yoga.

»

Workshops: The tab structure at the top of the page is a clear method to access the workshop content. The tabs combine the functionality of known interface elements with a subtle design that's integrated nicely into the page.

The "Teachers" page opposite also works well on several levels. On the left side is a scrolling menu that's exactly the size of the descriptions. Although there's a slight disadvantage in that all the teachers' names are not immediately visible, a clear scroll bar allows the visitor to find specific teachers quickly. The advantage of the scroll is that new teachers can be easily added in the future without having to redesign the entire page. Here again, space is used wisely. Rather than offering a long column of teachers that would require the user to horizontally scroll through the page, Apt5a simply recycles the same screen territory each time a teacher's name is chosen by the visitor.

Part of the navigation design for the Kula Yoga site came from a competitive analysis of other yoga sites. However, rather than adopt the material he saw, Bloom did the opposite. "When we built this site, it was useful to check out the competition and find out everything we did not want to do."

The simplicity, consistency, elegance, and dynamic content of the Kula Yoga Project's website conveys to visitors that their experience in the physical Kula Yoga community will be equally enjoyable.

» ORGANIZING

The phrase "a place for everything and everything in its place" should be on the desktop of every Web developer.

Organization is crucial and takes two main forms: what you see on the Web and what takes place behind the scenes.

In this section, you'll read about the type of content you should and should not consider putting on your site. You'll also find out how to group content, manage changes, choose content that reflects your particular message, and, most importantly, test that your content is organized in the most effective manner.

In the digital world, having the discipline to be organized frees up your time and energy for other pursuits. In other words, the more organized you are, the more creative you can be.

interactive**tools**.com
Software for your website

what we do:

interactivetools.com makes easy to use software for updating
resell our software to your clients, or use it on your own website
money, and give you a competive edge. [11 Reasons...]

featured products:

Roxen Internet Software is a mult
of Web Content Management produc

PaloAltoSoftware

Home Cart About Us C

Products Shop Online Downloads Support Resources Search Site:

**Powerful Planning
Tools for
Business Success**

Software, books and interactive tools
for business planning, marketing planning

NEW! Business Plan Pro 2004
• 400+ Sample Plans
• New Microsoft Word® Import/Export
• Designed for Windows XP
More Information

contact

skip

» OFFERING WHAT'S NEEDED

Deciding what content to offer is one of your most difficult decisions. Too much content may overload visitors' senses, but too little information could leave your visitors frustrated or confused.

Ask yourself: "What do my visitors really want and need? Why would they come to my site?"

Examine your content and ask yourself these questions:

► Are my goals clear?

► Have I determined my target audience? Does my content serve them?

► Does my navigation offer content in a manner consistent with the capabilities of my target audience?

► Is my content directed at my target audience?

► Is my site a resource for my customers?

► Am I using the website simply as a commercial for my business?

► When I inform visitors about my business, am I demonstrating value or just boasting about it?

A key point to remember about Web content: Most visitors have a limited attention span. Filling a page with content does not mean visitors will absorb any significant part of it. Visitors do not study pages; they pick and choose nuggets of information.

The Web is a visual medium, so long paragraphs of unbroken text are likely to be ignored by all but the most determined content miner. If you need a great deal of text to get your message across, break it into short sentences and paragraphs. Put descriptive headings over every two or three paragraphs so that visitors can jump to points of interest.

To get your message across, follow these two principles: Construct your content to be short and snappy, and make sure visitors can access the most important points of content through the main navigation.

When you keep the content essential, you can make visual content an integral part of the navigation. A well-spaced photo can also double as a link. This book recommends that when labels that identify photos or graphics are hyperlinks, make the photo or graphic a hyperlink as well.

The most important thing to remember about content on your website is that it should never be offered on a dead-end page that offers no navigation options other than those provided by the browser. In other words, don't leave visitors stranded on a page where they must use the browser's "back" button to load a different page of your site. The presentation of all the content must be controlled by clear navigation options presented by you.

Putting on
the Ritz

Client: **Bud Maltin Music and Entertainment**
Web Link: **www.budmaltin.com**
Design Firm: **Kimili** Site Builder: **Michael Bester**

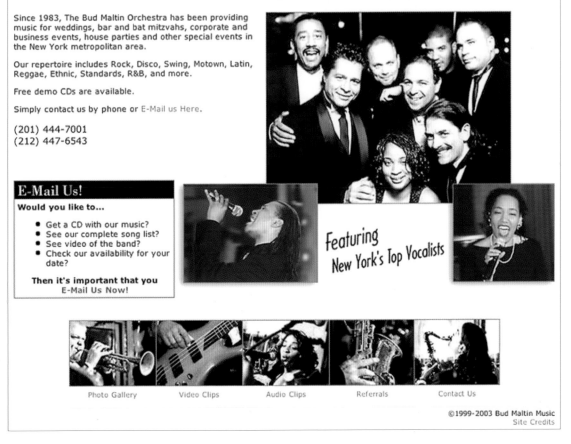

« Home: The homepage features good spacing and positioning of elements. A positive message is conveyed without a great deal of affectation or hype. The main navigation options are the star of the show and are offered on the top and bottom of the page. Photos on the bottom highlight the navigation and correctly double as links.

The Bud Maltin Orchestra has been providing music for special events in the New York metropolitan area for over two decades.

Though it sounds out of place in this technologically savvy world, Bud became convinced his orchestra should have a website while visiting his local carwash. When Bud asked about a coupon special, he was told they were available on the website. He figured if his car wash had a website, then it was certainly time for his band to have one.

Bud's site is an excellent example of what a small business should offer and how to do it on the Web.

»

Site Map: This site map completely describes the structure of Bud Maltin's simple but elegant website.

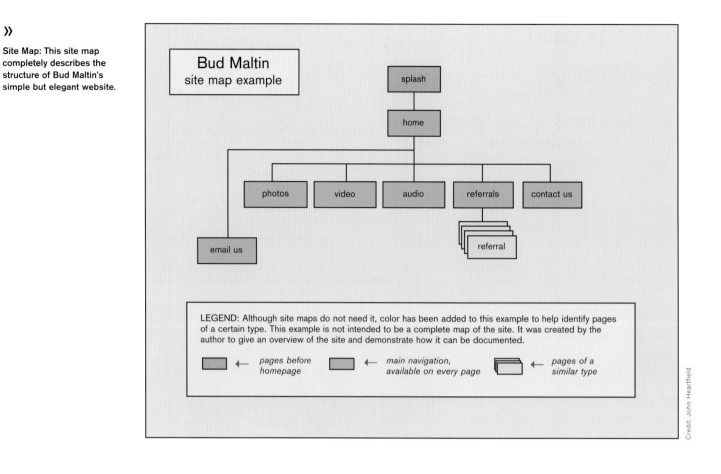

Start Me Up

Budmaltin.com loads a splash page with a large, professional photo of Bud. Sometimes, Web surfers are not pleased with splash pages that do nothing but invite visitors to enter the site. This splash page should be considered an exception because Bud is the ambassador for the band. Identifying him when the URL first loads helps brand the site and helps visitors place him in subsequent pictures, while at the same time setting the tone for the homepage.

"I felt that the homepage needed to quickly establish the mood of the site," says site designer Michael Bester. "An elegant, refined look was necessary. I chose a limited color palette and utilized black-and-white photography with some splashes of color to add life to a potentially flat look."

Visitors looking for a party band are probably concerned with the band's music, the look of the band, the consistency of their performances, previous client opinions, and price. If you're planning an expensive wedding or corporate event, you want to be sure the musicians will carry it off with style. To answer such questions one at a time, the top-level navigation is organized to offer both content and media information.

"When choosing labels, simplicity is paramount," Bester says. "I prefer to keep primary navigation elements to one word if possible. Today, it seems that users tend not to want to explore too extensively on a site. They want to find what they are looking for quickly and without hassle. The fewer clicks that a user needs to make in order to find that, the better."

On any homepage, an option to contact the owners of a website by email should be available, but budmaltin.com goes a step further. A highly visible email option is paired with questions about whether visitors would enjoy receiving a CD, seeing the complete song list, receiving a video of the band, and checking date availability.

PLANNING ORGANIZING PRESENTING

»

Photos: The text asks a question most visitors are probably thinking: What will the band look like performing? The photos with their distinctive shapes and styles answer that question quite nicely. The email option is essential for the site and is precisely duplicated from the homepage.

≫

Audio Page: Changes in page are mainly found in the content area in the lower right quadrant and in the text in the upper right quadrant. The "Email Us!" options remain identical on every page except the "Contact Us" page. It's important to understand that this duplication doesn't make the site boring but easier to use.

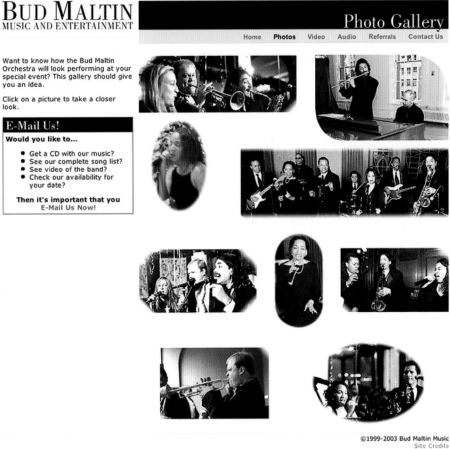

Just the Way You Look Tonight

Part of the excitement of any band is watching the musicians in action. On the "Photos" page (above), prospective clients can see thumbnails of the band in performance. There is a navigation instruction to "Click on a picture to take a closer look," and since the target audience for the site includes people who may not have a great deal of computer experience, that's a wise decision.

Clicking on the thumbnails launches larger windows. That is an accepted practice although, if possible, it's often more convenient for visitors when site builders reuse screen territory to display larger images when thumbnails are chosen.

Although some of the larger photos could be slightly better quality, all of the photos should make visitors feel as if they are in the moment with the band.

Music

Any business that offers a service must focus their website on that service. For budmaltin.com, the focus is the music, and the site presents the music by offering it in RealOne format (see previous page, bottom image). RealOne downloads music to visitors' local computer hard drives where it can be played by the RealOne Player. It's likely that several people will be involved in the decision to choose a band for an event. Therefore, this automatic downloading makes sense—the music needs to be downloaded only once from the Web and it can then be played directly from the visitor's hard drive repeatedly.

The disadvantage of using RealOne is that visitors must have the RealOne Player installed on their local hard drive. However, budmaltin.com makes it easy for viewers by offering a link to the Real site where the RealOne Player can be downloaded. Budmaltin.com also wisely includes the information that visitors do not have to download or pay for the feature-rich RealOne Plus application to access the audio clips; instead, the RealOne Player is a free download.

When you provide links to software that enhances your site, you should include relevant advice about that software. Visitors will appreciate it and if they become frustrated because of information you didn't provide, they'll probably associate that frustration with your site as well.

For each selection on the "Audio" and "Video" pages, a choice of download speed is offered for people with slower connections. Once again, this is a website for a target audience that may not be savvy computer users.

Consistency across Pages

"A foolish consistency is the hobgoblin of little minds, adored by little statesmen and philosophers and divines. With consistency a great soul has simply nothing to do."
—Ralph Waldo Emerson, "Self-Reliance"

Mr. Emerson may have been a great philosopher, but with that attitude it's unlikely he would have made an effective navigation designer. Consistency inside a website is a cornerstone of user interface because it helps orient the visitor and makes the interface transparent. As a navigation designer, you want to make sure that visitors have little to learn in order to do something on your site.

The "Video" and "Audio" pages on budmaltin.com are laid out in precisely the same manner. The selections are grouped into clear categories, so visitors, even naïve ones, quickly understand what to do and what to expect.

"The goal was make content clear and easy to find," Bester says. "The design was intended to facilitate that goal, not to stand in the way. I don't like to bury content in a site."

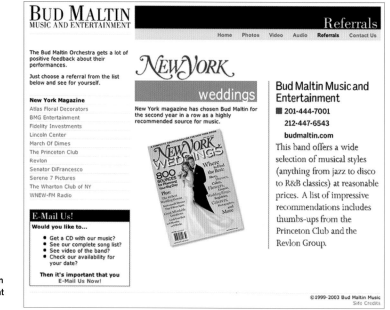

» Referrals: Over the course of his career, Bud has accumulated an impressive list of accomplishments and credentials. Rather than list all of them, the site wisely chooses to limit the selection to an impressive list of recent recommendations.

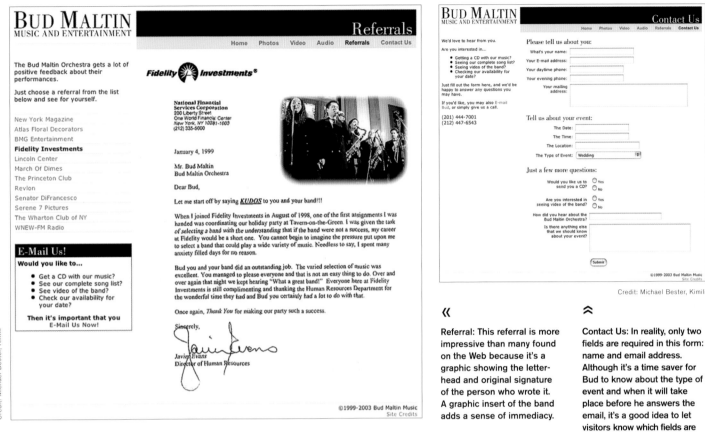

Credit: Michael Bester, Kimili

《

Referral: This referral is more impressive than many found on the Web because it's a graphic showing the letterhead and original signature of the person who wrote it. A graphic insert of the band adds a sense of immediacy.

✦

Contact Us: In reality, only two fields are required in this form: name and email address. Although it's a time saver for Bud to know about the type of event and when it will take place before he answers the email, it's a good idea to let visitors know which fields are required and which are optional when presenting forms.

I Heard It through the Grapevine

Much of the band's work comes through word of mouth, so it makes perfect sense to put excellent feedback on the website, especially when enthusiastic reactions come from sources like *New York* magazine and the Lincoln Center.

Once again, the "Referrals" page (opposite) is designed to be easy to use. Clicking on one of the obvious choices takes the user to a page where the full letter of appreciation is displayed along with a small image of the band (above left). The fact that the letter appears on the original stationary with the date and the person signature inspires trust in the referral.

"The website has been very successful," Bester says. "Overall, the reaction to this site has been compliments from its visitors and a direct impact on Bud Maltin Music's ability to procure new clientele. In fact, a bride chose Bud Maltin to provide entertainment for her wedding based primarily on the opinion that Bud's site was 'by far the best site for a band' she saw."

I Need to Know

On most websites, a contact link exists so visitors can request information from the people behind the site. Although budmaltin.com offers the usual contact link, the "Contact Us" page (above right) goes one step further by gathering information from prospective clients. Obviously, it's quite useful for Bud to have the kind of basic information requested on the "Contact Us" page.

If visitors don't want to provide the additional information, there are numerous links on the site to contact Bud Maltin without filling out the feedback form. Whenever a website requests additional information through a contact link, it's very important to provide contact alternatives in case visitors wish to simply write an email without providing information.

Bud Maltin's site is in perfect tune with the orchestra's music: professional and stylish. It plays to its target audience in a straightforward and thoughtful arrangement.

»

This is not a page or page layout, but an illustration of how a solid content-management system helps develop and maintain Web pages. Each person on the team is responsible for their content area on the page and is free to develop it in concert with the rest of the group. A file-naming convention (being consistent is most important) and a timely, structured backup plan are essential.

Managing Content:
A Necessity for Any Website

A website must evolve. It must alter its appearance because of visitor feedback and be prepared to accept changes from its owner. Now matter how often a site changes, the updating of content requires an enormous amount of attention to detail. Content has to be managed well in order to efficiently make changes in a cost-effective manner.

A small business may choose to purchase software to help with content management or handle content changes through their own personal process. Without the software, a group of people filter their input through one person who is very diligent about controlling the changes to the site. Production team members provide updates to that person who has the responsibility of integrating it, storing it, posting it, and making sure everything gets backed up.

Backup is an absolutely vital component of any website project. Countless hours of work are lost each day because developers fail to back up their files in a timely, organized manner. You must assume that your computer is *not* reliable. The list of disasters that could occur (including hard drive failure, viruses, and system corruption) is long.

Your only defense against these disasters is careful backup. First, use virus protection software before backups. Next, create a schedule to copy changes, and often the entire site, onto three different backups. Keep older backups for a reasonable time. Backup can be on any reliable media (CD, Zip drives, tapes, etc.) but backups *must be external* to your system. Rotate one complete backup out of your physical environment to another location (a nearby safe deposit box is ideal).

When people get busy they tend to put off backup, but backup is not something you do to protect your work. Backup is a vital part of your work.

Everything about content management, even the names and location of your files, requires discipline for those who forego great content management software. Here are a few tips:

▶ Before you do anything, think about your folder structure and sketch out a good one.

▶ Make folder structures like
 mySite
 ->sales->html
 ->sales->images
 ->sales->text
 ->info->images

▶ Name files consistently.

 Use a scheme that identifies files such as saleCust.gif or salePres.jpg. Don't name files image1, image2, etc.

▶ Use a spreadsheet to keep track of files and when they were last backed up.

Whether you do it manually or with content management software, the idea is to create, read, update, and delete your content in the most efficient manner. If you can afford it, take advantage of market opportunities to purchase good content-management software, which pays for itself in productivity hours. A Web search on "content management software" will yield several sites to fit your budget.

The purpose of content-management software is to store, index, search, retrieve, and organize content such as texts, links, graphics, audio clips, scripts, or any media that can be realistically categorized and stored for subsequent presentation. It builds a controlled environment that allows everyone involved in the creation, maintenance, and updating of a website to work together in an integrated environment.

Many companies let you try their software before you purchase it. Avoid the following in content-management software:

▶ Difficult installations

▶ Complete overhauls of your existing website

▶ Conflicts with your current Web development tools

▶ Complicated required training

▶ Unreasonable cost and hidden fees

Look for these elements in content-management software:

▶ Easy to learn and use

 Anyone who contributes to the site should be able to use it.

▶ No "flow" through one person

 Team members creating content shouldn't have to depend on anyone to publish it.

▶ Control of who has access to pages (or areas of pages) and who is responsible for reviewing and approving changes before they go "live" on the Web

▶ Flexibility to maintain a great deal of the structure of your current site

▶ Ability to control publishing of time sensitive content

 You might want some content, such as a sale price, to expire.

 Promotional campaigns should begin on a certain day.

Another factor to consider is whether or not you want content management to be handled on the server side or install it on every key player's desktop.

Content-management software is still evolving but it's improving every day. No matter how you go about it, the management of your precious content is an essential process for a dynamic website.

⩔

This layout shows just a few of the disasters that can occur when content management is done without a plan or discipline. Every hour devoted to building a content-management system will payoff ten times in gained productivity.

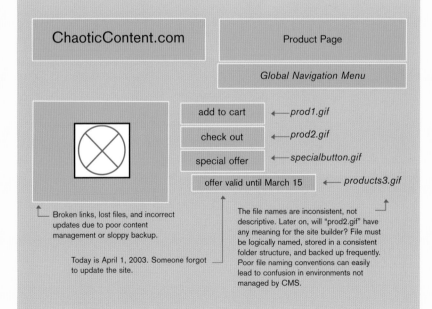

Credit: John Heartfield

» GROUPING ELEMENTS

Your content has been evaluated and gathered and is sitting in a big virtual pile. The task of organizing it into logical groups probably won't be obvious or simple. For the moment, don't think about labels or icons. Instead, rely on your knowledge of your business and your customers' expectations, and sort the content into groups that naturally go together.

First, decide what goes together, such as similar merchandise, type of services, and content that relates directly to information about the company. Next, organize your content until it looks right, then work on it some more. Doing this correctly saves you time and money when building the site. Keep in mind that if visitors can't find what they want quickly, they'll leave immediately and are not likely to return.

Once your content is well organized into logical groups, you must fit it together. The Foscarini website offers merchandise that might be displayed under several options: by type, style, price, creator, and more. In their main navigation, they've chosen to offer their merchandise by category—in this case, the type of lamp. In a standard drill-down structure, choosing a category of merchandise exposes the name of the products in each category. When visitors choose a name, there's a screen that displays the same product name in other categories and the product is fully exposed. Each level displays new facets of the product while the consistent grouping of merchandise by category keeps visitors centered.

In the preceding structure, a drill-down method is used along with links that tie the content together. The navigation succeeds because even though they may be in different categories, links in the product section relate directly to the products and the main navigation is always available, allowing visitors to enter other areas. As you design your own site, be careful about offering the same subnavigation options under more than one main navigation choice.

One way to approach the organization of your site is to view your site as a virtual filing cabinet. The main navigation consists of drawers that can always be opened, and the files inside can be items or groups that are accessible by opening the drawers.

Unfortunately, there's no standard template for organizing content within a navigation structure. The most important thing to keep in mind is how people will use the site. Think about what key information visitors are likely to want and make it easily available. Never assume, "they'll find it if they look for it."

Merchandise Illumination

Client: Foscarini Web Link: www.foscarini.com
Design Firm: Designwork SRL
Site Builder: Monica Faccio

FOSCARINI PRODUCTS COMPANY COMMUNICATION I HOME I SEARCH I CONTACT US

copyright© Foscarini Murano 2002 - credits

Credit: Foscarini Murano SRL

Foscarini is not a typical lamp company. Established in Venice in 1981, Foscarini started out exploring opportunities created by Murano glass. While ever watchful of its Murano heritage, the company works with both established designers exploring new trends and emerging exponents of alternative styles and approaches. The result is a stylized, highly original, and varied catalog.

Lamps are not sold directly on the website; rather, they are displayed like works of art. For visitors interested in buying, an option under "Company" lists distributors worldwide. The site is designed to provide visitors with details, such as size and color, while at the same time impressing them with their product line.

The website caters to the architect, the designer, the stylist, and other people concerned with design, so the site designer's goal was to make the site as sleek and modern as Foscarini lamps.

"We wanted to eliminate explanations," says Designer Monica Faccio. "Foscarini has invested heavily in a new image that has relaunched them into the market. A secondary goal was to showcase the many new products that Foscarini puts on the market each year."

Home: Foscarini's homepage speaks directly to its audience without using words. It is a reflection of the company's modern design philosophy.

Partial Site Map: This partial map shows the Foscarini splash page, which offers visitors a choice of either English or Italian text. The global navigation choices are shown and there are very few of them. It's apparent that global navigation options expand to several subnavigation options.

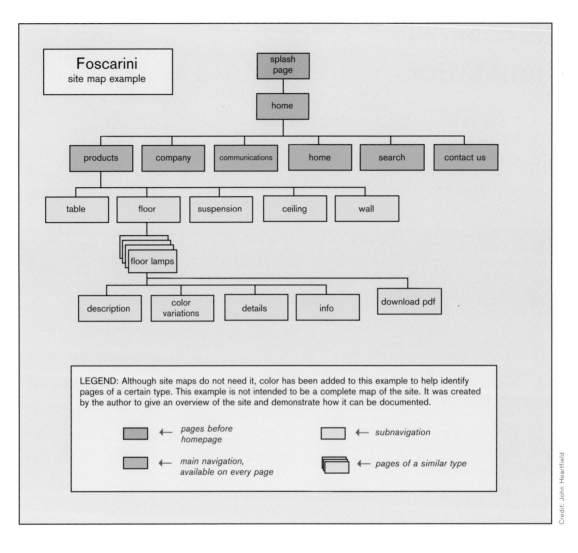

Credit: John Heartfield

Unusual Choices for an Unusual Website

Visitors reach the homepage by way of a splash page. The main function of the splash page is to offer a choice between English and Italian text. An animation with music runs if visitors stay long enough to watch it, but the likelihood is that they'll choose a language and go directly to the homepage, which contains a minimum of elements.

Even the orange graphic that dominates the page is more abstract art than product display. "When doing a competitive analysis, I found some sites very complex and dense with text," Faccio says. "We chose to communicate with forms and images, separate and minimize, and make our site easy to understand at first sight."

The navigation choices are well labeled though the order appears unusual. Normally, "Home" is placed at the beginning or end of main navigation list. Here,

the main navigation choices are subtly grouped. Notice the small lines between "Home," "Search," and "Contact Us." "Home" is at the beginning of its group, but seems a bit out of place in the center of the main navigation.

Clicking on main navigation choices causes subnavigation choices to appear on the line below. New screens do not replace the current one until new subnavigation choices are made. For example, if visitors choose "Floor" on the "Products" subnavigation menu, the floor lamps category is displayed. If they choose main navigation "Company" at that point, the subnavigation choices for company are displayed but the floor lamps screen remains. On most sites the main navigation displays new pages. Foscarini's main navigation only displays new subnavigation options.

Strong Grouping Illuminates the Product

Strong grouping is essential to Foscarini's navigation. Lamps are grouped in categories based on where they'll be used. Facts about the company are grouped into "Profile," "Philosophy," "Designers," "Distributors," and "Quality System." The options "News," "Editorial," "Advertisement," "Events," "Project Setups," and "Press" are grouped under communication.

"The labels were chosen to be logical, simple, and conventional," Faccio says. "Every choice I make is calculated because I'm always thinking good design is something that works for the visitor."

Product presentation is superior. A subcategory option such as "Floor" takes visitors to the product category page for floor lamps (right). On the left, visitors can choose a lamp by name. A discreet scroll bar is used if the list is longer than the page.

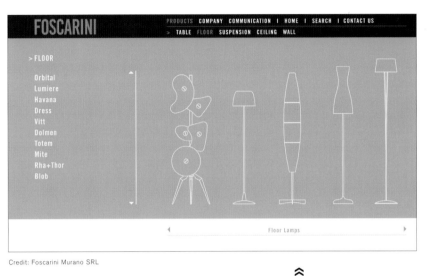

Credit: Foscarini Murano SRL

Credit: Foscarini Murano SRL

≫

Product Category (floor): Outlines offer visitors many styles on one screen without the download lag of larger graphics. The outline emphasizes to visitors that they are located in the floor lamp category.

≪

Product Type: For each lamp style, product photography is located to the left whereas information about it is displayed in the screen territory to the right. The product description is short and informative, recognizing that the audience wants facts about the product—not advertising copy.

Outlining Graphics for Style and Performance

On the right, visitors see wire outlines of the lamps. "A name on the right was not enough because visitors may not know the exact name of the lamp they're looking for," says Faccio. "So I added a visual of the product that would load very quickly."

A label above the scroll bar under the outlines performs double duty. It identifies the horizontal scroll group and on a rollover of an outline it provides the name of the lamp.

The lamp outlines also function as navigation icons. When a style of lamp is chosen on the product category pages, that lamp is shown on the product type page (above left). There, outlines enable Foscarini to show lamps of the same design but in different cate-

gories. For example, the Havana design is available in floor, ceiling, and wall models. As icons, the outlines navigate to different product detail pages. This is an interesting solution to the problem of how to display two distinct models of the same design type.

Each product detail page has an option below the photo of the currently selected lamp to return to the relevant category page (see next page, top left). Selecting the outline to load a different product detail page also changes the option for the category page below the product photo. This can be a bit disorienting. It might have been better to display multiple product category options below the product photos, one for each category represented by the outlines.

Grouping Screen

When an outline is selected there are four options underneath it: "Description," "Color Variations," "Details," and "Info." All of these options provide information in the same rectangle of screen territory on the right. The option "Description" provides the name of its designer and a short explanation of the materials used. "Color Variations" shows available colors and "Details" shows thumbnails of the lamp. Clicking on the thumbnails launches a window with a larger version of the thumbnail. "Info" provides the physical specification of the lamp.

There is an option to download a .pdf in the lower right hand corner. This allows visitors to save the same type of information offered on the product detail pages and print it, email it, fax it, or take it to a distributor.

The "Company" group offers five options. The subnavigation group "Designers" (below, center) contains dual scroll bars identical to those in the "Products" subcategories. Although the horizontal graphic of the designers is attractive, it takes too long to load, especially since it reloads every time visitors return to the page. This is one of the trade-offs between navigation and design. Because excellent photos of the designers and their work are available on the "Designers Detail" page (below, right), a bandwidth saving idea such as the outlines used to show lamps would have been appropriate.

On the "Designers Detail" page, the option for the "Designers" page is duplicated in the lower left hand corner with the label "Menu Designers." Many navigation designers would agree that it would be clearer to label that option "Return to Designers" instead. It is also acceptable to use identical labels for identical navigation options.

⩔

Product Detail: When visitors are deciding on purchases on the Web, offer them as much visual information as possible without significantly slowing down page loads. On this screen, thumbnails launch windows that show larger views when visitors request them.

Credit: Foscarini Murano SRL

Credit: Foscarini Murano SRL

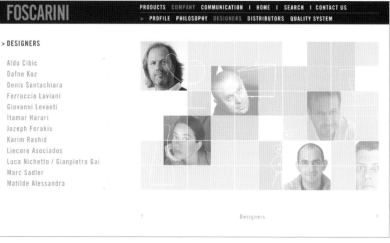

Credit: Foscarini Murano SRL

»

Designers: While the handsome graphic on the right helps visitors put a face on Foscarini, its file size is too large to be quickly downloaded, with faster connections. Since this page reloaded every time visitors return to the "Designers" screen, an equally attractive graphic file would be appropriate.

⩓

Designer Detail: This feature provides a great way to match designers with visuals of their creations. The text is just enough to offer a look at the designer's career without overloading visitors with too much reading.

FOSCARINI

PRODUCTS COMPANY COMMUNICATION I HOME I SEARCH I CONTACT US

SEARCH

>> Select type of information

1. ⦿ General Information ◯ Data Sheet ◯ Dasigner

>> Now select use option

2. ⦿ Table ◯ Floor ◯ Suspension ◯ Ceiling ◯ Wall

>> Enlight your product

3. [-------------- ▲▼]

Credit: Foscarini Murano SRL

Searching for Clearer Instructions

Finally, a word about the Foscarini search (above). Most visitors prefer a text search but the radio box search offered by Foscarini is a way of preventing empty search results. The instructions are provided, but they could be clearer. For example, the first instruction is to select a type of information. What if a visitor thinks they want general information about a designer? They may try to select multiple radio boxes and get frustrated by their inability to do so. A clearer instruction might have been, "Select one type of information."

The next direction is "Now select use option." That doesn't make sense; instead, it should read, "Now select a product." One of the problems with sites based in non-English speaking nations that offer English is a lack of usability testing by native English speakers. Most of the Foscarini website contains excellent, almost poetic, English. Sometimes it's easy to overlook a key component of the navigation, such as the instructions for search.

Once the information and product boxes have been selected, a pull-down menu appears with the instruction, "Enlight your product." Since there are no other attempts at lighting metaphors on the site, this key navigation instruction seems like an unlikely place to attempt one. Enlight is not a word, and even as an invented term for a label, it doesn't provide clear directions for visitors. The instruction should read, "Click a product in the menu below."

Overall, the sensibility of sparse navigation blends extremely well with the products that Foscarini offers. It does enlighten visitors in a modern, minimalist style that takes chances and accomplishes its goal.

≫

Search: Although it does provide a way to jump to particular products and designers, this search might be more of a hindrance than help to visitors because of its unclear instructions.

» TESTING, TESTING

Testing is probably the most overlooked, and yet the most important, process in building and maintaining website navigation. Your motto should be, "test early, test often." It's vital to gather feedback when you plan your site, build it, and put it on the Web.

There's little doubt that a successful website cannot be developed without feedback from impartial visitors who are *unfamiliar with the navigation*. Five or six people for every test cycle is enough.

People who match your target audience are ideal. Friends and acquaintances are okay for user testing, but workers from temp agencies, for example, are better. Regardless of your relationship to your test subjects, convince them that they won't hurt your feelings and that criticism is welcome. Never disagree with or correct someone who complains or expresses confusion. In fact, except for instructions, be as quiet as possible. In site testing, the tester is always right.

As you begin user testing, first decide what you're trying to find out. For example, can visitors easily and efficiently (with three clicks) perform tasks such as buying merchandise? Can they easily collect information?

Place your testers in a casual, comfortable atmosphere and have someone record their reactions. Leave yourself free to watch them. Don't lead them by saying things like "isn't this button great?" You can get feedback from them about such things as whether three options on the page are more appealing than a pull-down menu.

Testing should take place at several stages of development. You can test as soon as you have a viable navigation even if it's only sketched on several sheets of paper. It's simpler to use an eraser than to modify a digital website. You should also test after you've made a digital model of the site. Test again prior to launch and, of course, before launch, you must perform quality assurance by clicking on every active element and checking every piece of content.

After the site is up on the Web, use some method to get statistics on which buttons are being clicked. These paths can tell you which part of your site is popular and where paths led to frustration.

Like many other topics, much useful information can be gleaned from a Web search for "usability" or "user testing." There are companies that do nothing but usability testing.

Your navigation is service. Make certain your visitors are getting the best you can provide.

Conversion Rate

Client: **interactivetools.com** Web Link: **www.interactivetools.com**
Design Firm: **interactivetools.com** Site Builder: **interactivetools.com**

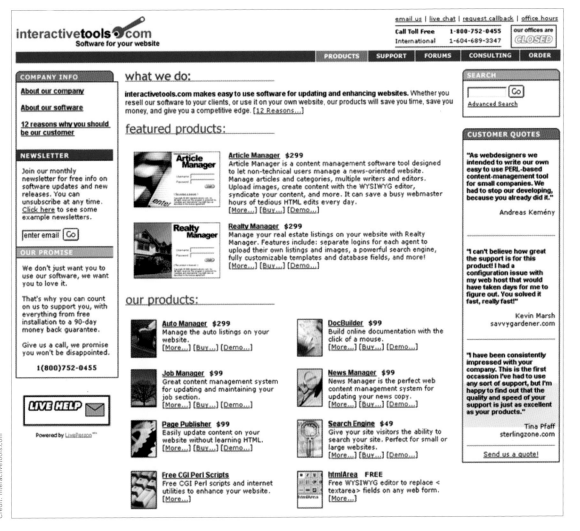

«

Home: The homepage is filled with information that is well balanced and well distributed. Among all of the text, the informative, hyperlinked options clearly stand out and provide visitors with obvious choices.

Interactivetools.com's software makes it easier to manage and enhance websites. The company started out building custom Web programs for individual clients, but in 1998, they realized that instead of writing specialized programs, they should concentrate on software targeted for specific needs and license it to a wide client base.

"Our website *is* our business," says Dave Edis, founder of interactivetools.com. "It's exceeded our expectations. Our main goal was to increase our conversion rate (the percentage of website visitors who purchase a product). From that perspective we asked: What could we do as a company to get greater returns from our website? From the perspective of a customer, we asked: How can we make the website simpler, easier, and more compelling?"

The company achieves these goals in large part by gathering and acting on visitor feedback.

Of course, interactivetools.com was tested many times before launch with their target audience and Web developers to ensure functionality and usability, but it really began to take shape after it was available on the Web. The company makes changes to their site by analyzing traffic logs, click paths, sales/conversion rates, and other helpful tools.

Dave Edis believes the real opportunity for improvement comes after a website is launched. Interactivetools.com measures clicks from the entry page right through to completing an order to see what works. They study the paths that are the most appealing and efficient for visitors.

Because a large amount of traffic travels through the site, interactivetools.com slowly makes incremental changes and analyzes the results. They try different groupings of product navigation links. When people place orders, interactivetools.com analyzes web logs to see which pages those customers had visited. What was it that had convinced them? Was it the screenshots of the software, the online demos, or something else?

Whenever interactivetools.com has a theory, they reorganize the navigation to suit it and repeat the process. If the new configuration generates more sales, it stays.

For example, there's a rectangular, blue button for an "Online Demo" on the "Product" pages (opposite page, left). Edis says, "Initially we weren't particularly fond of the aesthetics of it, but in testing we found that it generated significantly more click-throughs to the demos. The number of demos viewed directly correlated to the number of sales. That little blue box, aesthetics aside, makes us lots of money, and so we love it."

»

Partial Site Map: On this partial site map a search option displays the "no result" page when the search input is not found and the "search result" page when it is. "Advanced search" functions the same way though it's not explicitly shown. The map does show that "advanced search" is available on the "no results" page as well as the "simple search" page.

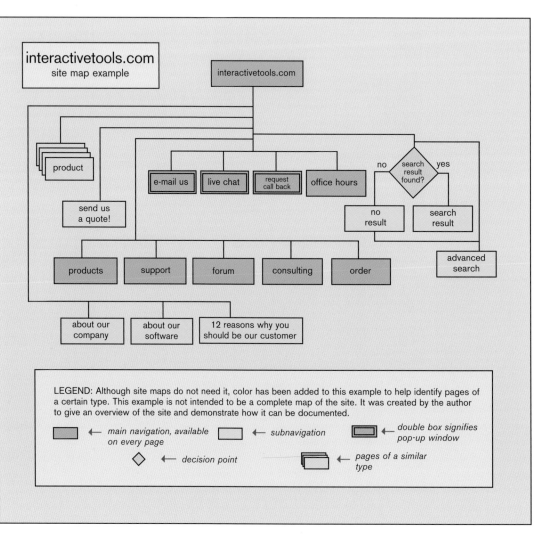

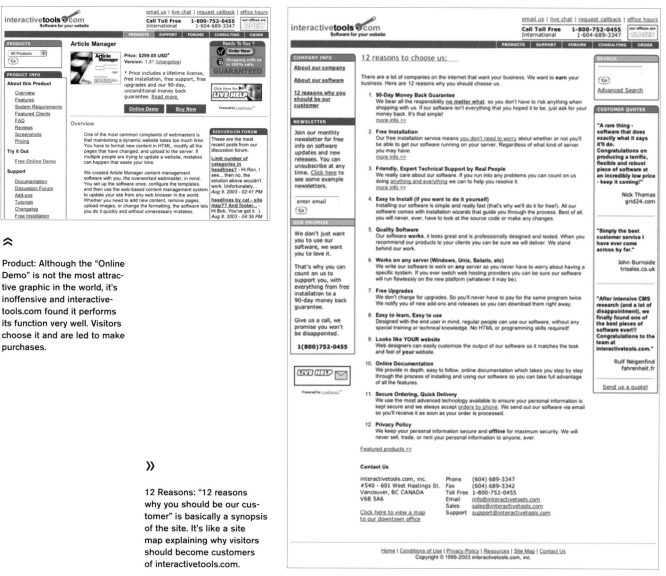

⮝

Product: Although the "Online Demo" is not the most attractive graphic in the world, it's inoffensive and interactivetools.com found it performs its function very well. Visitors choose it and are led to make purchases.

»

12 Reasons: "12 reasons why you should be our customer" is basically a synopsis of the site. It's like a site map explaining why visitors should become customers of interactivetools.com.

Who, What, Where, Why, How

The homepage of interactivetools.com is packed with information: company data, an invitation to join their newsletter, a service promise, a short explanation of what they do, products, a search, and even customer quotes. In addition, there are contact options and info.

So why does the page appear so organized?

One factor is judicious use of color and white space. The columns of gray bookend the product data. Each section has a heading highlighted in a placid color, and "Search," a service option, uses the same color heading as "Our Promise." In addition, "Newsletter" uses the same color as the group containing "Forums." There are also a couple of headings

with unique colors because using the same color all the time would be boring. However, using the same color in some related sections helps tie the page together.

Another factor that helps to organize the interactivetools.com homepage is the use of text as a graphic element. It's unlikely any visitor would read all the text on the interactivetools.com homepage, and this book suggests limiting text, especially on the homepage, to essential messages. However, if you need to use a fair amount of text to get your message across, this site is a good model for how to offer the text in manageable chunks as if it were a graphic element.

Direct to the Bottom Line

The interactivetools.com site flows well, beginning on the homepage with "What we do." To the left are the options: "About our company," "About our software," and "12 reasons why you should be our customer." At the bottom of "About our company" is a link that moves visitors to "About our software."

One of the bottom lines of web navigation is that you can, and should, tell a story in a linear fashion while at the same time offering visitors the choice to jump to any individual part. Interactivetools.com stresses the important interrogatories: who, what, where, why, and how.

The target audience of interactivetools.com is Web professionals such as website developers and Web masters. Direct answers to the questions above are the type the information those individuals want to get from a site.

As with other pages on the interactivetools.com site, there is a great deal of information on the "12 reasons" page (previous page), which is balanced by the fact there's not an overload of redundant information and options available. The site designers were careful to ensure that visitors could easily get from any one point in the site to another. Edis says, "We decided to focus on usability and function, and not worry about making things flashy or cool. Simple works and, even better, simple sells."

Two-Way Street

Another strong feature of the interactivetools.com site is their desire to provide a forum for their audience, rather than just a presentation.

On the "Support" page (below) there are links to a visitor forum (opposite) where a community of interactivetools.com users can post questions to both experienced customers and the company representatives.

Community-oriented features such as the forum and the free software interactivetools.com offers increase site traffic.

All Feedback Is Good

Another way visitors express their opinions is through the customer quotes column that is found on many pages of the site. Customer quotes can often be tricky. If you don't fully identify the source of the quote, visitors may not find it credible. On the interactivetools.com site, the commentator's website is identified. But if visitors go to the site and dislike it, that may reflect poorly on interactivetools.com. But Edis takes a different view.

"People are amazed that we actually post refund testimonials on our refund page. But it actually helps convince people that we are for real and that refunds are really as easy as we say they are."

Finally, you don't see one of the most important features of the interactivetools.com site. Because it uses Web skewed light graphics and well-designed text to get its message across, the pages display in a reasonable time, even on slower browsers.

"We wanted the site to be fast, both in page load times and in how long it takes somebody to find something or to 'get' our message," says Edis. "Often, you only have a few seconds on the Web to capture someone's attention, and if you don't… they're gone."

It's likely that visitors to a website like interactivetools.com will stick around to become interested buyers.

»

Support: All of the support options are available in one place and the choices are well described. If visitors can't find what they need here, it's unlikely their problem can be solved online.

Credit: interactivetools.com

email us | live chat | request callback | office hours

interactivetools•com
Software for your website

Call Toll Free 1-800-752-0455
International 1-604-689-3347

our offices are
OPEN

PRODUCTS | SUPPORT | FORUMS | CONSULTING | ORDER

Main Index | **Search Posts** | **Who's Online** | **Log In**

Interactivetools.com Forum
You are not logged in. Click here to log in.
If you are not a member, Sign up here!

2689 registered users

Forum Name	Threads	Posts	Last Post
General			
Announcements Announcements from Interactivetools.com. This is a read only forum.	12	12	Jun 20, 2003, 9:18 AM by Luke ➜
General General conversations about Interactivetools.com. Let other people know about your experience with our company and software.	48	253	Jul 13, 2003, 3:17 AM by tquinlan ➜
Feature/Product Suggestions What should we work on next?	204	776	Jul 23, 2003, 5:31 PM by Benjamin ➜
Template Designs and Designers Discuss and present your template designs.	45	201	Jul 25, 2003, 10:55 AM by Benjamin ➜
Off Topic Conversations Any topic that has nothing to do with Interactivetools.com or any of our software.	49	203	Jul 13, 2003, 9:19 PM by narumi ➜
Products			
Article Manager	804	3676	Jul 25, 2003, 2:17 PM by defrance ➜
Article Manager Add-ons	99	792	Jul 22, 2003, 12:02 PM by Donna ➜
Realty Manager & Auto Manager	461	1971	Jul 25, 2003, 1:21 PM by leeshields ➜
News Manager & Job Manager	42	140	Jul 11, 2003, 8:46 AM by Donna ➜
Page Publisher	79	274	Jul 25, 2003, 9:49 AM by gstrit24 ➜
DocBuilder	32	126	Jul 15, 2003, 4:14 PM by Donna ➜
Open Source			
htmlArea v2.0 Turn any <textarea> into a WYSIWYG editor	1068	4206	Jul 25, 2003, 2:02 PM by miked12345 ➜
htmlArea v3.0 - Alpha Release Discussions and bug reports on the new version.	212	739	Jul 25, 2003, 9:17 AM by Tobias ➜
htmlArea Add-Ons Posts of add-ons and mods for all versions of htmlArea.	122	1054	Jul 25, 2003, 9:50 AM by dsearles ➜

☐ = Forum has new posts
☐ = Forum has no new posts

Search all forums for [All words ▼] [_____] (Search) (options)

《

Forum: This option serves a great purpose and is one of those customer features that makes the Web a fantastic sales medium. Where else can a host of customers reveal their experiences and seek advice? It increases consumer confidence and encourages word-of-mouth advertising.

This is not a page layout but an illustration of good international practices. It's very difficult to be the perfect ambassador, but it's easier to begin thinking about this issue now rather than fixing it later.

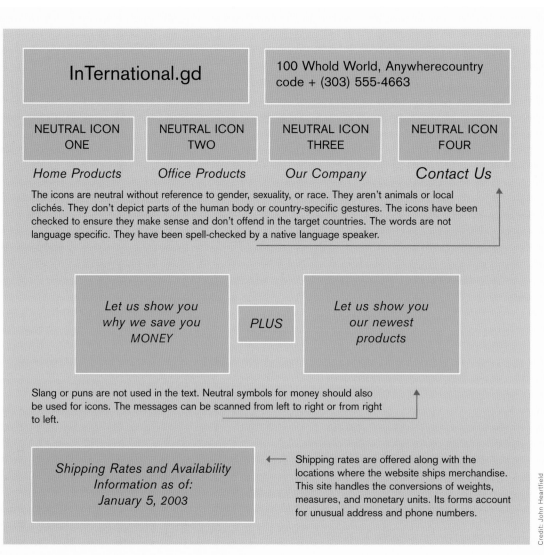

InTernational.gd

100 Whold World, Anywherecountry code + (303) 555-4663

| NEUTRAL ICON ONE | NEUTRAL ICON TWO | NEUTRAL ICON THREE | NEUTRAL ICON FOUR |

Home Products *Office Products* *Our Company* *Contact Us*

The icons are neutral without reference to gender, sexuality, or race. They aren't animals or local clichés. They don't depict parts of the human body or country-specific gestures. The icons have been checked to ensure they make sense and don't offend in the target countries. The words are not language specific. They have been spell-checked by a native language speaker.

Let us show you why we save you MONEY *PLUS* *Let us show you our newest products*

Slang or puns are not used in the text. Neutral symbols for money should also be used for icons. The messages can be scanned from left to right or from right to left.

Shipping Rates and Availability Information as of: January 5, 2003

Shipping rates are offered along with the locations where the website ships merchandise. This site handles the conversions of weights, measures, and monetary units. Its forms account for unusual address and phone numbers.

Credit: John Heartfield

International Issues: Making Your Site an Ambassadorial Success

The good news is that good usability and ecommerce practices are the same on the seven continents. If you make an effort to follow the advice in this book, your site will not require a great deal of modification to be a success in other countries.

Overall, language translation is the most important international issue. It's vital that a native speaker proof-reads the site when a foreign language is offered. Proofreading does not just apply to the text, but also applies to labels and icons.

In addition, consider cultural issues. In some countries, flowers are considered a formal gift and baskets of food are not given as gifts except to the needy. Coupons or gift certificates do not exist in some countries.

Review this list of actions in order to make your site a good ambassador:

Appropriate

► Translate icons and labels as carefully as the text.

Errors in spelling or grammar, especially obvious ones, make your site look unprofessional and your product or service suspect.

► Check labels and icons as carefully as the text.

Check labels that might make sense in one language but do not successfully translate to another.

► Use plants, clouds, rain, and other natural images as metaphors.

► Use neutral icons to depict money.

► Use arrows and universal geometric shapes.

The "+" symbol may not be used in Israel and some Muslim countries.

► Be cautious when using punctuation marks.

► Be cautious when using math symbols.

► Check the meaning of symbols, signs, and colors in other cultures. Their meanings can vary greatly and cause misunderstandings or worse when used inappropriately.

► Be aware of the reading direction (left to right, right to left, top to bottom) of your target countries.

► Keep gender and racial identifiers as neutral as possible.

► Include information such as shipping costs, availability, and conversion of weights and measures.

► Check the ability of order forms to handle unusual address and phone requirements.

► Represent dates of the year in a universal format.

"6/5/03" means the month of June in some countries and the month of May in others.

► Find out if countries permit their flags to be used in commercial applications.

► Find out international symbols for challenged individuals.

The wheelchair is an international symbol for many types of physical limitations. Black glasses on a face can serve as an indicator of a visual impairment.

Inappropriate

► Don't use icons that contain words.

Translations can be long. The English "on" is "aktiveret" in Danish.

Many languages do not have abbreviations.

► Don't use single-letter icons.

If "C" is used in an icon to indicate "Contact," it may confuse a German who spells it "Kontakt."

► Don't use puns.

► Don't use arm and hand gestures.

Many gestures that are normal in one culture are considered offensive or obscene in another.

► Don't use animals as symbols.

Animals have special meaning in some cultures.

► Don't use flags to indicate language choices.

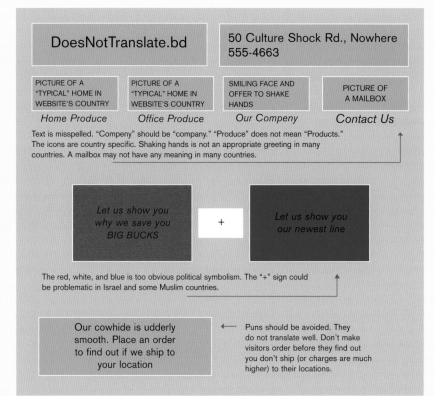

Credit: John Heartfield

► Don't use color combinations that evoke symbolic recognition.

A classic example is the red, white, and blue of the United States.

► Don't use parts of the human body as metaphors.

Be especially careful to avoid facial expressions that might be misinterpreted.

► Don't use sexual images or references to sex.

► Don't use metaphors that represent violence.

► Don't show local visual clichés such as brides, local money, etc.

► Don't show details about such things as electrical outlets unless they specifically relate to the product.

► Don't display religious images unless your site is based on religion.

► Don't display national political symbolism.

Check the Web for more detailed information about global ecommerce. In international websites, just as in diplomacy, it's essential not to inadvertently confuse, offend, or insult visitors.

⌃

Once again, this is not a page but a way of demonstrating a basic principle. A bad sales practice will lose customers. If you insult or confuse an entire audience you want to reach, that's a sales disaster of the highest order.

» MANAGING CONTENT

To programmers, *dynamic* implies something that changes and *static* implies something that remains constant. Pages on a website are often dynamic. Whether its navigation changes based on visitor feedback or when today's bargains are replaced with tomorrow's sale, a website should be modified at least as often as a store display.

Proper content management allows individuals in the development team to modify areas that pertain to their work. It also ensures that these changes can be reviewed and approved before the modifications are posted to the Web.

When content is managed with a process that doesn't employ dedicated content-management software, the task of storing, indexing, searching, retrieving, and organizing media such as texts, links, graphics, audio clips, scripts, or any other content can only be accomplished with constant discipline and a meticulous attention to detail.

Imagine a scenario regarding one simple change. The owner decides that two additional product options should be added. The information architect (or user interface designer) is informed so that the site map and wireframes can be brought up to date. The architect has to retrieve and store the updated files. The designer has to be sure of the correct placement, retrieve the old design, create the new options, and store the files. The HTML programmer has to retrieve the correct page and place the designer's work into the code so the page displays properly. The new HTML file must be properly stored. The quality assurance person has to check that the labels are correct and the links go to the proper places. The owner has to review the changes and, finally, someone has to be responsible for posting the updated files to the server.

Now imagine somewhere during this process that the owner added another product option. Even if the team is only one person, it's easy to see that if files are not stored and retrieved properly, the process would soon become an unmanageable mess.

If you're thinking that content-management software will solve all your problems, you may be in for a surprise. In February 2003, a Jupitermedia report stated that " …sixty one percent of companies who have already deployed Web content-management software still rely on manual processes to update their sites."

The good news is that more affordable and more effective content-management systems are being developed every day. Check the Managing Content sidebar on page 68 for more information.

Managing the Flow

Client: Roxen Web Link: www.roxen.com
Design Firm: In-house by Roxen Internet Software AB
Site Builders: Fredrik Noring, Jonas Walldén, Marcus Wellhardh,
Stefan Wallström, The Roxen Consultancy Team

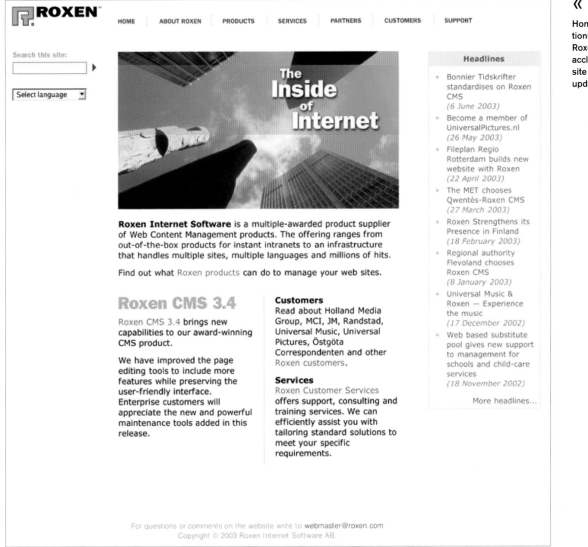

«
Home: The consistent positioning of elements on Roxen's pages helps visitors acclimate themselves to the site and allows Roxen to update their content at will.

Roxen has developed Web servers, content-management systems (CMS), and websites since 1994. Their prize-winning software products range from out-of-the-box solutions to an infrastructure that handles multiple sites, multiple languages, and millions of hits. Roxen has multiple websites, including one for developers.

"This site is aimed at customers, partners, and potential customers," says Fredrik Noring, M.Sc., system specialist of customer services.

A Template for Structure

Roxen uses the built-in graphically controlled navigation functionality of its own CMS to establish the navigation structure. One main (XSL) template is used to present the navigation elements on most pages. XSL stands for Extensible Stylesheet Language, a computer language for expressing stylesheets. Because templates can be connected, it's easy to make adjustments on particular pages while maintaining the overall layout from the main template. The navigation elements consist of images that are rendered dynamically using Roxen Graphical Text as specified in the template.

Of course, to manage their content Roxen uses their own CMS. But what if they made chairs instead of software? "There are a lot of content-management products on the market today," says Ronny Millberg, senior vice president of R&D/customer services. "It's best to stick to open standards such as XML and XSL to avoid getting locked into vendors. Look for vendors that support multiple operating systems, such as Microsoft Windows, Linux, and Mac OS. They'll provide you with more options in case you'd like to switch your server or client operating system."

Roxen believes their ability to maintain several websites and keep them orderly is due to the ability of their CMS to streamline website production and maintenance by providing solid structures for Web pages. A solid structure makes it easier to plan, design, implement, maintain, and develop websites.

»

Partial Site Map: Once again, it's important to emphasize that the site maps created for this book show only parts of the whole structure of the site. Site maps can be individualized for your specific needs. For example, page number, section, and/or template number can identify each page in the map. If color is not used, some other visual method can be employed to group the elements. For example, rectangles can be main navigation and ovals can be subnavigation. Diamonds are usually used for decision points. The system evaluates whether the answer to the question in the diamond is "yes" or "no" and direct the visitors accordingly.

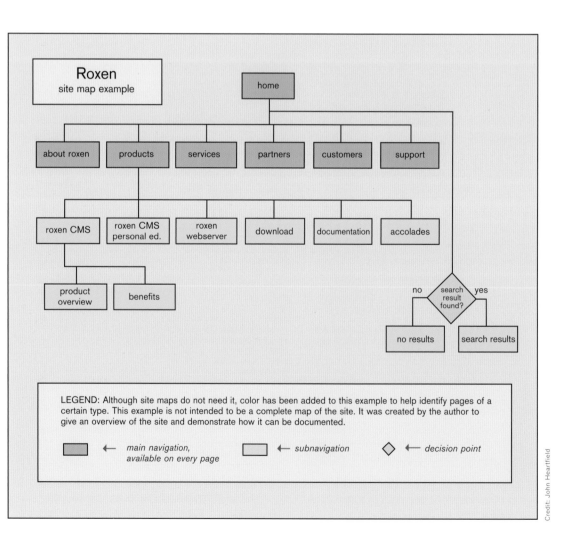

LEGEND: Although site maps do not need it, color has been added to this example to help identify pages of a certain type. This example is not intended to be a complete map of the site. It was created by the author to give an overview of the site and demonstrate how it can be documented.

■ ← main navigation, available on every page ■ ← subnavigation ◇ ← decision point

Credit: John Heartfield

« About Roxen: This page can be reached directly from the homepage, through the main "Press Center" page, on any other "Headlines" page, and even by loading itself. It's very helpful to give visitors a visual cue that a link refers to the page they're viewing and to prevent them from reloading that page by accident.

Small-Business Collaboration

"It's all about creating active websites in a very cost-effective and reliable manner," Millberg says. "Content management is definitely helpful for small business. For instance, since content-management software separates content and layout, it's very convenient to collaborate. For a small business, that means that an external design firm or individual can do the layout while the small company can update and maintain the content themselves."

Because a good CMS clearly separates tasks, maintaining content becomes much easier. A good CMS should also require very little technical training on the part of the end user. When a small business has a site that needs to be updated frequently that can reduce costs.

Roxen's homepage features clean elements laid out in a design that makes generous use of white space. The basic presentation of elements will be repeated again and again. However, this consistent placement of elements does not make for a boring site but, rather, one that allows visitors to explore without the necessity of learning a new layout for each section.

Automated Navigation

"I try to keep website navigation simple and consistent," Noring says. "When you go to some section on a website, it is important to quickly give a sense of what you can expect to find in that section without making the pages too large or too deeply nested behind links. On the technical side, I try to automate the navigation as much as possible through templates. This enables content editors to easily create new pages and subsections, which will automatically be included in the site navigation structure and layout."

On the "About Roxen" page (above), the global navigation options remain in place on the top of the page. Subnavigation is offered on the upper left. The "Search this site" and "Select language" options are carried over from the homepage but are simply moved down by the subnavigation options now above them.

There's a column on the left that offers a list of headlines, a natural choice for visitors are interested in reading press about Roxen.

»

Press Center: The large photo in the center of the page serves a dual purpose. It helps to soften this beautifully clean, but slightly sterile, website, while drawing attention to the important copy below it.

«

Services: At least two levels of navigation are apparent and because of placement and grouping, each set of options make sense. The "Services" page offers the subnavigation topics "Consulting Services," "Customer Training," and "Technical Support." The subnavigation within those options are readily available on the right.

The Relationship between Elements

The "About Roxen" page (previous page) creates an unusual navigation situation. The article chosen is offered in the center of the page. The visitor's location is noted by orange highlights ("About Roxen," "Press Center") in the global navigation and subnavigation. This page is a subsection of the "Press Center" section. But if visitors enter it directly from "About Roxen" and are then presented with other subnavigation options on the right, they may have the impression that this is the main "Press Center" area. In fact, it's not.

Clicking "Press Center" on the left brings up a page that not only has a clever graphic but also contains valuable information for reviewers and journalists (above, top).

This situation is easy enough to modify. Your navigation should present visitors with choices, but it's also important to consider the relationships between the options your site offers. Many of these relationships become evident by paying attention to visitor feedback.

Maintaining Quality Assurance

According to Noring, in a proper content-management system, quality assurance can be maintained though several stages. On an individual level, the author of the content previews changes before they're published. "For instance," he says, "When content, graphics, or templates are changed on the site, the owner of those changes should be able to browse the whole site and make sure it looks good everywhere before deciding to publish or discard the changes. No one else, including your colleagues, should be disturbed with the intermediate changes until you decide to publish them. That's part of what is called staging. Workflow is another important content-management tool that enables several people to be part of a quality assurance process."

When you present content that isn't self-explanatory, it's wise to identify it for your visitors. On the Roxen partners page (below left), the photo at the top seems to be a group photo of Roxen employees. It looks, however, as if it's identified by the text "Partners." Of course, "Partners" is the title of the section and it's certainly clear that this is a page devoted to RoxenPartner-based approach, but whenever there's ambiguity in any element of a Web page, it's wise to eliminate it. A small caption identifying the group of people in the photo and the location where it was taken might have been a good addition to this page.

Ease of Use Is Increasing

Roxen's customers are not just companies like MCI, educational institutions, and government services (below right).

"Making the Web accessible for small companies is exciting, and I believe that ease of use is one area that is being improved a lot today," says Noring. "This truly enables small companies to take advantage of the Web in a cost-effective way." One way Roxen reaches out to this audience is to offer a free download of their CMS Personal Edition. This feature has been a great success.

Millberg understands that visitors view a website as a reflection of a company's products. "People give positive comments on the clean and clear layout and the simple navigation," Millberg says. "It helps them to believe in our competence building software tools. In a way, our own site is a proof of concept."

Roxen continuously updates the site through research, visitor feedback, customer interaction, and by watching the competition. When they do need to change, they find that everyone's on the same page.

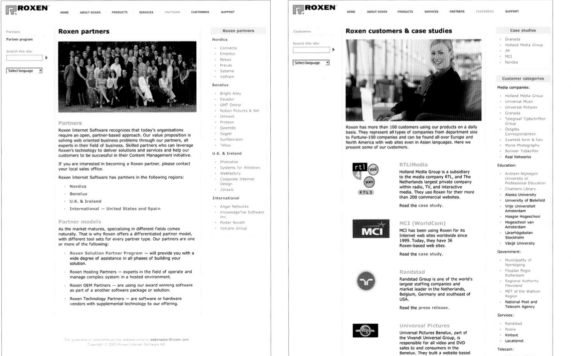

Credit: in-house by Roxen Internet Software AB, Photos by Morre Photography

Credit: in-house by Roxen Internet Software AB, Photos by Morre Photography

« Partners (far left): A photo of Roxen employees creates a friendly identity for the business, but visitors may wonder who they are. A small caption or paragraph identifying the members of this group might be a good idea.

« Customers (left): Demonstrating your experience with case studies and customer referrals is an excellent way to build customer confidence in your online business. Roxen also offers a free download of their CMS Personal Edition for customers to try.

» OFFERING MULTINATIONAL CONTENT

Start thinking about your site with the world in mind, because although the Web is already an international forum, soon it will be a universal marketplace. Reaching a multinational audience adds layers of complexity to website development and maintenance, but if you consider international issues during planning, you'll be ready to sell to the world.

The number one issue to consider when planning multinational content is language. Even American websites have to keep in mind that British English is different from American English. For example, if a car-parts wholesaler in California wants to sell in England, they must understand that spark plugs are located under the bonnet, not the hood.

Other language hurdles are florid translations and misspelled words. Site builders that offer more than one language often believe that a nonnative speaker can simply translate the existing site copy. It's much easier to read another language than it is to write in that language. If you want your site to appear professional, you must have a native speaker produce, or at least proofread, the text. Be sure the labels and icon text are checked as well.

A great deal of text on the Web is wordy, confusing, and poorly written. When that text is translated into a foreign language, it can read like mush. Here are some quick tips to improve your text and facilitate the translation of websites into other languages:

- Sentences should not contain more than twenty words.

- Only one thought should be expressed per sentence.

- Each paragraph should consist of a maximum of three sentences.

- Don't format text using uppercase type.

 Visitors tend to read slower when reading uppercase text.

Two other major issues stand out when opening up shop in another country: pricing and content management.

When your site offers merchandise in another country, you'll need to have some idea of the local cost of your merchandise and the tax and shipping issues. Sites should offer a monetary conversion feature; one possible solution is linking (ask for permission) to a good public site that performs this function.

For content management of international material, you may decide to have more than one URL or offer all your content on one site in different sections. In either case, an international site at least doubles the chore of keeping the site updated. You'll have to create a cohesive plan to handle the extra work.

All that extra work will be worth it when you're taking orders from around the world.

Selling Outside
the Border

Client: **Palo Alto Software**

Web Link: **www.paloaltosoftware.com/www.paloalto.co.uk**

Design Firm: **Palo Alto Software, Inc.**

Site Builder: **Noah Parsons**

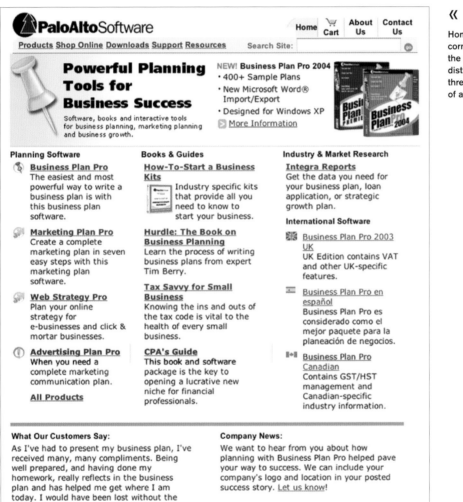

«

Home: In the upper right-hand corner of paloaltosoftware.com, the ecommerce option is distinguished from the other three choices with the addition of a shopping cart icon.

Credit: Palo Alto Software, Inc.

Palo Alto Software, Inc. develops, publishes, and markets software products for personal computers. Its target audience is small and medium-sized businesses that require business-planning software and start-up advice.

Based in Palo Alto, California, the company's software is available in versions specifically developed for a specific country's business environment and are marketed on the Web for audiences in those countries. Palo Alto Software's website provides product information and sales, product support, and online registration and updates.

To construct the navigation, the site builders analyzed statistics from their old site, interviewed existing customers, talked to potential customers, and consulted key players inside the company.

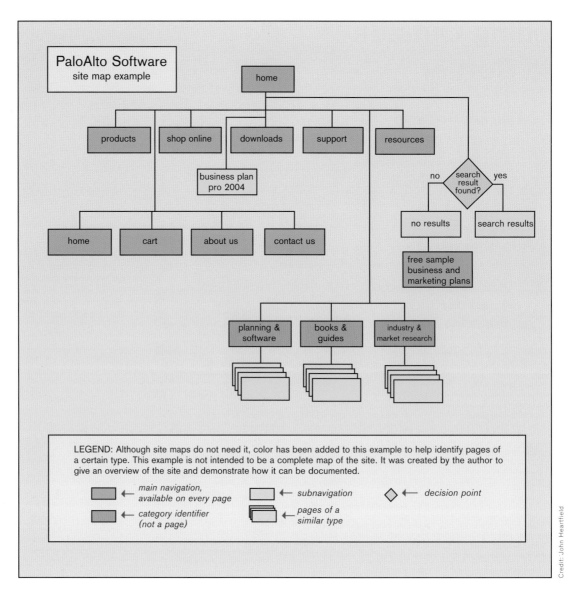

»

Partial Site Map: This partial site map contains "category identifiers" such as "planning & software." They're not pages but simply identify groups of options in the navigation. In this case, the site just indicates there are multiple pages under the "category identifier."

The Homepage Does Not Always Come First

"It turns out that the vast majority of our traffic does not originate at our homepage," says Parsons. "We found it's much more important to focus on product and product category pages because that's where the vast majority of visitors enter our site due to search engine listings and links from other sites around the web. Our primary landing pages have to be good entry pages."

To determine main navigation options, Palo Alto created profiles of their potential visitors. Then they analyzed the tasks those visitors would be likely to do and created scenarios. For example, a visitor might come to the site looking to find out if two products had the same features. The navigation has to simplify tasks as much as possible.

Parsons had an effective test when choosing labels for the main navigation. If he told a stranger a navigation label, it would have to be immediately clear to them where that option would take them on the site.

Designing with Card Sorting and Visitor Tasks

Palo Alto also did some simple index card sorting exercises to determine the primary navigation elements. What was the correct order? What option should be a subset of another?

We also followed certain established 'standards' in web design," Parsons says. "For example, we believed links to "Press" and "Privacy Statement" are usually found at the bottom of the screen. "Shopping Cart" links are typically in the upper right."

Credit: Palo Alto Software, Inc.

Credit: Palo Alto Software, Inc.

Credit: Palo Alto Software, Inc.

« Business Plan Pro Premier U.K. (far left): The British site www.paloalto.co.uk uses the same general layout, though there are many details to consider including monetary issues, product differences, and even language.

« Business Plan Pro Premier U.S. (left): There's a separate URL for the British version of this software, but if visitors land on this page, all of the international and cross-platform versions of the software are clearly available.

« Flash Product Tour (below left): A dark gray control strip in the bottom right corner controls the multimedia tour. Notice how the icons are immediately identifiable as: "Back to beginning," "Back one page," "Play," "Pause," "Forward one page," and "Information."

Multinational Sites Have Specialized Issues

In the lower left of the "Business Plan Pro Premier" page (top right) are options for United Kingdom, Spanish, Canadian, and Macintosh versions of the software (see above right). Offering international versions of the products and the website greatly increases the complexity of both development and maintenance. But that effort has paid off.

"Our move to the U.K. (above, top left) was an experiment and we were not certain that it would be successful," says lead designer Noah Parsons. "But it's grown faster than all of our expectations."

One of the most significant issues is pricing. When Palo Alto expanded internationally, they created a subsidiary business to function in the United Kingdom that handles its own taxes and manufacturing. This subsidiary needed to price for the local market while not differentiating too much from U.S. prices. Pricing correctly for the local market ensures that you are positioned for growth against local competitors.

"As with any foreign site, it is critical to not just do a translation of your website, but to also deal with nuances in the local language," Parsons says. "This concept is especially difficult to deal with when translating to British English."

Localizing content is just one step. Palo Alto Software also has to deal with managing similar, yet slightly different, user interfaces, keeping the two sites' content updated in parallel, and managing two separate store fronts with different merchant accounts.

Parsons says, "We've received overwhelmingly positive feedback for moving internationally and for dealing with the U.K. market specifically. Visitors are extremely happy that we aren't just trying to sell a purely American product."

Credit: Palo Alto Software, Inc.

≫

Side-by-Side Comparision: Visitors enjoy a side-by-side comparison of similar products, which allows them to make the most informed purchasing decision. Side-by-side comparisons may also convince visitors to make a higher-end purchase based on the extra features displayed.

Credit: Palo Alto Software, Inc.

≪

HTML Tour: This is the HTML version of the tour. Although it's much less flashy in appearance, it seems to serve its purpose just as effectively as the high-bandwidth tour. Making a decision about whether to offer low-bandwidth or high-bandwidth pages depends on the capabilities of your target audience and your own market research.

Visitors Must Retain Control

One feature visitors enjoy is the Flash demo that takes visitors through a Palo Alto software application step by step (see previous page).

Whenever a playable piece of media is offered on the Web, it's good navigation courtesy to let visitors control the presentation. This demo is controlled by a clearly delineated (by color and the hyperlink hand) control strip in the bottom right. The controls should be familiar to anyone who has ever used a CD player. The enormous importance of the familiarity quotient of icons has been mentioned in other places in this book and should be considered a vital component of website design.

Is a Flashy Tour Worth It?

For their low bandwidth audience, Palo Alto Software also offers an HTML version of their demo (above left). In fact, on the U.K. site, this is the only demo currently available. "The availability and penetration of broadband in Europe is much lower than the U.S.," Parsons says. "Broadband features are less likely to provide a good user experience in Europe. We also wanted to experiment with the Flash tour's ability to sell additional product. To date, we don't have conclusive data that indicates that the Flash demo is any more effective at selling the product than the HTML demo. Until the U.S. demo proves its marketing effectiveness, we won't make the investment in the United Kingdom."

Comparison Shopping

Often a website offers products that are similar in nature but vary a great deal in features and price. Under those circumstances, it's highly recommended that the website offer a product comparison page. Visitors want to know exactly what features they'll be missing with the less expensive version and what features they're getting for the added cost. Many times, a product comparison page can be the deciding factor in a buying decision.

Palo Alto had a high degree of feature overlap between their Business Plan Pro Premier and Business Plan Pro software. They listened when customers told them they would rather find the product information in one location so they could easily compare the products (opposite). The customers also wanted to be able to quickly navigate to a page solely about one product, such as Business Plan Pro Premier.

By featuring the products side by side on one page and focusing on the features and "What's New" of one product on another, visitors have a better overview of the two products and are better able to decide which is right for them. It also provides Palo Alto with a better opportunity to market the Premier features to shoppers who initially might only have considered the Pro product.

How Can I Help You?

When customers consider a buying decision, Palo Alto Software knows that their customer support system is as vital as the features of their products.

Their "Support" page (below) includes the ability to browse topics, a list of FAQs, and a separate "Search" option devoted to support issues.

Because small businesses often get and maintain customers based on their level of service, it's vital for the navigation to have a section that highlights the company's commitment to service, especially when the quality of the company's product is directly tied to good service.

Parsons is well aware of this. "Give the customer what they want, when they need it," Parsons says. "You have to ensure that customers can find exactly what they need in order to make a purchase decision while overall increasing company sales and also ensure that deep-linked customers from places such as search engines and other sites can understand what the site is about and how to navigate it from any entry page."

You'll Never Really Know until You Test

The best way to meet those goals is through solid planning and early and consistent user testing. Palo Alto Software conducted usability tests at every stage of development. They conducted two major primary rounds of testing and several internal rounds. They also continually redesigned individual pages and processes based on these tests and standard Web analyses.

Parsons says, "We avoided offering too many levels of navigation and made sure that critical links were obvious and easy to find. No matter where they enter the site, it's vital that customers can understand what the site is about and how to navigate it."

By taking that philosophy across international borders, Palo Alto Software has made its Internet presence so successful that they are looking forward to expansion into other international markets.

«

Support: The "Support" page features a product search, topics for browsing, live chat for some products, and an FAQ section. These are just a few of the support mechanisms built into the navigation. There's even a live chat feature to reach a company employee on the Internet in real time.

» DESIGNING FOR YOUR VISITOR

Your website should consider your visitors' interests, capabilities, and goals as well as their interactions with the navigation. A usable website cuts costs and increases visitors' satisfaction.

▸ Don't let visitors get lost.

Label each page so visitors always know where they are.

Ensure your navigation gives visitors a way out if they make an error.

Don't have dead-end pages. A dead-end page doesn't provide visitors with any navigation option except the back and forward buttons of the browser.

▸ Make options available, clear, purposeful, and easy to remember.

▸ Don't use frames. Frames interfere with the function of many browser features including printing, bookmarking, and the "back" button. Many Web users use the "back" button as a primary means of navigation.

▸ Find a balance between clicking down to targets and offering too many options on one page.

▸ Offer a search option and/or an online site map to complement navigation.

▸ Understand that visitors don't *read* Web pages, they scan for chunks of information.

▸ Make text easy to read.

Keep sentences short and simple.

Use sans serif fonts in body text.

Don't make text too small.

Don't use dark text on a dark background.

Don't use jargon, idioms, metaphors, puns, or too much humor.

▸ Make visual design a component of usability.

Create interesting pages that are uncluttered.

Use white space to make elements stand out and give visitors a visual rest.

Don't decorate the site with extraneous graphics.

Make important elements the most visible.

Think of text as a graphic element.

Visually separate and group navigation.

Design pages in black and white, then add colors sparingly and one at a time.

▸ Offer visual feedback if download constraints permit.

To make the guidelines above meaningful, you have to know how your target audience interacts with your site, so get them involved in the process as soon as you can. Don't lock yourself into a final design right away; instead, get as much feedback as you can from the people you want to reach.

And, of course, at every stage of the design, test the site. The only way to know if your site is usable is to have objective visitors test, test, and test again.

Be Our Guest

Client: **Taj** Web Link: **www.tajlounge.com**
Design Firm: **3dot3 media (3dot3.com)**
Site Builders: **Dirk Winkler (urbanagent)**

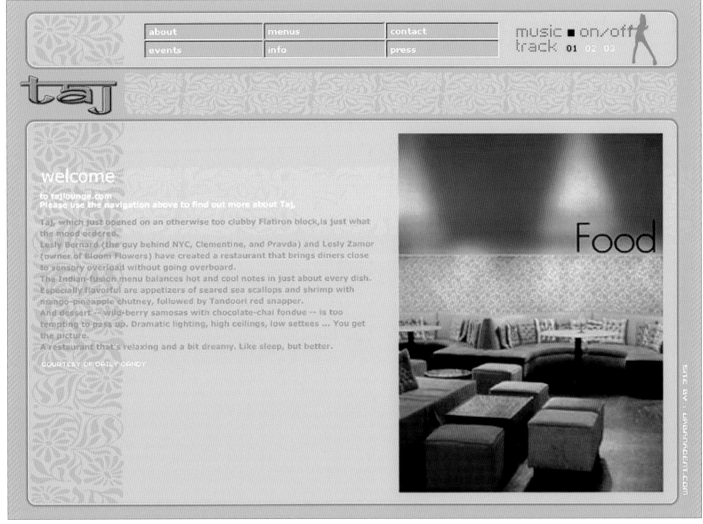

Taj, an Indian fusion restaurant and lounge, opened in April 2003. Long-time friends Lesly Zamor and Lesly Bernard created Taj by combining their experience in design, cuisine, and nightlife.

Site builder Dirk Winkler began by establishing the site structure and then the style and design direction. He drew his inspiration from the interior design, feel, and atmosphere of Taj.

To realize his design, Winkler relied on Flash and the result is an exemplary model of tasteful Flash usage. "Unless the subject matter calls for it, less is more in Flash," Dirk Winkler says. "Unnecessary glitz is heavy and disturbs good, clean design."

Home: This "Welcome" page is seen only once as visitors enter the site because once a global navigation option is chosen, there's no option in the navigation to return to it. It's less than a homepage and more a splash screen because visitors can navigate to other sections of the site from it.

》

Partial Site Map: This partial site map shows a slightly unusual navigation. Two splash pages precede a "Welcome" page that appears only once when the URL is loaded. After that, there are six main navigation choices and, in essence, the "About" page functions as the homepage.

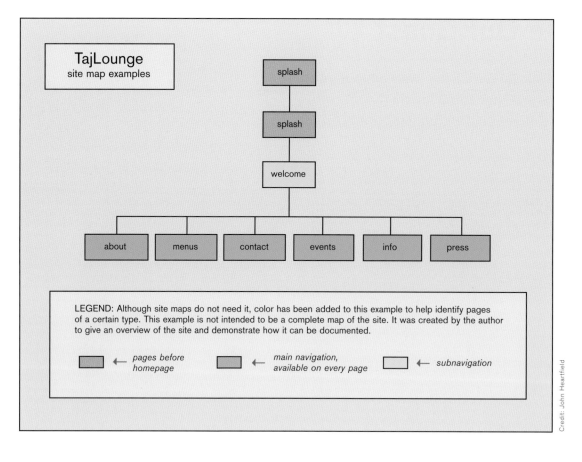

You Only Go around Once

Visitors see the "Welcome" page only once as they enter the site. Usually a page with that description is known as a splash page and is used to check such visitor parameters as language, plug-in (Flash, QuickTime) capabilities, or bandwidth preferences. Because it's meant as a site information or settings page, global navigation is not normally offered on the splash page. On the Tajlounge.com "welcome" page, visitors see a welcome text message and the actual global site navigation.

Dirk Winkler says, "It's meant to be 'the first page' of an interesting site. There's a quote from a press release to awaken interest, clean design, and clear navigation. I like to experiment if I can still establish my goals by doing so."

It's an interesting idea, but it can be problematic. If visitors arrive, read part of the press release, and then navigate to another part of the site, they'll have no way to return to the "welcome" page to finish reading unless they reload the site's URL. After any global navigation option is chosen on the "welcome" page, the "about" page (opposite, bottom) essentially becomes the homepage. Fortunately, the main navigation choices are so simple and clear this is not a major problem but it does show that when a designer challenges a very established convention such as the homepage, it can lead to difficulties.

Functional and Beautiful

The beauty of Tajlounge.com is noteworthy. Part of usability is pleasing the eye of the visitor. The muted but rich colors combined with striking photos and morphing labels on the right side of the screen are a feast for the viewer.

"The goal was to be informative as well as stylish and represent the good time you could have at Taj," says Winkler. "People like the dancing girl in the top right corner and the music choices. When they see the site they say, 'Wow, these guys are serious.' "

Next to a dancing girl, who seems to be gyrating in a random manner, is a nicely designed music control. When the welcome page is loaded, the "music on/off" button blinks several times to draw the visitor's eye to it. If visitors do not click the button in a second or two, the music starts automatically. If visitors prefer to mute the music, a discreet play button blinks until they turn it on again. There are three tracks of pleasing musical loops from which to choose.

Although Tajlounge.com does not follow this book's recommendation that sound should not be played unless visitors request it, in other respects the site offers visitors the basic controls that should be available when sound is not an essential aspect of the site's navigation.

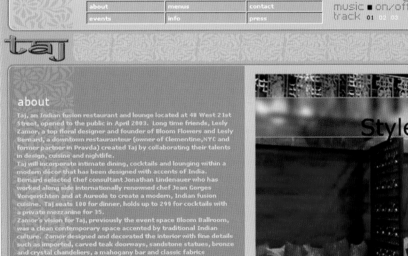

Credit: Dirk Winkler, 3dot3media

≪

Menus: Simply listing the ingredients of the entrées can make the dishes seem more irresistible than any flowery description could. The only thing this page lacks is a bit more space between the text paragraphs on the left.

≪

About: Once visitors pass "welcome," the "about" page is the closest thing to a homepage. It's a somewhat unusual navigation, but Tajlounge.com pulls it off nicely because of the clean, simple structure of the navigation options.

Credit: Dirk Winkler, 3dot3media

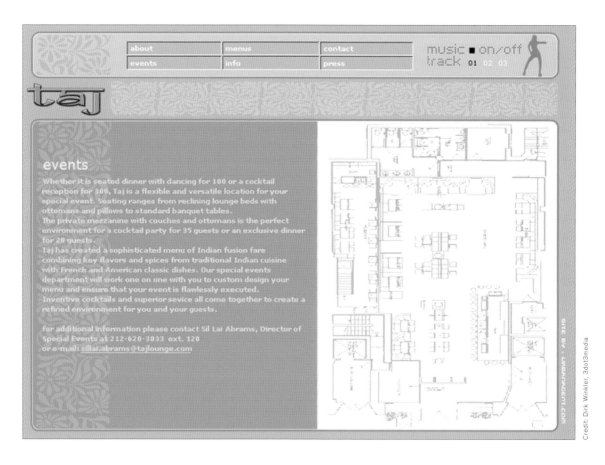

So Tasty

⌃

Events: People who plan events often require floor plans. It's always good to be able to say to a customer, "That information is available on our website." It would be great to have a printable version, such as a PDF file, of the floor plan as well.

Other than the music options, there are only six navigation choices: "about," "menus," "contact," "events," "info," and "press."

When visitors roll over one of these options, they receive visual feedback in the form of a quick animated color change and icon display. This animation does not interfere with navigation as visitors can click through it at any time.

Clicking on menu adds four more options, "appetizers," "desserts & drinks," "entrees," and "cocktails," whose design echoes the main navigation. Each option loads a portion of Taj's menu onto the right-hand side of the screen. The name of the entrée, a simple list of ingredients, and the prices provide visitors with information they want to know. Winkler says, "Remember that people do not like to read volumes on the Web, and only valuable information should be displayed."

To the left are several short paragraphs about the food at Taj. It might have been better to introduce some space between these paragraphs for better Web readability.

"It's on Our Website."

One of the ways to encourage traffic on your site is to make it a resource for your business. Imagine the following scenario: Someone wants to organize an event, so they phone Taj and ask about the floor plan of the restaurant. Taj's special events coordinator is able to say, "We can fax one to you or it's available on our website (previous page)." The prospective customer goes to the Taj site to retrieve it.

The customer then says to three or four friends, "I just saw a great site–take a look." Each of those people tells three or four more in turn, and soon, a large number of potential customers has been made aware of Taj. This concept is known as viral marketing and is a good reason why every small business website should offer something of value to potential customers.

The People behind Taj

The "information" page (below) offers all the information that a potential guest of Taj could want and more. Naturally, there's essential information such as the address and phone numbers, but this page also contains the names of the designer, the managers, and the executive chef. This instills a feeling of confidence that there's pride in the creation and operation of Taj.

Taj owners and employees should also be proud of the website. Tajlounge.com is a visually engaging site that welcomes visitors and follows tenets of good navigation design.

Information: While the dancer dances in the upper right corner and the screen continues to morph in a gentle, nondistracting manner, Taj's information is offered on the left side. Overall, Tajlounge .com gives visitors a multi-sensory feel for an atmosphere that seems sure to attract new patrons.

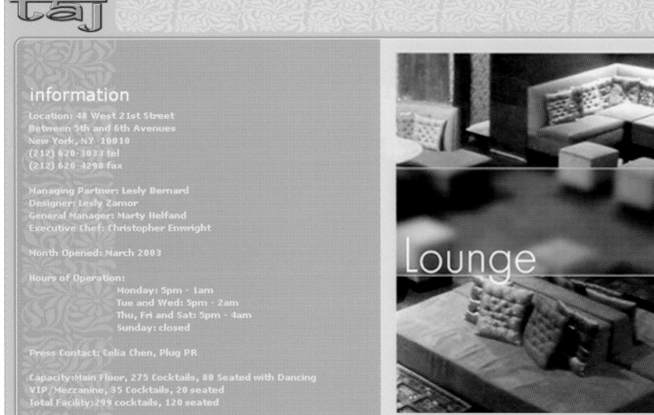

about menus contact music ■ on/off
events info press track 01 02 03

taj

information

Location: 48 West 21st Street
Between 5th and 6th Avenues
New York, NY 10010
(212) 620-3033 tel
(212) 620-4298 fax

Managing Partner: Lesly Bernard
Designer: Lesly Zamor
General Manager: Marty Helfand
Executive Chef: Christopher Enwright

Month Opened: March 2003

Hours of Operation:
 Monday: 5pm - 1am
 Tue and Wed: 5pm - 2am
 Thu, Fri and Sat: 5pm - 4am
 Sunday: closed

Press Contact: Celia Chen, Plug PR

Capacity:Main Floor, 275 Cocktails, 80 Seated with Dancing
VIP/Mezzanine, 35 Cocktails, 20 seated
Total Facility:299 cocktails, 120 seated

Lounge

» BEING YOURSELF

This book stresses simplicity and consistency again and again. But some readers may wonder if always being simple and consistent leads to boring websites.

The truth is that because the Web contains so many sites that are not simple and/or consistent, if you follow the advice offered in this book, your website will be the exception rather than the rule. In contrast, it's the frustrating and annoying sites that are boring.

Consider this: When you use a remote control to watch television are you more concerned with what's on the screen or interpreting and appreciating the design of the remote control? What most people want from a remote control is ease of use. It may be innovative for a remote control to have a button "→" on the right to lower the volume and a button "←" on the left to raise the volume but that design goes against accepted standards. Its inconsistency would likely annoy and confuse the user.

That does not mean that navigation design should not be innovative—quite the opposite. Navigation is a tool like any other. Everyone waits for a pioneering interface designer (or information architect) to construct a revolutionary and highly usable navigation.

However, the chances of an amateur designer stumbling upon such a navigation are about the same as an amateur cyclist developing a groundbreaking method of constructing a world-class racing bicycle. It's not impossible, but it is unlikely.

There are instances where you should consider giving your navigation a main role in the show:

▸ You are an expert at a particular technique and you use that technique to present your information.

▸ You are working with an experienced and talented interface designer or information architect.

▸ You're convinced your product will not shine on its own on the Web and unique navigation will help it stand out.

Even when any or all of the above conditions apply, remember the advice in this book as well. If you be yourself, make sure "yourself" is always helpful, coherent, and clear.

My Name Is Alexis Trépanier

Client: PixelPharmacy
Web Link: www.pixelpharmacy.com
Design Firm: Alexis Creative Interactive
Site Builder: Alexis Trépanier

Credit: Alexis Creative Interactive

Credit: Alexis Creative Interactive

The PixelPharmacy website navigation doesn't reflect some of the basic navigation advice offered in this book. So how did Alexis Trépanier, the Montréal-based creative/interactive digital artist, fly in the face of many established interface tenets and still create his extremely entertaining and usable website?

The answer is that Trépanier knows exactly what audience he wants to reach and how he wants to present himself. PixelPharmacy is a site about discovery. The site's navigation challenges visitors to uncover all the amusing surprises Trépanier has incorporated into the navigation as they browse.

Home: Trépanier, shown here about to set down a contact button at the beginning of his welcome speech, has just placed a skip button on the screen. Any site that automatically plays an animation, video, or sound must offer a clear option to the visitor to skip that presentation.

Partial Site Map: This partial site map shows that there are a great deal of main navigation options. Although the site is inventive and amusing enough to challenge some navigation principles, it might have increased usability to group some of these options.

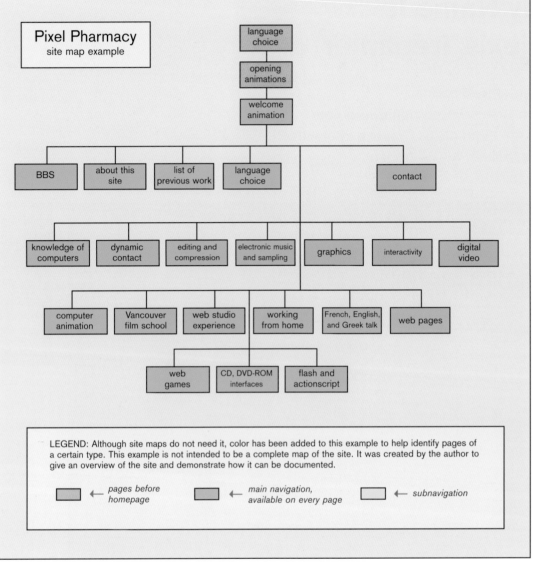

Credit: John Heartfield

A Very Personal Welcome

PixelPharmacy's group of sixteen main navigation elements is introduced one by one during a video about the life and work of Trépanier. This speech plays automatically when the visitor enters the main site. A short, but mandatory, animated introduction with music precedes it.

After Trépanier's welcome speech is complete, the navigation buttons are available on the screen in a circular pattern with no apparent hierarchy. Only icons identify them. On rollover, text informs the visitor what information is available by clicking on the icon.

"The navigation is based on my speech," Trépanier says. "I wanted it to be laid down as naturally as possible like in a live presentation." Fortunately, his presentation is very humorous, a key component of any good speech.

"I personally prefer being told something with sound and images instead of text when possible," he says. "That's what I tried with my portfolio."

Trépanier never worried about graphically designing anything when he was in school because he was too busy playing with all the computers, cameras, and sound equipment. After graduating he discovered he needed a portfolio to find a job.

An Essential Option to Skip

At the beginning of his welcome narration, Trépanier places two buttons on the screen, allowing the visitor to skip to the site's content or contact Trépanier. Later, these choices become "replay" and "contact" and are always available to the visitor (below left).

His introductory video is so appealing most users will probably watch it more than once. Where did he get the idea to present his interface elements in this manner? He had long hair and decided it was time to get it permed. Trépanier brought a digital video camera to film the process. Looking at the footage in accelerated mode gave him the idea for the PixelPharmacy portfolio.

Everything is based on his narration. The order in which interface elements appear on the screen is the order that naturally came to him while writing the speech.

"I vaguely knew how the interface would look when I wrote it," Trépanier says. "I just wanted to make a big 'in your face' Flash stunt. First, I thought of presenting myself as a cheesy Flash character and then I thought it might be better if I made something more subtle. That's when I had the idea of recording the speech while getting my afro cut little by little."

Once he had the footage he started designing the way the buttons would appear along the speech.

"I tried a wave going from left to right, but it looked messy. Then I tried organizing them into a circle around me. Then again, just the buttons appearing out of nowhere didn't make much sense. That's when I tried different ways to sit them down on some kind of a tab that would follow the circle idea. I made the bevelled circular tabs with the Photoshop layer styles and voilà," Trépanier says.

This is Trépanier's personal style of design. He's obsessed with innovation and wants to push media formats to make them work as he wants them to work.

Credit: Alexis Creative Interactive

≫

Main Navigation:
PixelPharmacy is constructed in Trépanier's voice. The PixelPharmacy navigation is like having a congenial host inviting you to explore the many interesting rooms of his house. Although it's usually not a good idea to have visitors read long instructions regarding the navigation, the host, Trépanier, wants to show the visitor around.

1. The interface :
A Flash file containing all the programming, the graphics, the animations and the short text.

2. The text :
Split into dozens of tiny files, this information is instantly downloaded when requested. Being stored in simple text files it is extremely easy to make changes without needing anything else then a text editor.

It is also more efficient to use this method to integrate text requiring special characters like japanese assuming that the users have the japanese font on their computer.

3. The speech:
Recorded in 3 languages it is stored in 3 different MP3 files that download simultaneously to allow seamless switching between languages during the visit of the site.

4. The video track:
Another Flash file, bigger, that starts downloading as soon as the site is accessed. A script evaluates the remaining download time and starts the playback before the file is even finished downloading.

Credit: Alexis Creative Interactive

«

About This Site; Most magicians don't like to reveal their secrets; however, Trépanier is not selling the magic but his ability to create it. This is an excerpt from his "about this site" option.

How It Works

≽

Computer Animations: These choices are subsections of "computer animations" (the lighter button). They are reached through a short written introduction where Trépanier calls animators "animals comparable to monkeys or seals, skillful and entertaining." Trépanier definitely wants visitors to know him as well as his work. Clicking on the titles launches small windows that display clever animations.

The site works brilliantly on faster computers with broadband connections but falls apart when accessed on slower machines and/or dial-up modems. However, Trépanier wasn't concerned that his site wouldn't be available to everyone because he had clearly decided on his target audience. This site was meant to help him find work. Whether it was going to be within a company or as a freelancer, he didn't want to make 56 K content. He wanted his site to feature streaming video.

The main navigation choices are always consistent yet each element has a unique style. For example, the "at home" frying pan is larger than the "digital video" choice. That was an accident and not a choice. In such an artistic navigation, it's less important to ensure that every element of equal weight is the same size.

Room to Breathe

Like any good digital designer, Trépanier uses space sparingly and well. Although he offers many navigation choices, much of the screen is empty and his design does not appear crowded. His subnavigation choices consistently appear in the center of his main navigation choices. He often uses sentences such as "here are some animations I did" to invite the visitor to explore further.

Even with so many clever visual effects on the site, Trépanier avoided animated navigation elements except in two places. One occurs when the visitor chooses "at home" and the pan fries up a crepe. However, it's done in the background and information can be accessed immediately.

There are six interface elements that stand apart from the others on the upper left-hand corner of the screen. Three allow the visitor to change the site's language to English, French, or Japanese. The other three are a "list of previous work", "about this site", and "BBS" (opposite). "About this site" is an interesting behind-the-scenes look at how the site is designed. "BBS" is a bulletin board where visitors can post their reactions to PixelPharmacy.

A BBS, or Bulletin Board Service, is an area of the site where visitors can post their opinions, ask questions, or read the postings of other site visitors. The term may not be familiar to novice Web users. Trépanier realized that afterwards when his mother called him about his site rather than leaving him a message for him on the PixelPharmacy BBS.

Another minor problem for visitors could be that there's no visual feedback on rollovers of "list of previous work," "about this site," and "BBS." Trépanier's response is quite practical. "I gave myself however long I needed to come up with a good website. For some reason, after two months of doing only that, sleeping when I was tired, waking up when I felt like working again, these details became invisible to me."

The Somewhat Unusual Planning Stage

In other sections of this book, it's recommended that the initial design of a website should be done with a pencil and paper. For most developers, that's a good policy. However, you should always work in the design medium that feels most natural to you. "I draw, program, experiment in Flash better and faster than I can sketch on a piece of paper. In a way, we can call it digital sketching. I usually do that kind of stuff for planning websites. For PixelPharmacy, I did it directly since it comes from a timeline and not a site map with a hierarchical structure," states Trépanier.

In general, while incorporating some established interface practices into Pixel Pharmacy's innovative navigation design, Trépanier was able to play with the interface structure because he was secure about his goals and his audience.

"I'm a very down-to-earth person. For me the purpose leads. Websites usually have as a goal: informing, entertaining, or selling something whether it's an idea or a product. Some sites combine more then one purpose. I think a site's navigation is successful when the goal(s) is achieved without trying to achieve more."

If Trépanier's goal was to showcase his abilities, his talent, and his sense of humor, PixelPharmacy succeeds.

» PRESENTING

More than any other, one theme runs through the material in this book. Developers who participated in this book overwhelmingly use the phrase "keep it simple" to describe their Web philosophy.

As you read through this section, keep in mind that the goal is always to present content for the visitor. Don't put your ego above the needs of your audience. There are websites that force visitors to watch some multimedia effect such as an animation before reaching the content of the site, and possibly those developers believe people will sit still for it. The reality is that a great many Web visitors won't, especially if they're forced to view the same effect more than once.

This section shows you how to keep it simple and how to properly handle effects that make a website's presentation richer, more useful, and more fun.

» BUILDING A CONVINCING HOMEPAGE

Hopefully, this book has made it clear what should and should not be offered on a small–business homepage. If you still have questions, refer to "First impressions–Elements of an Effective Homepage" (page 32). That being said, there's always that large gap between knowing what to do and doing it.

If you want to indicate that your company offers creative solutions, it's appropriate that you do something creative on your homepage. But unless you're an artist or a designer who wants visitors to discover their site by unfolding the navigation options, don't exert your creativity by building an elaborate navigation. Keep it simple and clear by following the advice offered throughout this book.

If you're not a professional designer, don't attempt a complicated design. One of the tenets of usability is to have a pleasing and clear navigation. You can design the page yourself, but keep the design as simple as the navigation. You don't need a revolutionary navigation or a stunning design to convince your audience that you are what you claim to be.

If you're a sales site don't say you have great service; instead, offer clear links to pages such as a good FAQ page that includes information about shipping, return policies, and product support. Show your potential customers or clients awards and quotes from well-known sources. When attempting to convince visitors that you'll be there for them, one small piece of convincing content is worth a thousand words.

The most important factor is to find elements of content that blend with your message. Of course, your navigation should be planned, storyboarded and labeled, but once the navigation is determined, it can be handed off to a graphic designer who can integrate it consistently into the pages of the site.

Welcome your visitors with clarity, simplicity, and compelling reasons for them to stay awhile.

Visualizing the Message

Client: **Wert & Company, Inc.**

Web Link: **www.wertco.com**

Site Builders: **Nick Law (creative director), Marlon Hernandez (design and Flash development), Noah Landow (systems integration), Mark Munro (automation and programming), Joseph Aulisi (programming), Peter Norton (programming), In-house Team at Wert & Company, Inc. (content)**

Credit: Wert & Company, Inc.

ABOUT US
CANDIDATES
CLIENTS
INDUSTRY RESOURCES
CONTACT

Wert &
COMPANY
INC

CREATIVE RECRUITMENT

Judy and Jeff Wert cofounded Wert & Company, Inc. in 1995, with a desire to synthesize recruitment expertise with their interests in design and business. They were determined to infuse a palpable sense of whimsy into their website to complement the serious and empathic approach necessary to deal with candidates seeking new opportunities and the employers looking to find them.

Wert & Company, Inc. describes itself as a creative recruitment company, but more importantly, their website demonstrates their creativity.

≫

Home: Each time the home-page is loaded, a new, animated, and sometimes interactive graphic is loaded as well. This one features a beacon in a sea of dots. The type of candidate Wert & Company, Inc. wants to find will quickly under-stand the metaphor.

»

Partial Site Map: This partial site map shows the subnavigation options of one main navigation option "about us." The subnavigation option "bios" offers links to "judy wert," "jeff wert," and "our team."

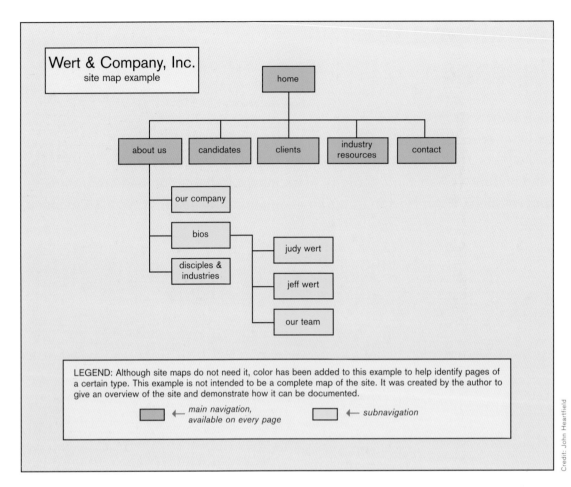

Everything New Is New Again

"We thought the homepage was a perfect opportunity to foster a sense of play at the outset," Judy Wert says. "The in-house and creative team assessed various design approaches and persistently returned to the visual metaphor of seeking and uncovering. It resonated on many levels with the nature of our services and our mission."

The majority of homepage screen territory varies each time visitors load the URL. While familiar enough to brand the site as wertco.com, the screens are playful enough to get the point across. Wert & Company, Inc. doesn't have to say, "We're not your standard recruiters"–the homepage clearly shows it.

The varying graphics and games play out above the constant main navigation. In several, the question "looking?" is revealed when visitors roll their mouse pointers over the images. Having to search for the word "looking?" is an excellent metaphor to show visitors that Wert & Company, Inc. understands the process of searching for the right job.

Judy Wert says, "As a relationship between recruiter and candidate or client spans time, we liked the idea that a candidate or client might enjoy a different experience on subsequent visits."

Credit: Wert & Company, Inc.

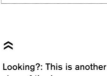

Credit: Wert & Company, Inc.

«

Subnavigation Options: When the mouse rolls over main navigation options, the sub-navigation options are displayed and remain on the screen until the user takes some action to remove them. This scheme is preferable to menus where the user must maintain some action to keep options available.

≽

Looking?: This is another view of the homepage. "Looking?" is a theme that runs through the homepage graphics. Converging lines gradually work together to uncover the word, while the process clarifies the theme.

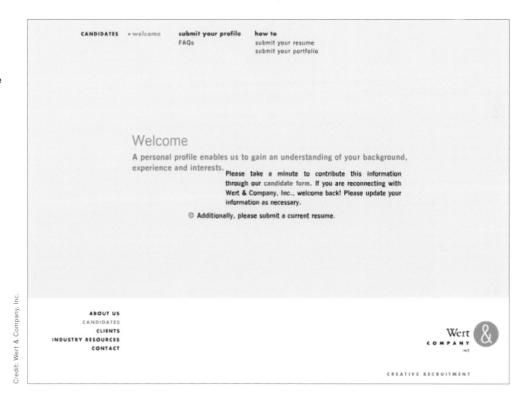

Persistent Rollovers

There are five clear main navigation choices. Subnavigation choices are revealed upon rollover and remain available to visitors until another main navigation is chosen or until the mouse rolls into the content area (above right). This method is a good way to handle an option rollover.

On other websites, rollovers often bring up menus that disappear as soon as the mouse moves away from the option or the revealed menu. These types of menus can be awkward and annoying to use. One slip of the mouse and your options disappear.

≽

Candidates: When a main navigation element is chosen, it drifts to the top of the screen and remains there until another main navigation option is selected. This allows visitors to view the content and its correspon-ding navigation without changing focus.

Animated Content

Once a subnavigation option is chosen, the main navigation choice and its corresponding subnavigation quickly drift to the top of the content area (previous page, bottom). There, visitors can exercise any option in the subnavigation with one click.

"With a diverse candidate base in terms of experience and discipline, in addition to industry-leading clients, we needed to develop an interface that served everyone's varying interests and needs," Judy Wert says. "Each candidate and client arrives at the site at a different point in their story, some hoping to share their information with us quickly and move on, and some carefully assessing whether we're the right resource. Our global navigation presents different

sections of the site. That allows the in-and-out candidate to momentarily assess where they want to go, and candidates or clients conducting research to access the critical information they require."

Content, mostly in the form of text, slides into view from many different directions. It may have been better to eliminate some or all of these sliding effects. Even on a broadband connection with a fast computer, visitors have to wait a precious two or three seconds before the text settles enough to read it. Although they add a bit of animation to the content delivery, it's recommended that when content is requested, it should be delivered as quickly as possible.

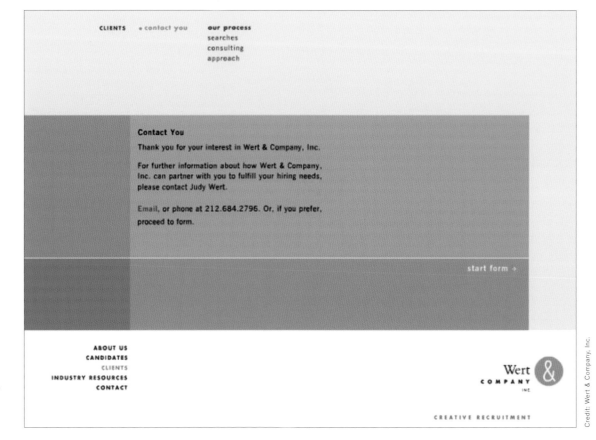

»

Clients: The "Clients" page offers multiple options for clients to send their requirements to Wert & Company, Inc. By making "Clients" a main navigation option, Judy Wert lets clients know that she's giving their requests personal attention.

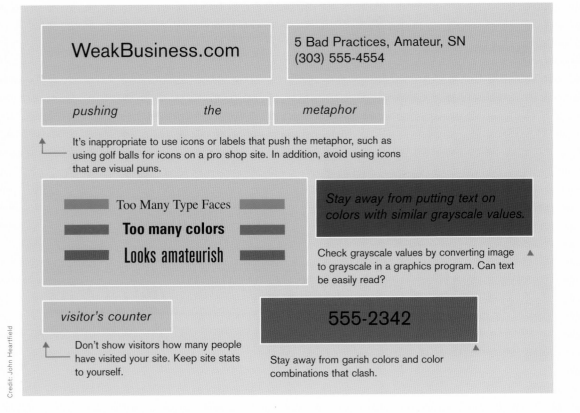

Credit: John Heartfield

« Although this is not a page but an illustration, it's as unsightly and ineffective as some of the pages it depicts. The time when a business could knock off a Web page for some cheap advertising or quick cash is gone. Unless you've invented a new fountain of youth, how you sell on the Web is as important as what you sell.

Appropriate

► A merchant account and credit card authorization system

► A shopping cart with the ability to easily modify the items contained in the cart

► An order-management system that fulfills orders as soon as possible after they're placed on the Web

► An email-management solution that ensures visitors' email gets to you

► An email-management solution that allows you to answer visitors' email in a timely manner

► A navigation element that is updated as orders are received and that informs visitors if items are not in stock

If you take orders you can't fulfill in a timely manner, you will probably lose that customer forever.

► Convincing demonstrations that your expertise comes from experience and comprehensive knowledge

► Useful advice and up-to-the minute details about the product

► An excellent photo of yourself can personalize your service website

Inappropriate

► A visitor's counter

Instead, use some simple Web tracking software that lets you know the number of visitors and what products they viewed.

► Navigation icons or labels that have nothing to do with your business

A custom pen manufacturer who uses diamonds as navigation icons because their pens are real "gems" appears amateurish.

► Navigation icons that are too obvious

It's a poor design choice for a camera store to use small cameras as navigation icons.

► Any element that does not relate to your business

► Garish colors or inappropriate combinations of colors

Don't use text color on backgrounds with a close grayscale value.

Successful selling of goods and services online is directly tied to the quality of your navigation. A sloppy navigation means rude service. Poor product accessibility is the same as putting your stock in a locked storage closet. To inspire trust in your customer, you must be the most thoughtful of hosts.

» KEEPING IT SIMPLE

A complex or confusing navigation is bad for business. Unless you're a navigation design professional, stick with accepted methods–the more straightforward, the better. Think of it this way: If you were bound to attend an amateur musician's piano recital, would you prefer the musician play manageable compositions or attempt Gershwin's *Rhapsody in Blue*?

Fortunately, one of the simplest forms of navigation, hierarchical navigation, is also one of the most popular. Options are grouped. Clicking on a member of the group can show a page or reveal another group of options. With hierarchical navigation, you can drill up, drill down, or drill across the site. To help ensure the usability of the site, the top layer of the hierarchy, the main navigation group, should be consistent and visible on every page, so visitors can always jump where they want.

There are other forms of navigation you can add into the mix without increasing complexity, though. For example, add appropriate, hyperlinked graphics, preferably with short text descriptions. Often, sites that want to duplicate main navigation choices or highlight special offerings use this method. It's recommended that if you decide to duplicate links, do so sparingly and use identical labels for identical hyperlinks to avoid confusion.

Many amateur designers who try to construct websites use text navigation, a technique that was quite popular when the Web began. It consists of hyperlinks in a page's text. This way of navigating seems to be used less and less, possibly because usability experts determined that Web visitors don't read pages, they scan them for data. In addition, sites that rely heavily on text hyperlinks can be harder to manage. Despite these objections, this technique definitely still has its place but should be used sparingly.

One excellent navigation aid is an online site map of your website. Take your navigation structure and unfold it. Make each option a hyperlink in a structure such as this:

Our Products	Company Info
Shoes	About Us
Sneakers	Store Locations
Socks	Contact

The online site map is only a complement for your navigation; it should not be used for main navigation.

There are other navigation types but, generally, it's not wise to break new ground in navigation design, especially when your ultimate goal is to offer visitors an effortless way to access the business content in your site.

The Ride
Built for You

Client: **Serotta** Website: **www.serotta.com**
Design Firm: **Serotta's In-House Team**
Site Builder: **Ian Campbell**

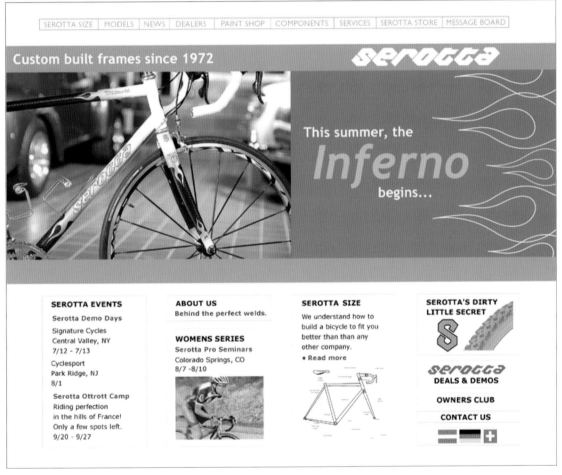

Credit: Serotta's in-house team

Serotta is a small, independent bike company with just thirty-three employees who put advanced technology under discerning riders worldwide. It's proud of its thirty-year history of Serotta road bikes being raced to gold medals internationally. Serotta employees are an excellent target audience for the company's website because they are road, trail, and track riders who are passionate about cycling.

⌄

Home: The homepage directly addresses issues of interest to the target audience. How will the bike fit? How is it constructed? What kind of service can I expect? What events are currently happening in the sport?

The Serotta homepage is built for this audience. It's presented in a solid grid format with three distinct areas of navigation. On top is a simple row of options, the center of the page contains a large graphic of the hottest item of interest, and below that are several smaller graphics that also function as links. Ian Campbell's goal when designing the site was to have it be "clean with pleasing graphics. I wanted it to have a light feel and be easy to get around."

The entire page is tailored to the interests of riders of high-quality bikes. The main navigation options on the top of the page revolve around merchandise and how bikes are constructed, sold, and serviced. None of the larger options below mirror them except "Serotta Size," the far-left choice in the main navigation. That option is important enough to also be featured below in "Serotta Fit." Both options go to a page explaining how Serotta fits bicycles precisely to owners. It might have been better to use an identical label for both elements to avoid any confusion.

A basic layout that incorporates a solid use of white space allows visitors to hunt comfortably through the homepage for items of interest. Campbell says, "The bikes and detail shots are dropped out of white so that the product doesn't have to compete with bold or dark colors."

»

Partial Site Map: This simple, partial site map shows the subnavigation links of one of the main navigation options "paint shop."

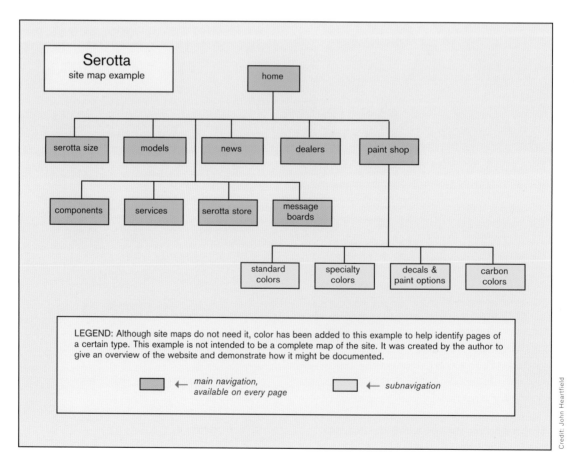

Credit: John Heartfield

Credit: Serotta's In-House Team

» Services: Service has to be an important issue for anyone who purchases a custom-made bike. The key sentence on this page is, "The same craftsmen who build our frames complete all repairs." That warrants a distinctive type size and font color.

⪡ Models: A clean page that splits the models into categories that make sense for the target audience. Bottom navigation is offered even though the page is short. Visitors will often go to the bottom navigation first to find options.

Credit: Serotta's In-House Team

Clean and Simple Wins the Race

Campbell gravitates toward simple, clean design. The "Models" page (above left) is a straightforward list of the bikes divided into road and mountain categories.

Notice that bottom navigation is offered even though the page is relatively short. Bottom navigation that mirrors the main navigation options is highly recommended in this book. Remember that visitors don't read Web pages but they do scan them. Notice how easy it is to scan the bottom navigation for navigation options.

The bike names on this page are obvious links to pages that show and describe the bike in detail. When this format is used, it is usually a good idea to offer a "Back to Models" option in a prominent area of the page. That's true even though very many visitors use the browsers back button as their main form of navigation. Never design a page, however, that depends solely on the browser's back button for navigation.

Riding Alongside the Customer

Since Serotta custom builds its own bikes, highlighting service on their website is vital. Visitors can spend their time absorbing this important message because of a combination of strong design elements. The most obvious is the simple, familiar grid layout of the page (previous page, right).

In addition, the text on this page is like another graphic element. The paragraphs are nice and short and well spaced, and the sentences are brief and to the point. The body text uses a sans serif font that is preferable for use in Web body text because it's easier to read. Verdana is an excellent sans serif font for the Web, especially when the text is not offered as a graphic.

Because of the length of the service page, bottom navigation is imperative. Include a "top of page" option in the bottom navigation of long vertical pages.

Scrolling through long vertical pages is normal, but studies have shown that visitors do not like to scroll horizontally. For a long time, the design standard was 640 by 480 (horizontal by vertical) pixels. Now the standard seems to be 800 by 600. Don't make your website pages more than 800 pixels in horizontal length.

Carbon Clear

This "Paint Shop" page (below) has minimal design but also serves visitors well. The colors are shown on their tubing because that's how they'll look on the bike, and each one is identified by a number that can be referenced on the left.

On the bottom of the page are three options to view different groups of colors in the "Paint Shop" section. On this page, bottom navigation is omitted because it could have made it more difficult to pick up the section choices. For the sake of consistency, it might have been better to place the group choices in another area of the page and include bottom navigation, even though the page is quite short.

⋙

Paint Shop: Colors are identified on the left and categories of colors are differentiated on the bottom. Often the simplest navigation design is the best.

SEROTTA SIZE | MODELS | NEWS | DEALERS | PAINT SHOP | COMPONENTS | SERVICES | SEROTTA STORE | MESSAGE BOARD

Home

serotta

Paint Shop

Carbon Clear Coats

1. Green
2. Blue
3. Red
4. Harlequin
5. Copper Harlequin
6. Rainforest Harlequin

1. 2. 3. 4. 5. 6.

standard colors | specialty colors | decals & paint schemes

Credit: Serotta's In-House Team

| SEROTTA SIZE | MODELS | NEWS | DEALERS | PAINT SHOP | COMPONENTS | SERVICES | SEROTTA STORE | MESSAGE BOARD |

(H)ome *serotta*

Main Index Mission Statement | Help/FAQ | Image Gallery

Log In

Available Forums

Serottas Owners Forum Posts: **46801** Last Post: **08-12-03 09:59**

Open discussions about Serotta bicycles, components, and just general banter!

Question of the Week Posts: **2** Last Post: **07-08-03 02:18**

Serottas official response to forum topics, updated weekly.

Bike Fit Posts: **88** Last Post: **08-11-03 08:04**

Discuss your specific fit issues here.

Classifieds Posts: **223** Last Post: **08-12-03 05:22**

Classified ads for Serotta bicycles and components.

serotta size | models | news | dealers | paint shop | components | services
home | details | serotta store | message board

《
Forum: A visitor's forum is a strong way to build customer confidence and increase site traffic. One of the categories in the forum is also a Serotta main navigation option.

A Smooth Write

"Forum" launches Hydromedia.com, a different website, in a new window (above). Hydromedia supports an open forum for Serotta and the page design is virtually identical to those at serotta.com. In fact, if Serotta navigation options are chosen at Hydromedia, the visitor is returned to the Serotta site even though they remain in the new window. This might cause a bit of visitor confusion, but the forum itself is an excellent feature, as is the administration by Hydromedia.

The forum, entitled "The Serotta Message Board," is designed for Serotta owners, potential owners, and cycling enthusiasts worldwide. The purpose of the forum is to provide an outlet and gathering place for bike enthusiasts, especially Serotta owners. Although Serotta the company peruses the forum and offers input, the design function is not for Serotta to advertise, but for its audience to meet and interact.

Serotta does not patrol or enforce the topics on the message board, but it does have to monitor it to ensure that retailers and bicycle manufacturers do not use this forum for solicitation purposes or to obscure or mar the character of Serotta bicycles.

When asked to summarize his design philosophy about the Serotta site, Campbell says, "The site had to load quickly and be fairly self-explanatory. I wanted to be sure it was not one of those navigations where too much is going on."

Unlike Serotta's world-class bikes, the serotta.com has some flaws, but it rises above them by keep the navigation design simple and consistent.

» DESIGNING ICONS AND LABELS

A Web icon is a small picture that suggests a hyperlink or action is available. Labels are short descriptions that do the same.

Some popular beliefs about icons are that they

- Are appreciated because visitors don't have to waste time reading labels

- Take up less screen territory than labels, which have to be big enough to be read

- Help illiterate people understand the navigation

- Add an element of cool graphic design to the navigation

- Make it easier for a website to reach an international audience

- Make it easier for visitors to understand the navigation

In reality, though, it's extremely difficult to design stand-alone icons that would verify all or even some of the statements above. The task becomes even more difficult when an icon attempts to describe an action such as "download our catalog" rather than a noun such as wine.

Another consideration is that an icon that appears by itself may mean something entirely different to visitors if it's included in a group; two icons may look very similar to each other in a group.

Everyone wants their website to be different, but when it comes to icons, developers should not try to reinvent the wheel. While making your icons attrac-

tive, remember that visitors are used to certain icon conventions on their computers and they'll be more impressed by an easy navigation than by ground-breaking, potentially confusing icons.

Icons (and navigation graphics) should almost always be labeled. Labels that appear on rollover are acceptable if the labels are in close proximity to the icon, but it's preferable to have labels that are always available.

On average, scanning a label takes about 30 to 300 milliseconds. Understanding a label could take quite a bit longer if the label is not short, descriptive, and unique to the pages of the site. It's okay to have multiple "your cart" labels on a page. It's not acceptable to have the same icon representing the visitor's last order under a "shopping history" heading and appearing again in another place on the page to signify the option to view the current contents of the visitor's shopping cart. In other words, use one icon for one option or task per site.

Of course, both icons and labels add a layer of complexity to international websites. A gesture such as the upheld palm of a hand means "stop" in America but in other countries signifies an obscene gesture. That's another good reason to keep icons as neutral as possible.

For more advice on icons, see William Horton's *The Icon Book* (Wiley, 1994).

Familiarity Breeds Understanding

Client: **Rullkötter AGD {Werbung + Design}**
Web Link: **www.rullkoetter.com**
Design Firm: **Rullkötter AGD {Werbung + Design}**
Site Builders: **Dirk Rullkötter, Marco Rullkötter**

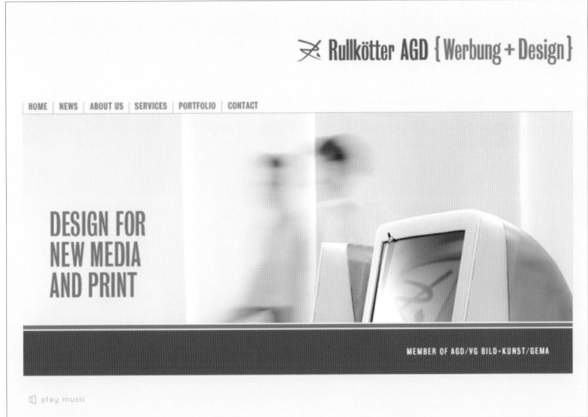

⌃

Rullkötter AGD {Werbung + Design} is a German design bureau that specializes in the design and development of new media and print projects. Their website is a classic example of stylish design and sensible functionality. Since its launch, the website has brought increased interest to Rullkötter and their services.

The splash page offers a choice between German and English, and as with any site that relies on Flash, it properly offers a link to the Macromedia download page. In addition, the splash page gives the location and contact information for the Rullkötter bureaus in Kirchlengern and Bielefeld.

Home: The homepage clearly identifies the business and what it offers. There's a strong branding of the logo both in the upper corner and on the computer screen.

»

In this partial site map, the "portfolio" option leads to a page that splits the portfolio into "new | media" and "print | design." The new media portfolio contains examples of work for new media clients. There's also a group of new media project pages.

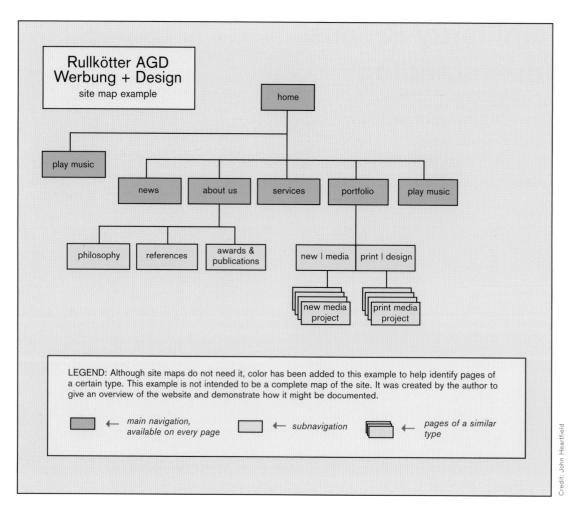

Rullkötter AGD
Werbung + Design
site map example

home

play music

news · about us · services · portfolio · play music

philosophy · references · awards & publications

new | media · print | design

new media project · print media project

LEGEND: Although site maps do not need it, color has been added to this example to help identify pages of a certain type. This example is not intended to be a complete map of the site. It was created by the author to give an overview of the website and demonstrate how it might be documented.

← main navigation, available on every page

← subnavigation

← pages of a similar type

Warm Design, Clear Navigation

The homepage features the Rullkötter logo followed by the words "Werbung + Design." This is one of those instances where translation can be tricky. "Werbung" means *advertisement* in German, and the German word for design is identical to the English one. So English-speaking visitors, thinking the word *design* is English, may be puzzled about the meaning of the phrase "Werbung + Design."

"The company is called Rullkötter AGD {Werbung + Design}," Dirk Rullkötter says. "It can't be different on the English version of the website, because it is our name."

Main navigation options on the homepage leave no room for confusion. The six labels "Home," "News," "About Us," "Services," "Portfolio," and "Contact" are familiar to any Web surfer. Visitors do not have to study or learn the navigation and are free to enjoy the handsome, balanced design.

"Our target audience is a business audience searching for exceptional design," Rullkötter says. "We wanted to make sure that audience didn't get lost on the site. Visitors must be clear what awaits them if a button is clicked."

Both Sides Together

Clicking on "Portfolio" takes visitors to a page that clearly shows Rullkötter has two sides in its new media and print design divisions.

To the bottom left of the page is a button that's globally available. The "play music" button allows visitors to enjoy light jazz during their stay at the site. Although visitors can choose to enjoy the music, the site does not force it on them. Also the music keeps playing smoothly as visitors switch from page to page and the music will play even if visitors switch to another application. The music stops only when the site is exited or the music button icon is chosen again.

"Visitors from around the world have commented that they enjoy the warm color scheme and the clean design of the website," Rullkötter says. "The smooth jazzy music is a welcome change from the technolike sounds from other websites they've visited. But it has to be controlled. Music can be annoying if you listen to it over and over."

The icon that accompanies the "play music" button is a small speaker, the universally recognized icon for turning digital music on and off. Even so, Rullkötter makes a wise choice to accompany the icon with the "play music" label that clarifies its function and brings visitors' attention to it.

≫

Portfolio: Could there be a more transparent direction to find the path of your choice? As with all good navigation, the main navigation remains constant.

Silence May Be Golden

Sound also accompanies every mouse click on the Rullkötter site. A short audio cue is heard each time the user chooses an option.

"It's an acoustic signal," says Rullkötter. "You can turn it off by switching off your speakers in the same way you can switch off the sounds of some operating systems like Windows XP and Mac."

The navigation of the website does not currently offer visitors an option to turn off this feature. This book highly recommends that when any type of sound is component of a website, the navigation should offer an option to mute that sound. Think about buying a radio that goes on by itself and then could not be turned down or off.

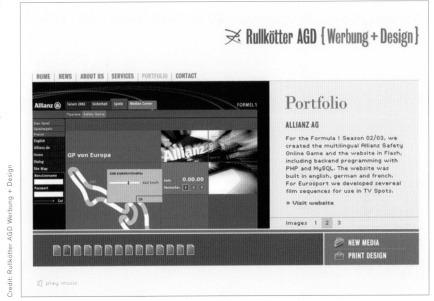

Credit: Rullkötter AGD Werbung + Design

≪

New Media Portfolio: The "new media" folder is open indicating that the files are available for viewing. Although these icons are familiar to anyone who has used a PC interface, they are integrated beautifully into the design.

Credit: Rullkötter AGD Werbung + Design

Familiar Metaphors Help Visitors Get Comfortable

The new media portfolio makes use of a selection of well-known icons. File icons are employed to designate each portfolio entry, and when the mouse rolls over an icon, its name is displayed to the right in close proximity.

When a portfolio entry is chosen, the file icon changes color to indicate it is currently active. It may contain several images, which is shown with numerical icons. The iconography is made even clearer by adding the label "Images" to the left of the numbers. Visitors also have the clear option to view work for clients in the portfolio. Of course, those websites launch in a separate window.

In the lower-right corner is an option to move between the new media division and the print division (below). That's convenient for visitors because they don't need to return to the portfolio page to visit the print division.

One File Opens, Another Closes

When visitors choose the "Print Design" option, they move to Rullkötter's other division (below). Notice how all the iconography is identical. The only change is that the "New Media" folder icon in the lower right-hand corner is closed and the folder holding the "Print Design" files is open.

The fact that this metaphor has been used again and again in computer software is an extremely positive feature of the site. The metaphor is executed stylishly and consistently. Chances are good that visitors will recognize it quickly and feel comfortable.

Easy Identification

On the "About Us" page (opposite, top), the metaphor of files is used in the navigation once again. If visitors have come from the "Portfolio" pages, they are now completely familiar with the iconography of the site. If visitors have come to this page first, the iconography is already familiar to them from other systems. High identification potential is a win-win situation and the reason why developers should consider standard computer conventions when choosing icons for the site.

»

Print Design Portfolio: This page appears to be a close replica of the "new media" page, but one small, significant icon, the open "print design" folder, lets visitors know their current location.

HOME | NEWS | ABOUT US | SERVICES | PORTFOLIO | CONTACT

Rullkötter AGD {Werbung + Design}

Portfolio

HWI INFORMATIONSSYSTEME GMBH

For the innovative company we developed a new corporate design, which is very reduced und clearly. Conqueror Smooth was chosen as paper for the stationery.

Images 1 2

NEW MEDIA
PRINT DESIGN

play music

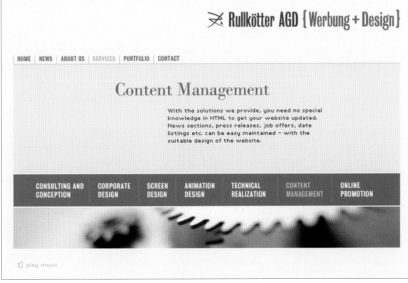

Credit: Rullkötter AGD Werbung + Design

Credit: Rullkötter AGD Werbung + Design

≈

About Us: The file icon metaphor continues, although here there is a persistent label identifying each one. Notice also that the speaker icon is available in the same location on every page. It's vital that visitors are able to control sound.

《

Services: The target audience is business decision makers, and each of these labels clearly lets them know what services are available from Rullkötter.

Content in a Flash

A similar level of clarity exists on the "Services" page (above, bottom). The seven options are clearly labeled. When one is chosen, a large heading in a complementary font that is unique to the page accompanies the text to identify which service is being addressed.

As with many other sites that employ Flash, when an option is chosen the content slides in from the side rather than appearing immediately on the screen. This page identifies its content so well that it does not need that visual reminder that the content is changing. Other than creating a slight animated effect, there is no benefit to sliding the text because it slows down the delivery of information to visitors.

Perhaps the best way to sum up this fine website is to use Rullkötter's own words: "We would like to provide clear solutions, which are not only nice to watch, but also appealing to rich functionality."

» CONTROLLING SOUND

Adding sound to websites, whether in the form of music or effects, is here to stay. There are a great variety of sites dedicated to either demonstrating how to create sound or selling software that enables you to add sound to your site. In addition, new sound formats seem to be constantly appearing.

Yet it's difficult to imagine a media more misused on the Web than sound. Often it's frustrating, annoying, and repetitive and, what's worse, it's added to websites without offering any tangible benefit to the navigation or the content of a site.

It's always necessary to be cautious with sound because people will tolerate bad visuals for much longer than annoying sound. For example, people will watch a video with poor picture quality and good sound much longer than they will the same video with good picture quality and bad sound.

The lesson is that sound will drive visitors away if it's not used properly. There are two properties that must be remembered when offering sound on any website: spare and controlled. Visitors must always be able to control sound, so do not play music automatically when visitors arrive at your homepage. Make sure you have a clear option to mute all sound on your site. If you want to go through the added trouble, you can add a volume control on your site but a mute button is mandatory.

Some developers feel a visitor's experience is enhanced by having auditory feedback on navigation options, but this is a very delicate matter. If the feedback is too subtle, the purpose is defeated and work and download time is wasted. If the feedback is too garish, it can quickly become annoying to visitors. A balance has to be achieved.

When deciding on how much sound to add to your site, a general rule to follow is the principle "less is more." Spend more time ensuring the sound you offer is excellent and visitor-controlled, and less time adding a great deal of sound for mood and effect. In any case, you need to allow visitors to determine when and where sound is appropriate.

Sound Off/Sound On

Client: **Stockmusicvault**
Web Link: **www.stockmusicvault.com**
Design Firm: **Soundoftheweb Group Media Network**
Site Builders: **Ben Basten**

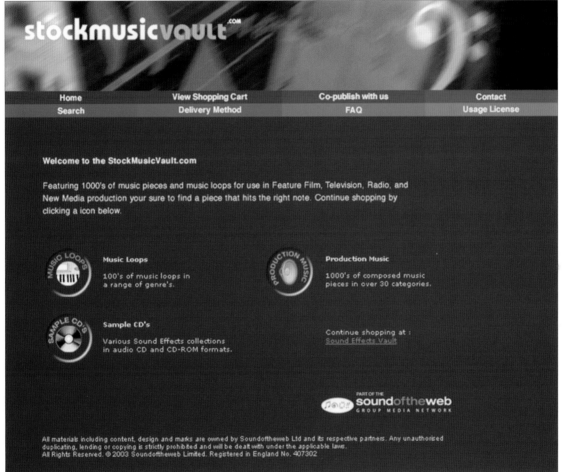

《

Home: To ensure readability, white or another very light color is a good choice for dark backgrounds. Don't put text on a color with a similar grayscale value, the shade of gray a color becomes when all hues but black and white are removed.

Stockmusicvault is one of the four online music and sound effects companies that comprise Soundoftheweb Group Media Network. Stockmusicvault, along with Soundeffectsvault, Voiceovervault, and Drumvault, has a huge audio library. It features thousands of pieces of music and music loops for use in film, television, radio, and new media productions.

"Soundoftheweb wasn't originally formed to be a sound and music library," Ben Basten says. "It has been a natural progression and now takes up most of the company time."

The presentation of sound on the site and the way sound is described and sold is an excellent example of solid Web auditory technique.

»

Partial Site Map: On this partial site map, stockmusicvault is one of the four sites that are available through soundoftheweb. There's an option on stockmusicvault to visit soundoftheweb and from there you can navigate to any of the four sites.

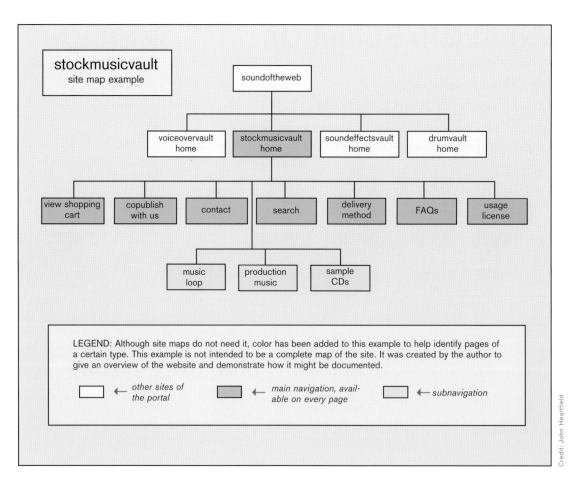

A Silent Welcome

The first thing visitors might notice upon arriving at the Stockmusicvault homepage is the silence. Even though this is a website that specializes in music, sound effects, and aural feedback, none of those features is offered on the homepage. Of course, it makes sense not to associate the site with any particular music or effect since the company is in the business of selling many different types of sound. However, as with any Web page, the opportunities for the frivolous use of sound are limitless and Stockmusicvault avoids all of them.

"Our end customers work in an industry where design and presentation are key," Basten says. "We had to make sure our site fit into those disciplines."

As to the navigation options, the white text works well against the dark blue shades. This site is about sound, hearing it, selling it, and buying it, so the text is kept short and to the point. The main navigation options, aligned in rows at the top of the page, do not directly offer any subnavigation groups.

The CD-shaped objects in the middle of the page, each differentiated by a small graphic in the center, are good icons for the site navigation options, including "music loops," "production music," and "sample CDs." Concise explanations of the labels are included.

Moving from Site to Site

One unusual feature of the homepage is the "Continue shopping at: Sound Effects Vault" option. This takes visitors to the homepage of "Soundeffectsvault.com," another Soundoftheweb website.

This page is virtually identical to the Stockmusicvault homepage except that the graphic on top is tinted differently and the CD-shaped options are different. Here, the same type of option above can return visitors to Stockmusicvault.com, providing a toggle switch between the homepages.

The intention of Soundoftheweb seems to be to create a network in which visitors can enter either through the Soundoftheweb portal or move between the various websites of the network. In addition, visitors may enter the network at any point through either search engines or recommendations.

Because the intention is to have different sites for each component of Soundoftheweb, it might be better to vary the color scheme slightly or change the graphic design more noticeably to give visitors a visual cue that they've moved from one site to another. In addition, in the graphic shown, the grayscale value of the Soundeffectsvault link is too close to the color of the background. The white against the background is excellent and a lighter color would have been more effective for the Soundeffectsvault link.

Looping Icons

On the "Music Loops" page (below, left), the same CD-shaped icons are used as options to offer categories of stock music. Visitor confusion is avoided by clearly labeling the icons and supplying a short, but informative, description.

Notice that once visitors have gone past the homepage of the site, the option to switch to another site or to return to the Soundoftheweb portal is wisely removed. It would be too confusing to have these options anywhere but on the homepage.

Credit: Soundoftheweb Group Media Network 2003. Designer: Ben Basten

Credit: Soundoftheweb Group Media Network 2003. Designer: Ben Basten

«

Music Loops: The CD icons are appropriate, visible, and distinguishable by the small graphics inside them. Because they are clearly labeled, the designer can play with the labels on the CDs themselves.

⌃

Search: A good search handles all cases or lets visitors know how their input into a search is interpreted by the system. On the other hand, it's frustrating to search for "Blue Money" and have a negative result returned because the system can't find "blue" or "money."

Searching for Just the Right Tune

"We were careful to avoid overcrowding, clunky Java scripts and too many links," Basten says.

The search engine on Stockmusicvault is anything but confusing; instead, it's a very good example of a simple search (previous page, right). Clear instruction is offered above the search text box: "Use our search engine to narrow down your sound effects. Enter multiple keywords separated by a single space."

Visitors can search by "any words," "all words," or "as a phrase." These options clarify search box entries. Visitors also have a choice of the number of items displayed per page. Some may like to scroll long lists of search results, whereas others like to have their hits indexed into lists they can scan easily.

Another nice feature of this search is that the text box remembers what visitors type. For example if they do a search for "jazz," then a search for "pop," and then want to perform the jazz search again, the text box will complete their entry and offer a list of the previous searches, similar to way most browsers handle URL requests in the address view. Finally, misspellings are handled well. For example, if a visitor types in "jaz" the search results for the closest match, "jazz," are returned.

All of the features above constitute elements of a strong search engine, whether it's individually built or purchased.

Play Nicely

The search result page is formatted in precisely the same style as pages that are displayed when one of the music category options, such as "ambient" or "classical" is chosen (below).

Selections are offered in rows, and each column contains a nugget of information about it. The sound file format, in this case, .wav, is shown as an extension to the file name. There's a concise description of the content of the file, the length of the file in seconds, and Stockmusicvault's price for the sound. In short, the empirical data visitors need at a glance.

Of course, visitors need one more piece of information about the selections, the way they sound. That's accomplished through the simple play icon combined with the label "play." This is one of those cases where the most straightforward icon seems to be the most appropriate.

To hear the .wav file, all visitors have to do is roll over the play icon, and it turns green and the music starts playing. When visitors move the mouse away, it turns white again and the music stops. This site provides an effortless way for visitors to hear what they're getting. "People comment on the ease of use," Basten says. "We also get countless compliments on the quality of our music."

There's more for visitors to know than how the music sounds—they must also agree to a usage license. Although the agreement is clearly shown on the site, most people have an aversion to reading legal documents, whether they are music usage agreements or software licenses.

Two of the questions visitors may have are addressed in the FAQ section (opposite, bottom) are: What's all this usage license business with Stockmusicvault purchases? Can I edit or sample Stockmusicvault purchases?

That is an excellent way to offer information on the Web. The FAQ summarizes the data in the much more detailed usage license. The site offers visitors a useful summary of information and also provides them with the option of getting the complete picture, if they want it.

Credit: Soundoftheweb Group Media Network 2003. Designer: Ben Basten

«

Search Result: This is a balanced and informative page in every respect. When visitors roll the mouse over the play icon, it turns green and plays the selection. As soon as they remove the mouse the music stops.

≫

FAQ: An FAQ helps visitors find answers to their specific questions. A FAQ response should be a summary of more detailed information in other parts of the site. The idea is to provide detailed but simple, clear answers and, if necessary, direct visitors to the location where information is available.

≪

Soundoftheweb.com: This is the portal site for websites of the Soundoftheweb network. You only need a portal when your company has clearly defined divisions.

Soundoftheweb.com

Back on the homepage, there is an option for Soundoftheweb.com (above left), which is a portal for the four current Soundoftheweb websites: Soundeffectsvault.com, Stockmusicvault.com, Voiceovervault.com, and Drumvault.com. An Internet portal is a site that offers information about and access to related sites. Soundeffectsvault is a particularly enjoyable site to visit, containing such memorable sounds as "hysterical comical laughter" and "a short zap."

Basten says, "We wanted to create a site that could challenge the well-established sound and music libraries. When we started out, we researched every competitor, and we still do. Our conclusion was content is key, but a well-designed site speaks volumes about the way you do business."

For a company that deals in sound, Soundoftheweb shows admirable restraint and the sound that you hear on the sites is particularly resonant.

» WEBSITE METAPHORS

One definition of metaphor is "The transference of the relation between one set of objects to another set for the purpose of brief explanation." For example, you might show a graphic of Tom's head on top of a big rooted tree in the town square to indicate that Tom is firmly rooted in his hometown.

Navigation metaphors convey the structure of the content through components like graphics, layout, and placement of options. Websites often use metaphors to help visitors relate to navigation systems by presenting them in the form of another commonplace system. A metaphor that is often used is the tape deck controls of audio and video programs, such as QuickTime. Using this metaphor, the options of a home tape deck, such as cueing and counter reset, can be added to the navigation controls without adding a great deal of complexity to the interface.

Metaphors can be use to help organize a site, help visitors perform actions like checkout, or guide them to locations. For example, clicking on a small picture of "Ellen, Our Product Rep" could take visitors to an FAQ page about products.

When using metaphors

▶ Use them consistently.

▶ You may use more than one metaphor if they complement each other, but don't use so many that they become confusing.

▶ Don't build a metaphor for the homepage and then abandon it on subsequent pages.

▶ Don't use a metaphor that applies to only a single navigation option.

▶ Don't force a metaphor because you feel it applies to your business.

▶ Watch out for metaphors that don't cross cultural boundaries.

The use of navigation metaphors is a tricky business, so user testing is crucial. Unless metaphors are chosen with style and executed with consistency, the site will appear amateurish. Good metaphors, on the other hand, can give your site a distinctive and memorable presence.

Welcome to the Neighborhood

Client: Einstein Bros Bagels Web Link: www.einsteinbros.com
Design Firm: Einstein Bros Bagels
Site Builders: Peter Larson (web designer), Kym Foster (illustrator),
Nick Hartshorn (copywriter), Launa Stiles (project manager)

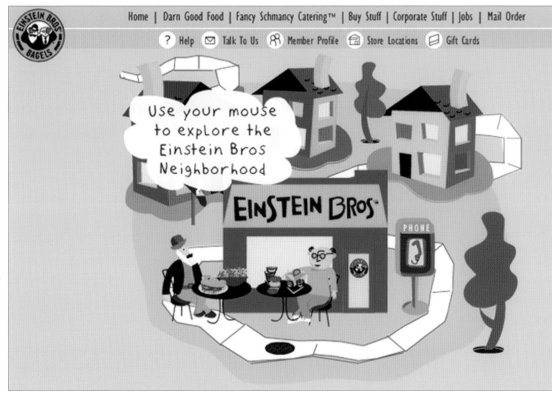

Credit: New World Restaurant Group, Inc.

《

Home: On the Einstein Bros homepage, Melvin and Elmo welcome you to the neighborhood. It's clearly a casual place to get a bagel and a schmear and get in touch with the local residents.

Einstein Bros is not a local bagel restaurant. Regardless of how they began, they're now a growing chain. Their website—from the playful navigation to the corporate job listings—conveys the friendly, crusty atmosphere of a local bagel joint.

"We looked at the local feel of our stores and tried to accurately represent that in the Web design," says Peter Larson. "Early on, we came up with the concept of the neighborhood and decided that this would be a great metaphor for the navigation and overall look of the site."

The website's navigation succeeds because the site's metaphor is consistent and engaging, which is essential when tying a site together with a metaphor to avoid being obvious or forced.

Generally, unless you have professional graphic design skills and a strong, consistent vision, it's probably best not to attempt a site such as Einstein Bros. On the other hand, if you feel a metaphor would add distinction to your site and you'd like some pointers on how to do it right, the Einstein Bros neighborhood is a good place to visit.

»

Partial Site Map: This partial site map shows the main navigation choices. When visitors drill down to the "Darn Good Food" page, the sub-navigation choices are noted. The splash page just checks the browser and doesn't require input from visitors.

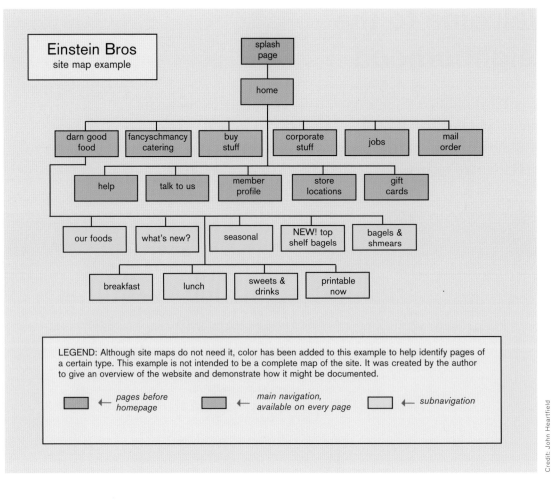

Hungry? Here's the Food.

Visitors enter the Einstein Bros neighborhood, where they are greeted by the site's two virtual guides, the bearded Melvin and the bespectacled Elmo, who are both spokesmen and customers. Melvin and Elmo maintain the bagel joint metaphor by appearing on almost every page.

"I worked through several versions trying to make the navigation whimsical to represent the feel of our brand," Larson says. "In the end, I decided that it would be best for the user if I made the navigation simple and clean, leaving room for the rest of the page to be creative and more playful."

On the homepage, Melvin and Elmo are enjoying their lunch outside Einstein Bros. Occasionally, a bird flies by, conveying messages such as, "Thinking salads?" A text balloon advises visitors to "Use your mouse to explore the Einstein Bros Neighborhood" whenever the homepage is loaded. Rollovers of graphics launch short, amusing animations that offer most of the options in the main navigation menu.

Visitors have commented they enjoy these animations. Because the animated options are clearly duplicated in the main navigation menu above, execute fairly quickly even on slower connections, and add character to the navigation, they appear to be an exception to the general rule that an interface should not animate navigation options.

The neighborhood is painted not just with images but also with sound. On rollovers, the telephone rings, a door squeaks open, and Elmo's belly rumbles as the site asks, "Hungry? Here's the food." The appearance of the chirping bird is automatic, which could become tiresome over time. Although the sounds are amusing, there is no way for visitors to mute them without muting the sound level on their computers, which is why this book does not recommend sound that can't be controlled by visitors.

Warm, Fresh Icons and Labels

The main navigation labels at the top of the home-page support the casual atmosphere of the neighborhood without forcing it.

For example, "Darn Good Food," "Fancy Schmancy Catering," "Buy Stuff," and "Corporate Stuff" are in step with the informal tone of the navigation without being unclear. The term "Fancy Schmancy Catering" has actually been trademarked by Einstein Bros, but labels such as "Jobs" and "Mail Order" in the same group do not attempt to push the metaphor. Metaphor consistency should seem natural, not forced.

Good Enough to Eat

"In the quick-casual restaurant industry, the competition has not largely explored digital media as a marketing tool," Larson says. Except for a few competitors, little effort was put in to pushing their brands forward with their websites. Also, food was not well displayed or described among our competitor's websites. "Darn Good Food" offers graphics of food that look good enough to make the visitor hungry (below, top).

To keep the navigation consistent, Melvin and Elmo are seated in the corner of this page enjoying a nosh. Just as on the homepage, the graphics are links that show small animations on rollover but each graphic is mirrored by nonanimated menu options on the left.

Credit: New World Restaurant Group, Inc.

«

Darn Good Food; Roll the mouse over the sandwich and watch it disappear in a few big bites. Without the mirrored menu options on the left, such animated navigation becomes tiresome after several repetitions. Here, visitors can choose the playful animations when they want them and navigate directly to the menu options when they don't.

»

Top Shelf Bagels: The delicious graphic gets the message across. The ingredients of varieties, such as "Spicy Nacho," are described to get visitors' attention but not text such as "mouthwatering." This is critical on the Web. Advertise with information, not with ad copy. Melvin and Elmo are in the same position as on the "Darn Good Food" page, which helps orient visitors.

Credit: New World Restaurant Group, Inc.

On every page but the homepage, the main navigation options remain consistent along the top edge. The homepage main navigation is unique in one respect. Both icons and text labels on the homepage identify these five options: "Help," "Talk to Us," "Member Profile," "Store Locations," and "Gift Cards." On all subsequent pages, the labels are dropped and icons appear without any explanation.

These icons are by no means obvious, especially the last three. In a case where an icon is not universal, such as the "?" for help, it's a good idea to include a label, which can be a rollover, if necessary.

Once the food is introduced on the "Darn Good Food" page, visitors can examine the food more closely on pages such as "Top Shelf Bagels" (previous page, bottom). This is an example of a drill-down navigation. In other words, it's only possible to reach "Top Shelf Bagels" by clicking into the "Darn Good Food" page. For sites like Einstein Bros, this scheme makes perfect sense.

There are very few levels of navigation on this website, so mouse clicks to the desired item are minimal. By directing visitors through "Darn Good Food" the company has a chance to show off other items on the menu. Finally, a drill-down scheme can reduce the number of navigation options on one page.

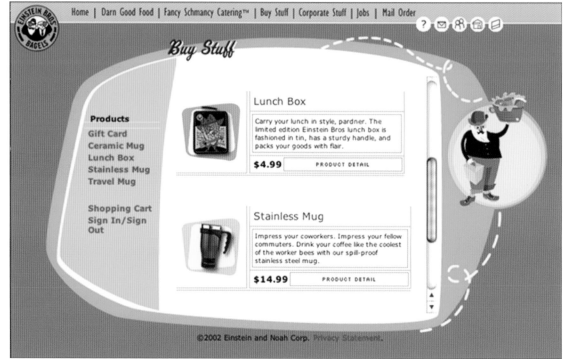

»

Buy Stuff: Stuff for sale on the Einstein Bros website is most likely an impulse buy. Visitors like the site and decide to pick up a souvenir coffee mug. It is especially important in this case to make the buying experience as quick and convenient as possible.

Credit: New World Restaurant Group, Inc.

As Long As You're Here

Navigation to the "Buy Stuff" page (above) is organized in the same manner. But the kind of stuff offered on the Einstein Bros site are impulse buys, so there are no cute animations to get between customers and the ecommerce. Melvin's still there to maintain the metaphor and there's some clever copywriting to get visitors to buy.

Terse, punchy text such the copy in "Buy Stuff" is a strong asset to a site's navigation. If you can afford it, get a writer who understands the limited attention span of Web surfers. If you have to write the text yourself, write only what you have to write. Keep sentences short, express only one thought per sentence, and break anything longer than three sentences into paragraphs or sections.

What Can I Get You?

Before leaving the neighborhood, it's worth looking at the Einstein Bros help option (below). Offering help on a website often seems like a daunting task. Somehow it always seems much easier to build a site than to explain how to use it.

Einstein Bros shows it can be done without making it a major undertaking. The help section offers seven links that Einstein Bros believes are either good for the site or valuable for visitors. Each link offers a scrolling text box of information that includes relevant hyperlinks.

For example, the text box for "Finding something on the website" includes

How do I find the Einstein Bros menu?

You look hungry. Really hungry. Please click here to have a look at our menu.

[Back to Help]

The "click here" options take visitors to the "Darn Good Food" page, and "Back to Help" is included at the end of each answer to a question. It's a system that's simple to implement and helpful for visitors.

Feedback Is Rising

"Our programs for customer feedback have allowed us to focus on the areas and the promotions that our customers respond to and to cut out the sections that are not as well appreciated. We've even begun to use this data to drive our print media messaging," Larson says.

"My personal philosophy," Larson continues, "is that you should do what is appropriate for the particular website. No matter how creative you get, though, never sacrifice usability for creativity. Otherwise, the designer is the only one who likes the site."

Einstein Bros imparts a personality to its website and by keeping it in character with consistent elements, labels, and icons, it offers a fun place to visit and whet your appetite.

Home | Darn Good Food | Fancy Schmancy Catering™ | Buy Stuff | Corporate Stuff | Jobs | Mail Order

Help

I need help with...

Finding something on the web site.

Einstein Bros® Gift Cards

Technical Information about the web site.

Ordering Einstein Bros® Merchandise
Placing an Order
Payment Options
Registration
Shipping
Return Policy

©Einstein and Noah Corp 2002. Privacy Statement

«

Help: A help section doesn't have to be complex or comprehensive to be effective. Einstein Bros determined the most common needs of its visitors and then basically indexed an FAQ section. Elmo is popping out of the same hole as on the homepage, which shows visitors their location when they choose "Help" on the homepage.

» OFFERING SEARCH FUNCTIONALITY

A website search option lets visitors quickly locate merchandise, services, and information. Unlike Web search engines, site search engines add expense and/or programming complexity to your website. So why add one when you've built a great navigation where visitors can access everything within three clicks?

Perhaps

▶ Your site offers a great deal of merchandise and you'd like to have a digital salesperson show visitors where a particular item is located.

▶ Merchandise may fall into different categories— for example, visitors could see all instances of "gloves" in both the "leather products" and "sheepskin products."

▶ The search engine can take visitors directly to pages where buy decisions are made.

▶ You can record which searches were made and get an overview of visitors' interests.

▶ Visitors can't find items or prefer to be directed by a search engines.

On the other hand, consider these factors:

▶ If a search engine continually returns useless or void results, the customer will probably react to it as they would to a rude salesperson in the real world.

▶ It will add additional cost both in initial construction and maintenance.

▶ Factors such as misspelled words or phrases have to be considered.

▶ By offering a search engine, you could reduce the chances that visitors will browse through your site and make impulse purchases.

If you decide to offer a search engine use a text box with a "go" option. Usability studies show visitors overwhelmingly prefer a text box to a search button option. However, avoid the label "search" instead of "go." Visitors may mistake that for a link to a separate search page

Many third-party search engines are available to add to your site. Shop around for the best one by trying them out and seeing which ones are the most natural to use and offer results in the best format.

One final thing to remember is that if you're building a site using Macromedia Flash, be aware you probably won't have the option of offering a search because the interior of navigations built with Flash are not searchable at this time.

Searching for a Way to Offer Products

Client: **Stonewall Kitchen**
Web Link: **www.stonewallkitchen.com**
Design Firm: **Stonewall Kitchen internal design team**
Site Builder: **Stonewall Kitchen and Competitive Computing**

Credit: Stonewall Kitchen internal design team

☆

In 1991, Stonewall Kitchen opened for business on a card table at the local farmers' market. They offered a few dozen vinegars and jams that had been hand labeled hours before.

Today, their website offers an award-winning, nationally recognized line of specialty foods and merchandise yet retains the feel of a New England country store. But this country store has great digital service because it offers several ways to search for, find, and purchase items.

"We wanted the guest experience, brand image, and presentation to replicate the atmosphere of our stores," says Sarah Gallant, Stonewall Kitchen's ecommerce content coordinator.

Home: The Stonewall Kitchen homepage not only has a strong grouping of main navigation, it also groups appealing photos of its tempting merchandise into a theme visitors can navigate.

»

Partial Site Map: This partial site map may appear complicated, but once you get used to reading one, it's like reading any other map. From "home," there's access to a variety of similar "product" pages. Site builders can note global navigation or subnavigation in many ways. Here, it's done with color. Bottom navigation is shown on this map.

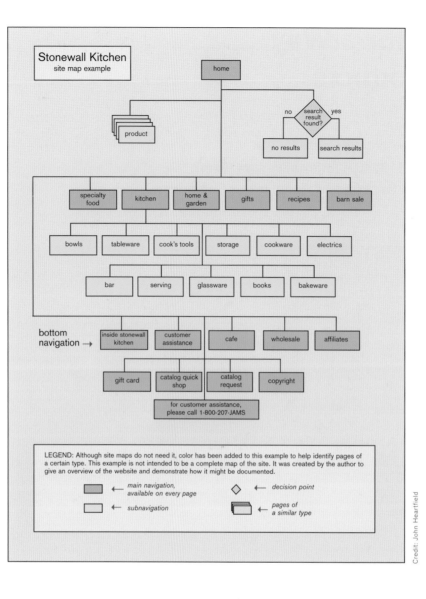

Credit: John Heartfield

The Perfect Downeast Breakfast

Homepage main navigation is located on the top and bottom of the page. The bottom navigation does not mirror the top.

Visitors looking for merchandise can find it in the logical, layered navigation choices on top, but visitors looking for more information about the company itself will have to notice that it's located in the bottom navigation. A toll-free number is clearly displayed. Without a doubt, this top navigation is meant to emphasize products without unnecessary distractions.

"Our old website featured background music, which we decided was not consistent with our brand nor was it appealing to guests shopping online," says Natalie King, VP of sales and marketing. "We also stay away from aggressive customer retention programs, pop-up windows, and other frustrating Web marketing features."

In the center of the homepage, the navigation groups six products together around the heading, "The Perfect Downeast Breakfast." To the right is an element that plays a large Flash animation of four more products that fit into the breakfast group, Stonewall Kitchen's Farmhouse Pancake and Waffle Mix, Wild Maine Blueberry Jam, Maine Maple Syrup, and Coffee. Showing off merchandise on the Web is a requirement and Stonewall Kitchen takes great care to make their merchandise look terrific and be relevant.

"For marketing reasons, we designed the site to be flexible enough to allow our content to reflect our evaluation of product trends, seasonality, industry trends, and promotions of newly released products," Gallant says.

Search Me

In the upper left-hand corner is the main search feature. When visitors type in a word the system recognizes, such as "apple" or "butter," all pages of the site containing that word are displayed to the user. The pages are displayed in three possible categories along with the number of total pages in each category (below).

Specialty Foods - 12 results
Other Products - 2 results
Recipes - 20 results

Gallant says, "Providing search elements on our entire website allows Stonewall Kitchen to offer our guests the quickest and easiest method to find a product they are looking for. It ties into our goals for ease, organization, and guest experience while on the Stonewall Kitchen website."

If the system does not recognize a word, such as "computer," a message is shown: "We're sorry no matches were found for computer."

Explaining How to Use the Search Can Be Difficult

The problem of phrases is handled by treating every word in the search box as a separate search. For example, the word combination, "apple butter," is treated as a search for "apple" and "butter." Although visitors may be looking for "apple butter," they will have to search through the search results to get what they want.

No search scheme is perfect, and communicating how to use a particular search is always a difficult task. Including detailed instructions on how to use a search, in effect, defeats the purpose of the search, which is to retrieve information without a great deal of effort.

An advantage of the way Stonewall Kitchen handles main search is that because the information is indexed, the information can be brought up very quickly. For example, the requested word "apple" is matched. All pages where "apple" appears are known in advance so those results are presented to the visitor quickly.

STONEWALL KITCHEN

SPECIALTY FOODS | KITCHEN | HOME & GARDEN | GIFTS | RECIPES | BARN SALE

search [____] [go]
basket sign in

product search results

Your search results for walnut. search again

Specialty Foods · 2 results Enter new search text:
Recipes · 13 results search [____] [go]

specialty foods

Fig & Walnut Butter
This decadently rich fruit butter is the perfect topping for your favorite ice cream, cake or pastry. For a sumptuous breakfast treat, spoon atop pancakes, waffles or French toast. Create an elegant dessert by filling a pastry shell or gently warm More

Maine Saltwater Taffy
Made in York Beach, Maine by our friends at the Goldenrod who have been perfecting their candies for over 100 years. This hand-pulled taffy is everything candy should be: sweet, sticky, and fun! Twelve flavors in each one-pound box: vanilla, strawber More

recipes

Apple Pie with Fig & Walnut Butter
This apple pie is synonymous with good things in the American home. Adding the fig and Walnut Butter creates the next level of flavorful Americana.

Banana Walnut Waffle
The crunch of walnuts adds a wonderful touch to this breakfast or brunch treat.

Beet Salad with Fig and Walnut Vinaigrette
A perfect combination of sweet and savory.

Endive, Apple & Walnut Salad
A refreshing and unique salad to serve as a first course or as an accompaniment to a turkey club sandwich.

Fall Macintosh, Spinach, Toasted Walnut and Stilton Salad with Cranberry Balsamic Vinaigrette

Fig and Walnut Butter Bruschetta
This is a delicious appetizer or late night snack with a dessert wine.

Fig and Walnut Butter Cookies

Fig and Walnut Butter Eclairs

Fig and Walnut Butter Tart

Raspberry Vinaigrette for a Hearty Summer Salad
Light and luscious, you'll want to keep this dressing in your refrigerator at all times to add character to any salad made with fruit, smoked turkey or other poultry.

Roasted Beet, Candied Walnut Spinach Salad with Garlic Honey Mustard Vinaigrette
The textures and tastes of these wonderful ingredients create a memorable and impressive salad.

Thumbprint Jam Cookies
A traditional crisp cookie dabbed with our finest preserve. Serve with a piping hot cup of tea or a glass of milk.

Turkey Cranberry Walnut Salad
A delightful salad that's hearty, colorful and filled with flavor. You might even add leftover wild rice.

search again

Enter new search text:
search [____] [go]

Inside Stonewall Kitchen | Customer Assistance | Cafe | Wholesale | Affiliates | Catalog QuickShop | Catalog Request | Copyright
For customer assistance please call 1-800-207-JAMS (5267)

«

Product Search Results: The main search results are organized into convenient categories showing the number of hits for each category. A search for "walnuts" shows "specialty foods," and "recipes." Categories are clearly divided on the page, and each search hit is a hyperlink to a relevant product page.

The Road to Blueberry Jam

The placement of the Stonewall Kitchen logo is different on the homepage. On all subsequent pages, such as specialty foods, the logo appears above the main navigation options.

The subnavigation choices are displayed directly below the currently selected main navigation category. For example, there are nine subnavigation choices for "specialty food." These choices are mirrored in the center of the page where large thumbnails illustrate each category and serve as links as well. Underneath the graphics are words and the subnavigation options to identify them, which also serve as links.

Let's imagine visitors want to purchase some blueberry jam. First they must navigate to the "specialty food" page (below). Then they choose "Preserves" and go the next page where they have a choice between "Jams," "Marmalades," and "Savories." They choose "Jams." They must scan a list of jams on the left until they see "Wild Maine Blueberry Jam," which they

choose. Now they're on the right page to choose a quantity and begin the shopping cart process.

The number of clicks is being pushed to the limit, but none of the preceding is a sales disaster. The advantage of leading visitors through this path is that they also see a large selection of other tempting jams and complementary items like marmalades. The click path to items is why the searches are so valuable. Visitors may miss the blueberry jam in the large list of jams or feel certain of what they want that day. At that point, they can type "blueberry" into the main search. Looking at the result list, they'll find a link to "Wild Maine Blueberry Jam."

It's worth noting that two very important navigation choices are grouped with "search": "basket" and "sign in." Because search is very visible in the navigation, it makes very good sense to put these three items in the same vicinity.

》

Specialty Food: On every page but the homepage, the company logo is located on the upper left of the page. Many subnavigation options are shown as product graphics on the page. As it should be, the pictures are subnavigation links as well.

Raspberry Peach Champagne Jam

Searching for Gifts

The most notable feature of the "gifts" page is that a secondary search option is added. A pull-down menu allows visitors to search for gifts for specific occasions and/or specific price ranges.

The results of a gift search are different than the results of a main search. It makes sense to display the gift search results in large thumbnails because visitors will want to see what they're ordering for their friends and family. In some categories, such as weddings, there are a great number of gifts available and displaying them is handled with the same consistent page number system that is used on the "gifts" page.

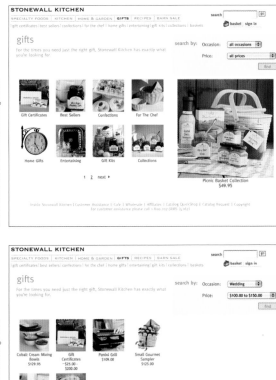

Credit: Stonewall Kitchen internal design team

⌃
Gifts (top): The "Gifts" page offers viewers categories of gifts as well as secondary search features. Occasion and price are excellent search parameters.

⌃
Gifts Search Result (bottom, left): A search result is displayed with images and prices. If more thumbnail images than could fit on this page were returned, a simple and familiar numerical list such as "1 2 3" would be offered under the graphics along with an option to move between the "previous" and "next" result pages.

Recipe Results Look Tasty

Just in case great food and service aren't enough to keep visitors coming back, Stonewall Kitchen also offers a "recipes" page (below right) and yet another search. This method of offering multiple search options works well because the results of each search are formatted differently. The main search returns a list of recipes.

For Stonewall Kitchen, the programming that drives both searches is similar. For visitors, each search option is tailored to its relevant section and none requires any computer search expertise. "The 'recipes' page is part of the lifestyle that represents Stonewall Kitchen," Gallant says. "It's a highly requested feature by visitors."

At the moment, the "recipes search" may pose one problem for some visitors. They must distinguish that "Products" is a separate search from "Recipe Ingredient" and "Recipe Type." This might have been clearer in the navigation.

Part of having a website is the commitment to constantly have it evolve into something better. "The design of the 'recipes search' page is being reorganized," Gallant says. "We've found that many visitors like to search for recipes by several criteria. We're working to improve that search."

"Simple is better," she continues. "Functionality and usability were primary in navigation design."

Overall, the Stonewall Kitchen site is a feast for the eye and a pleasure to navigate. It's enjoyable to type an ingredient into one of their product search engine and see the delicious combinations of foods. There's no doubt this company that began not far from the farmers' market will continue to grow.

Credit: Stonewall Kitchen internal design team

«
Recipes: Another search feature on the recipe page lets visitors search for recipes by Stonewall Kitchen product, recipe type, or recipe ingredient. It's a great feature, but because the two searches are exclusive, Stonewall is planning to reorganize the options to avoid confusion.

» OFFERING HELP

In an ideal navigation, options and actions would be so obvious that there'd be no reason to include help. Since it's highly doubtful that any navigation is ideal, the question becomes: "Are the issues raised by my navigation complex enough to warrant a help section for visitors?" In addition, "Do my visitors need to have some knowledge to enjoy my features?"

Here are some reasons why a website might offer help:

▶ Visitors may need technical knowledge.

You can't assume that visitors will know about certain preferences, such as connection speed.

▶ The content of your website raises common questions in the minds of visitors.

The ubiquitous FAQ is usually found in "help."

▶ You want to provide an avenue for visitors to address specific issues.

You may have a contact email address, but what if you want users to send bug reports such as broken links, suggestions for improving the website, and other specific information to a specific email address?

You could also provide a form for rating the various aspects of the site such as design, navigation, and content. That could give you a formatted database of visitor feedback.

▶ Visitor must perform certain actions in a certain order.

Even though this is not generally a good practice, sometimes it can't be helped. If your instructions are clear, including a detailed explanation in the navigation seems unnecessary and too clunky for the majority of visitors, but some may need a step-by-step explanation.

When instructions are included in the navigation they should be short and to the point. Wordy directions can be worse than no directions at all.

On the other hand, a help section should *not* be used for the following:

▶ To explain how to use the navigation

If you need a help section to explain how to use your navigation, design a new navigation.

▶ To explain what icons mean

Don't put up icons in the corner of the screen and then include a help page to tell visitors what they signify. This book recommends labels to identify all but the most self-explanatory icons.

Often an online site map is an integral part of a help section. An online site map can help visitors quickly find links that are not obvious to them in the navigation.

Just like an online site map, remember that your help section is a complement for your navigation—not an auxiliary for a weak navigation or a place to explain away ambiguity.

An Online Media Empire

Client: **sputnik7** Web Link: **www.sputnik7.com**
Design Firm: **sputnik7 in-house design team**
Site Builders: **James Berry (creative director, Flash), Duncan Creamer (art director/designer, Flash), Noah Mittman (senior implementer), Danny Wyatt (programming), Dave Stenglein (operations), Ken Bolton (producer), John Niernberger (content manager), Steve Sargent (quality assurance)**

Credit: sputnik7 In-House Design Team

Sputnik7 is an audio/video Web–entertainment complex that broadcasts an eclectic mix of independent music, film, and anime programming via interactive video stations, audio stations, videos on demand, and digital downloads.

The website's award-winning design allows visitors to chat, purchase music, get free downloads, make requests, rate videos, and find information on artists, all without interrupting their audio/visual entertainment experience.

"Our goal was to create an entertaining experience and environment, and more importantly, provide intuitive access to the content," says James Berry, creative director.

The key challenges were to how to organize content with very different properties while making the site flexible enough to accommodate new entertainment options as they became available. At the same time, it was essential for the site to maintain a distinctive look and feel.

Home: Rolling the mouse over any of the five rectangular elements at the bottom of the page reveals the entire graphic that expands downward into a square. Often you can maximize screen territory by expanding under the bottom border of the page and avoid covering existing areas of the page with elements that become visible upon rollover.

»

Partial Site Map: This partial site map shows that there are two subnavigation options on the homepage, "watch info" and "submit content." The login scheme is not specified in this map. See the FreshDirect site map on page 22 for a documented login procedure.

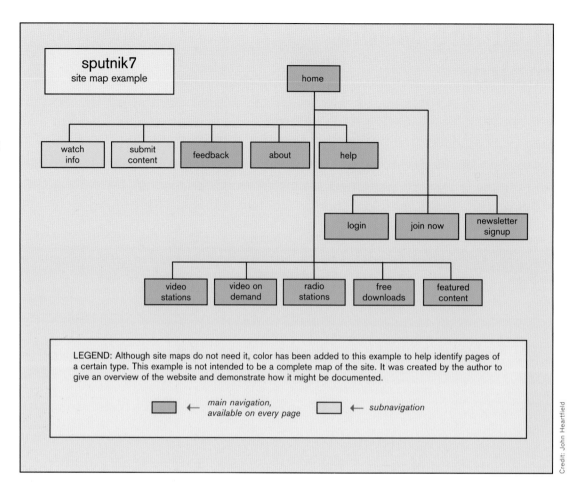

A Feature Is Born

"We didn't want sputnik7 to look like an average Internet portal site," Berry says. "Although very functional, we offer something a bit more mysterious and interesting. Rather than crowd pages with as much information as possible, we decided to highlight just a few artists and features. Visitors can decide if they want to download songs, watch a specific video, listen to radio, read a feature article, or watch VJ's programming while chatting with other people around the world who were watching exactly the same thing."

As the company moves forward, the current navigation will evolve to accommodate new services. For example, rather than offering content by different types, the navigation will direct visitors to an artist's page where all types of content will be available to them.

Sputnik7 wisely chose not to have sound play automatically when users arrive. One reason is that sputnik7 presents a wide variety of entertainment, and it's just as likely a rock music fan might be as turned off by rap music as the other way around.

Good Feedback

The homepage is the gateway to the sputnik7 experience. Current "features" are located along the bottom. There are five options on the center right of the page: "Video Stations," "Video on Demand," "Radio Stations," "Free Downloads," and "Featured Content." When visitors rollover an option, they're presented with a short paragraph of information and some cool visual feedback (right).

The rollover feedback is complex enough to appear almost like an animation. Clicking on an option takes visitors to their destination without any delay, as it should. One of the reasons sputnik7 can offer a visually rich navigation is that its target audience is composed of visitors with Web connections that can support it.

"Sputnik7 is geared towards trend spotters, generally fifteen to thirty-four, though many of our users fall outside that age group," Berry says. "We appeal to people looking for the kind of cutting-edge entertainment that you won't find on MTV or VH1. In addition to mainstream artists, we seek out exceptional new work. Our audience loves electronic music, anime, and indie films, and sputnik7 appeals to their eclectic tastes. With so much out there, our visitors trust us as a filter for content that meets their expectations."

⪢

Homepage Options: A rollover of one of the five entertainment options causes a great deal of interesting, nonanimated visual feedback. Some combination of the squares on the left turn white, a paragraph about the option appears, and small pointers identify the option as the current rollover.

Credit: sputnik7 in-house design team

«

Videos on Demand: After the homepage, the main navigation options are consistent and appear in the left column of the page. The size and placement of these options are meaningful. The larger type of the top group shows that the site's content is of paramount importance. The three options composing the group on the bottom all launch windows where visitors can access desired content.

Credit: sputnik7 in-house design team

Credit: sputnik7 in-house design team

Credit: sputnik7 in-house design team

⩘

Settings (above): Once a visitor becomes a member of sputnik7, their player preferences and connection speed are stored. Although the user settings can always be altered through the "User Settings" option in the middle main navigation group, this feature allows visitors to enjoy the site immediately when they return.

»

Help System (right): The help pop-up windows offer advice on categories from "Homepage" to "Jobs." It is also launched whenever visitors choose "About" from the bottom group of the left navigation menu. Each heading like "Digital Downloads" offers at least one submenu option such as "Common Questions."

Tools for the Visitor

Sputnik7 offers a great deal of content so strong navigation is imperative. On pages other than the homepage, a global navigation menu is offered on the left. In the center of the "Video on Demand" page (previous page) are choices for "Music," "File," and "Anime." On the right are links to popular videos.

The "Video on Demand" page contains many obvious options, but it also contains choices such as "Join Now" and "User Settings" (above left). The former is necessary to take advantage of the sputnik7 site and the latter is required to enjoy it properly. The functional aspects of these options aren't obvious but they are absolutely necessary to enjoy the full effect of the sputnik7 experience.

On a page that is already pushing the content envelope, how does sputnik7 guide visitors through common navigation parameters that might otherwise frustrate them? The answer is a full-blown help system that is offered in a pop-up window (above right). "We wanted to make sure that if anyone had any problems getting around the site or watching video, they could find answers quickly," Berry says. "Browsers, player versions, and player settings are very important for optimal viewing so we wanted to make sure that information was readily available."

One Label Becomes a Good Explanation

In the help system pop-up window, each bolded heading expands to subtopics when clicked. Visitors can click on their topic of interest from finding what they need in order to enjoy sputnik7, to how to take full advantage of the features of the site, to finding out more about sputnik7 and applying for jobs.

The help window on sputnik7 is not just for answering questions. It's also used as a way to clearly define options that exist within options. For example, "About" in the main navigation menu automatically launches the help window. The "About" option goes to a topic in the help section labeled "Who We Are," which contains company information about sputnik7. Under "Who We Are" are the subnavigation options "Copyright," "Privacy," "Partners," and "Contact Us." Each of those options contains enough vital information to answer the majority of visitor questions.

Feedback of a Different Kind

Right between "About" and "Help" is the "Feedback" option. "Feedback" launches a window very similar to "Help" that allows visitors to give their feedback on the site, report any bugs or just make comments. "Feedback" is different from "Comments" in that it contains a very short evaluation form, whereas "Comments" is simply a text box to send email to sputnik7. The distinction between the two could be made clearer. Perhaps "Message" is a better label than "Comments" in this instance. Regardless, visitor feedback is invaluable to any website.

Berry says, "Visitors let us know what content they would like to see, what features and functionality they would like, and what bugs they are running into. It's helped immensely in shaping the site and fixing bugs or issues that we didn't catch. We've made several improvements to the next version of the site based on this input."

Free for Them, Good for You

When asked what features visitors enjoy now, Berry said they loved the fact they can view entire anime films for free. People still expect free features on the Web and offering some free valuable content to your visitors is a great way to build your audience.

The sputnik7 site contains a great deal of diverse content, but the builders were careful to make the site feel similar no matter what content was being offered and to avoid having too many levels of content. The deepest point of the site is Video on Demand, which is only four levels deep. Registered visitors on the homepage are only two clicks away from watching or listening to content.

"Simple is best," says Berry. "Unless you want to do an arty site that people will view once or twice because it's cool, people just want to get to the content as fast as they can. We believe there are generally two types of visitors. There are those who know what they want and want it quickly. They're less concerned with appearance and more interested in how fast the navigation reacts. The other type likes to explore. Aesthetics and innovation are more important to them. At sputnik7, we tried to create a balance to meet both types of user."

⩘

Music Video: The music video page is well structured to allow a great deal of options. Visitors can find videos of their favorite artists, jump by letter, or search using a text box. It's possible to buy the CD that contains the song or even send the current video to friends. On the right side, new music and top music choices are categorized under headings for easy access.

Credit: sputnik7 in-house design team

» GLOSSARY

The following definitions are not precise industry standards but simple, understandable definitions of the terms found in this book. In almost all cases, the names of the terms, such as Above the Fold and CMS, are standard. More information about terms or other definitions can be gotten from the Google define tool. Just put "define" in front of a word or phrase in the text box and Google brings up the definition.

Active Element
An element that responds to input, such as a mouseclick or a rollover, by performing some action for visitors. An active element might be a hyperlink or some button that performs a function, such as removing an item from a shopping cart.

Above the Fold
The visible part of a long vertical page when a browser window is open to a standard size. This is derived from newspaper terminology. Imagine a long newspaper page folded in half horizontally—the area that contains the title of the paper is above the fold.

Aural Feedback
Any sound that is played when visitors take an action such as clicking or rolling over an element.

Automatic Sound
Any sound that plays without being specifically requested by visitors.

Bandwidth
Computer jargon used by Web surfers to describe the volume of information a computer network can handle in an amount of time. More bandwith usually translates to a richer multimuedia experience.

Below the Fold
The invisible part of a long vertical page when a browser window is open to a standard size. *See* Above the Fold.

Bottom Navigation
A group of simple hyperlinks, usually text, found at the bottom of website pages that provides easy access to key pages in the site.

Client (as in Client/Server)

Any computer that is part of a computer network. Your visitor's computer, the client, could request that your website, on the server, download pages of your website.

Connection Speed

The speed at which you connect to a network. Today, dial-up connections are the slowest, cable modems and DSL connections are much faster, and T1 and T3 lines are very fast. As of this writing, the majority of visitors still have the cheaper dial-up connections, so make sure your website does not make them wait a long time to download your pages. Keep your file sizes small.

Content Management

The tasks of storing, indexing, searching, retrieving, backing up, and organizing media such as texts, links, graphics, audio clips, scripts, or any other content. Content management also allows an administrator to create new pages and edit or delete current pages on the site.

CMS

A content-management system is software that is dedicated to content management. *See* Content Management.

Content Navigation

An interface element that transports visitors to desired content.

Dead End

A page that doesn't provide visitors with any navigation option except the back and forward buttons of the browser.

Functional Navigation

An interface element that performs some function when activated. For example, on a shopping cart page, a visitor wants two shirts instead of one. They put "2" into the quantity text box, then click the functional element "update quantity" to update their order.

FAQ

Frequently Asked Questions. A method of addressing the most common questions posed to the owners of a website by posting the questions and the answers on the site.

Flash

Macromedia Flash is a software program that employs vector animation so that rich media can be delivered in smaller file sizes. It is being used more and more as a navigation tool rather than strictly an animation tool by small businesses that present the entire site as Flash (.swf) files.

Global Navigation

Navigation options that are visible on every major page of the site.

Grayscale Value

The shade of gray a color becomes when all hues but black and white are removed from it.

Hierarchical Navigation

A navigation scheme where there is a top level of navigation. Each option in the top level exposes an option or group of options that is considered subnavigation. Those options can expose further options below them and so forth.

Hyperlink

A link between one hypertext file (Web page) to another location or file.

Hyperlink Hand

The small, white hand that appears when visitors roll the mouse over a hyperlink. Some Web developers convert the hand into another small graphic.

Hyperlinked Graphics

Graphics that double as hyperlinks. The hyperlink hand appears when visitors roll the mouse over them.

Icons

A small picture intended to represent something in a user interface. Icons are usually small .gif files optimized for the Web.

Information Architect

(also referred to as user Interface designer, or interface designer): A person who designs graphical user interfaces. Good information architects are concerned with the overall visitor experience. They carefully determine the goal(s) of the site, the target audience(s), and map out the structure of the site.

Internet Portal

A site that acts as a gateway to related sites. For example, a company might have a portal site where it would offer the URLs of each of its divisions.

Labels

A text word or very short phrase that describes a hyperlink destination. For example, "about us" could be a label below a photo of the company that links to a page describing the company.

Launch

To initiate something such as a pop-up window, a piece of software, or a live website. The "launch date" is the calendar date the site is scheduled to go "live" on the web. "Launching an application" is starting a piece of software.

Link

A connection between one hypertext file (Web page) to another location or file. The link is usually activated by clicking a navigation element at a particular location on the screen.

Main Navigation

The options at the top of the navigation hierarchy.

Metaphor

A method of creating a transference of the relationship between one set of objects to another set for the purpose of facilitating navigation or adding entertainment value to a Web navigation.

Navigation Element

An active element that moves the visitors to either another page or another location within a page.

Navigation Group

A logical grouping of related options in a website navigation.

Navigation Menu

A clearly delineated area of the screen that contains a group or groups of navigation options.

Online Site Map

An outline of the structure of the website navigation offered for the purpose of allowing visitors to jump to any desired location in the site.

Option

Any active element in the Web navigation that allows visitors to make a choice.

Out-of-the-Box Solutions

Software that is not custom-made. For example, some companies sell out-of-the-box CMS (content management systems) that can closely match the requirements of your business.

Quality Assurance

A systematic, planned approach to perform the actions necessary to be reasonably assured that the website will be problem-free and able to fulfill visitors' expectations.

Rollover

A rollover is an element that responds in some fashion when the mouse pointer rolls over its location.

Screen Territory

An area of the screen that appears in the content portion of the browser.

Server (Computer)

The computer that provides client computers with access to files and other services on a computer network.

Site Map

A graphical representation of the architecture of a website. The site map is used by the production team to define and document the relationship between the site's Web pages and decision points.

Splash Page

The page(s) that may appear before your homepage when visitors type in your URL. Typically, a splash page is used to introduce the site, inform visitors of the site's requirements, and direct them to resources (like plug-in downloads), if necessary. Splash pages appear only one time per session and should be inserted only if they are required.

Storyboard

See Wireframe.

Subnavigation

Navigation options that are grouped at some level beneath the main navigation or do not appear on every page of the site.

Target Audience

The particular group(s) of visitors to whom your message is mainly directed.

URL

Universal Resource Locator. The unique address of a website on the Web. A URL begins with "http" or "https" and is located in the address box of the browser.

User Interface Designer

See Information Architect.

Usability Testing

A systematic, planned approach to performing the actions necessary to ensure the effectiveness, efficiency, and satisfaction with which users can perform tasks and achieve goals in a environment such as a website. High usability means a website navigation is: simple to learn, provides clear visual feedback, efficient, visually pleasing, and quick to offer clear solutions if visitors make errors.

User Testing

See Usability Testing. User testing should be performed at all stages of website development.

Visitors

Visitors are people who enter and explore your website. Visitors are also known as users, web surfers, and, hopefully, customers.

Visual Feedback

Any visual change that occurs when an active element is selected or chosen. The hyperlink hand is a classic example of visual feedback. So is a change of color when a menu option is rolled over.

White Space

The unoccupied screen areas between content elements on a Web page. The right amount of white space helps to delineate elements and gives the visitor's eyes a rest. Too much white space makes the page look empty, and too little makes it appear crowded. Try to find a good balance.

Wireframe

A representation of the elements found on a particular Web page. The wireframe (or storyboard) is simply a record of the structure of the page. It is not meant to depict graphic design or element location though certain conventions are usually followed. For example, on a wireframe, the logo is usually placed in the upper left, the navigation groups are shown as vertical or horizontal, and bottom navigation is shown at the bottom.

» DIRECTORY

Apt5a Design Group, Inc.
28 Warren Street, 2nd Floor
New York, NY 10007 USA
212-608-1130
www.apt5a.com

DataArt
475 Park Avenue South
New York, NY 10016 USA
212-378-4108
www.dataart.com

Foscarini Murano SRL
Via Delle Industrie 92
30020 Marcon, Venice,
Italy
+39-041-595-1199
www.foscarini.com

FreshDirect
2330 Borden Avenue
Long Island City, NY USA
866-279-5451
www.freshdirect.com

interactivetools.com, inc.
#540 - 601 West Hastings Street
Vancouver, BC, Canada
V6B 5A6
800-752-0455
www.interactivetools.com

Kimili
www.kimili.com

Henry Kuo
737 Olokele Ave, #1007
Honolulu, HI 96816 USA
808-779-7181
www.henrykuo.com

New World Restaurant Group, Inc.
1687 Cole Blvd
Golden, CO 80401 USA
303-568-8000
www.newworldrestaurantgroup.com

Noble Desktop, LLC
594 Broadway, Suite 1208
New York, NY 10012 USA
212-226-4149
www.nobledesktop.com

Palo Alto Software, Inc.
144 E. 14th Avenue
Eugene, OR 97401 USA
541-683-6162
www.paloaltosoftware.com

PixelPharmacy
3842 Laval
Montreal, QC, Canada
514-248-6568
www.pixelpharmacy.com

Roxen Internet Software AB
Box 449
SE-581 05, Linköping, Sweden
+46-13-376800
www.roxen.com

Rullkötter AGD {Werbung + Design}
Kleines Heenfeld 19
D-32278 Kirchlengern,
Germany
05223/73490
www.rullkoetter.com

Scholz & Volkmer Intermediales Design GmbH
Schwalbacher Str. 76
65183 Wiesbaden,
Germany
+49-(0)-611-180990
www.scholz-und-volkmer.de

Serotta Competition Bicycles
41 Geyser Road
Saratoga Springs, NY 12866 USA
518-584-1221
www.serotta.com

Sound of the Web Limited
Studio E, 1-11 Howard Road
Bromlem, BR1 3QJ, England
+44-0-208-466-041
www.soundoftheweb.net

sputnik7.com
601 West 26th #1150
New York, NY 10001 USA
212-320-3600
www.sputnik7.com

Stonewall Kitchen
Stonewall Lane
York, ME 03909 USA
207-351-2713
www.stonewallkitchen.com

3dot3 media
101 Old Palisade Road #C3
Fort Lee, NJ 07024 USA
201-944-1103
www.urbanagent.com

Wert & Company, Inc.
222 5th Avenue, 5th Floor
New York, NY 10001 USA
212-684-2796
www.wertco.com

Acknowledgments

Thank you to the wonderful people behind the websites that appear in this book. They were as cooperative as they are talented. It was a pleasure.

A special thank-you to my editor at Rockport, Kristin Ellison, for her good humor and expert advice.

I enjoy extended acknowledgment lists as much as lengthy Academy Award speeches. There is, however, a group that helped this book become a reality and I'd sincerely like to thank them. This is the short list:

Red Burns, Phil White, Tina Buckman, Winnie Prentiss, Ann Fox, Amy Sutton, Janet Cadsawan, Andrea Moed, Charlie Zicari, Morry Galonoy, Katharine Sands, Mark Doerrier, Catherine Jacobson, Don Jacobson, Tom and Lina Heartfield, my family in Italy, Sabine Roehl, Ninja v. Oertzen, Jim Heshedahl, M. T. Sky, Michele Cencig, Anya Whitmont, Bill Vanyo, Noriko Mukai, Michele Paris, B. L. Ochman, Alissa White, Maria Ferrari, Maria Azzinnari Marra, Vica Vinogradova, Alexei Miller, Jessica Orkin, Younghui Kim, Dean Garner, Sherlin Hendrick, Jennifer Strom, Camilla Beltrami, David Goldfarb, Merideth Clark, John Lobel, Bill Vanyo, all my friends and list mates from ITP, the entire Margoshes clan (especially Steve and Koky), and Dorothy.

About the Author

John Heartfield is an international consultant specializing in information architecture and Web development. Formerly, he was a professor at both the Stern School of Business, NYU, and the Interactive Telecommunication Program, Tisch School of the Arts, NYU. His courses centered on the Web and multimedia programming and design. He also writes fiction and songs. He lives in New York City.